THE
JEWISH
JOURNEY

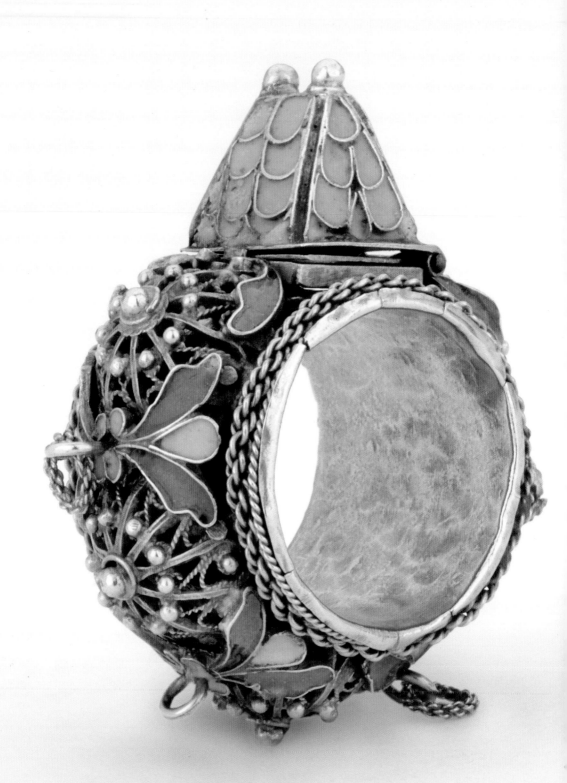

THE
JEWISH
JOURNEY

4000 years in 22 objects

FROM THE ASHMOLEAN MUSEUM

REBECCA ABRAMS

FOREWORD BY Simon Schama

To the memory of Abram, Annie,
Joshua, Esther, Harry and Charlotte,
who all left their homes and
journeyed to new lands

Text copyright © Rebecca Abrams 2017

Design, images and format copyright
© Ashmolean Museum, University of Oxford 2017

Rebecca Abrams has asserted her moral right to be identified
as the author of this work in accordance with the Copyright,
Design and Patents Act 1988.

ISBN: 978-1-910807-03-3

British Library Cataloguing in Publication Data
A catalogue record for this book is available from the British Library

Published by the Ashmolean Museum, University of Oxford

Designed by Ocky Murray
Printed and bound in Italy by D'Auria Printing spa

This book was published with the generous support of the
Henry Posner Fund, the Ullman Trust, and Dr Evie Kemp,
in memory of her parents Rose and Dan Kemp.

ASHMOLEAN
MUSEUM OF ART AND ARCHAEOLOGY UNIVERSITY OF OXFORD

Oxford Jewish Heritage

CONTENTS

'Remember the days of old,
examine the years of
successive generations'

Deuteronomy 32:7

FOREWORD
BY SIMON SCHAMA

'OF THE MAKING of books there is no end,' grumbled Ecclesiastes' morose preacher. Undeterred, Jews have plunged into oceans of words, to the extent that Victorians such as Matthew Arnold identified 'Hebraism' with text and 'Hellenism' with art. Given the Second Commandment (often taken to be a prohibition against idolatrous sculpture) and the defining ritual of reading the Torah, that was understandable, but the truth is that Jewish life over the millennia has been rich with art. It was the Oxford historian Cecil Roth who had the audacity in 1957 to produce a book of essays on 'Jewish Art' at a time when that was still taken to be an oxymoron that needed explaining.

Jewish art – in its broadest sense of objects that tell the Jewish story – describes a famous paradox. On the one hand it has been deeply absorbent, picking up characteristics of all the cultures it has brushed up against, or been overwhelmed by. On the other hand it has remained stubbornly true to its inner, distinctive core. A fifth-century BCE potsherd from the garrison town of Elephantine in Upper Egypt (see p.51), made during the time of the Persian Achaemenid empire, is at once universal in its concern for the welfare of children and altogether Jewish in mentioning the observance of Passover.

Equally revealing are epitaphs from the Jewish catacombs in Rome, such as that of the sausage seller Alexander (see p.93), which closely resemble those found in non-Jewish burial sites, but often also feature a menorah, the seven-branched Jewish candlestick. The persistence of the

image of the menorah down the centuries acts as a mark of obstinate, defiant memory.

Jewish culture, then, has always been a work of wandering, so it is appropriate that visitors to the Ashmolean keen to learn more about Jewish history should also wander through the museum's galleries in pursuit of the thread. But this is how modern illuminations best happen: not through blockbuster cozening, but by being gently, wisely steered towards serendipitous understanding. *The Jewish Journey* takes 22 of the great riches of the Ashmolean Museum, from ancient Mesopotamia to catastrophic Sachsenhausen, and with the wonderfully imaginative guidance of Rebecca Abrams, the model of a learned story-teller, provides a route through time and its objects to moments of illumination. What you do with its revelations, Jewish and not-so-Jewish, is up to you.

Simon Schama

INTRODUCTION

'To somewhere beyond the final point
Towards an endless beginning
Far in the distance'
Uri Zvi Greenberg, *The Man Who Stepped Out of His Shoes*

A TINY JASPER SEAL from late Bronze Age Judea; a Roman coin made from gold looted from the Temple in Jerusalem; the funeral plaque of a Jewish sausage maker from fifth-century Italy; a medieval magic amulet inscribed with Hebrew text and the face of Christ; a forged banknote made by Jewish prisoners in a Nazi concentration camp. These are just a few of the 22 objects from the Ashmolean Museum in Oxford whose stories are told here. Preserved in stone, marble, copper and paper, gold, glass, ink, wood and paint, the mere fact of their existence and survival is in many cases remarkable, as are the stories they tell: stories of the men and women who made and used them, and the different political and social contexts in which they did so. Spanning 40 centuries and thousands of miles, these objects come from diverse countries and reveal the influence of diverse cultures. They represent the material traces of a singular culture with myriad variations. All are connected in one way or another to the history of the Jewish people, from the time of their emergence in the Ancient Near East around four thousand years ago, to their gradual evolution over the next two millennia into a distinct group of people with their own language, customs, territories and religion, and their subsequent journeying, sometimes enforced, sometimes voluntary, to all four corners of the globe. These 22 objects are not only seasoned travellers in their own right, but representative of the mobility of the Jewish people as a whole, and the transmission and dissemination of Jewish ideas, beliefs and customs.

All 22 of the objects featured in *The Jewish Journey* are drawn from the collections of the Ashmolean Museum and the majority are on permanent display. Dispersed throughout the Museum's galleries and collections, they are nevertheless easy to miss among the wealth of treasures. Even knowing where to look and what to look for, a non-specialist might still be none the wiser about their specific relevance to Jewish history and the particular stories they have to tell. This hidden quality was the genesis for *The Jewish Journey*, which grew from a desire to bring these precious and extraordinary objects into clearer focus. My choice of these 22 objects was guided by the overarching aim of shining a clearer light on the Jewish objects in the Ashmolean's collections in order to reveal their unique significance to Jewish history and, in turn, illuminate some of the critical moments and events to which they relate. The goal was not to tell a comprehensive history of the Jews, but rather to identify objects which, like stars in a complex constellation, would connect in such a way as to convey the sweep of that hidden history and reveal the immense diversity of experiences it contains.

As it happens, many of the objects I have chosen to highlight were themselves hidden at one time or another. The beautiful little perfume flask, described in Chapter 2, was buried with its owner deep underground in a Canaanite tomb. The Roman gold coin in Chapter 9 was found in the nineteenth century embedded in a field in Oxfordshire. The magnificent Bodleian Bowl in Chapter 14 was discovered four hundred years after it was made, at the bottom of a disused moat in Norfolk. This theme of concealment resonates with one of the darker motifs running through Jewish history: the recurring imperative for Jews to conceal themselves, and their belongings, in order to evade anti-Jewish persecution. Another strand in the story, represented by a number of these objects, is the long history of voluntary and partial concealment through assimilation and integration. The jasper seal in Chapter 3 belonged to a Jewish woman named Hannah, yet at first glance it looks thoroughly Egyptian. The *viola da gambas* in Chapter 17, made in Italy by master instrument makers Gasparo da Salo and Girolomo Amati, bear no outward signs of their Jewish connections, but yielded rich stories related to the pressures on Italian Jews in the sixteenth and seventeenth centuries to convert and assimilate. However, as the stories behind the paintings by Camille Pissarro (Chapter 18), David Bomberg (Chapter 19) and Mark Gertler (Chapter 20) show, assimilation was not without its difficulties.

The question of what Jews look like has been raised by people hostile to Jews and Judaism at many points in history yet, as the stories behind

these 22 objects reveal, the answer is as elusive as the question is objectionable. Jewish life has taken many different forms over the centuries and is as diverse as Jewish people themselves. In one sense, all 22 objects in this book represent a form of assimilation: Jewish as they may be, they have become integrated in the galleries in which they are now displayed. Set within the larger 'culture' of the Museum itself, they too are no longer immediately identifiable as Jewish. On the one hand this has the undeniable advantage of locating Jewish history in its wider geographical and cultural context; on the other, it runs the risk of erasing, however unintentionally, the specifically Jewish significance of these objects.

The Jewish objects in the Ashmolean's collection are additionally important and unusual in that they document the material culture of Jewish life rather than Jewish faith. While Jews and Judaism are closely connected, they are not – and never have been – wholly synonymous. Jewish religious culture is relatively well-preserved in museums, libraries, synagogues and archaeological sites around the world, in objects ranging from fragments of ancient mosaic floors, medieval Hebrew manuscripts and Renaissance prayer books to exquisitely embroidered scroll covers, silver finials and ivory pointers, as well as other ritual and sacred objects. Antique Torah scrolls are still in daily use in many synagogues, indicative of the Jewish veneration for the past and the continuity of Jewish worship. Many of these sacred objects survived thanks to Christian scholars and collectors. With supreme irony, the Nazis also helped to preserve a great many precious Jewish artefacts, which they collected with the intention of showcasing their success in eradicating both the Jewish people and Jewish culture.

While objects related to sacred and ritual Judaism are often distinctive to particular regions and countries, they are recognisably connected to a singular religious faith. By contrast, the material remains of daily Jewish life are far less common and rarely represented outside museums dedicated to Jewish history. This reflects in part the mobility of Jewish people over the centuries (all but the most wealthy immigrants tend to travel light) and in part the physical erasure of many Jewish communities. But it also reflects a tendency to focus on what has made the Jewish people historically distinctive, i.e. their religion, rather than on other aspects of Jewish existence, such as what they shared and exchanged with other cultures. Historical scholarship and oral testimony have gone a long way to correct this imbalance, yet in terms of museum culture a tendency persists to decontextualise Jewish life from the places in which it was being lived and instead present evidence of what made it different and distinctive. The result has frequently

been a conflation of Jewishness with Judaism. A question running through this book, by contrast, is what were Jews doing when they were not practising Judaism? The answers furnished by the objects highlighted here include cooking, trading, fighting, travelling, falling in love, raising children, making jewellery, playing music, painting and much else besides. This picture by no means excludes Jewish religious life, but neither does it end there. Scattered throughout the galleries of the Ashmolean, these 22 objects remain located in their wider historical context, helping to contextualise Jewish life within a larger frame, while at the same time elucidating their specific Jewish significance.

Inevitably the objects in *The Jewish Journey* reflect the history of the Ashmolean Museum itself, and the evolution of its acquisitions, curatorial tastes and interests. The Bodleian Bowl, for example, is one of the treasures of the Museum, not because of the story it has to tell about the Jews of medieval England, but because it was one of the Museum's earliest acquisitions. The cryptic Hebrew text encircling the belly of the bowl excited curiosity in Protestant England in the seventeenth and eighteenth centuries, a time of renewed scholarly interest in Hebraism, and also explains why for several hundred years it was catalogued not as an object but as a manuscript. The abundance of objects relating to the Jewish presence in the Ancient Near East and eastern Mediterranean, up to and including the period of the late Greek and early Roman empires, likewise reflects the expansion of archaeological excavations in the Near East in the mid-twentieth century, many funded by British institutions, including Oxford University.

Since these objects determined what moments in Jewish history this book would tell, not vice versa, there are gaps in the story, places on the Jewish journey that I have had to leave out. I was unable to identify objects relating, for instance, to the long and fascinating Jewish histories of North Africa, India, the Arabian Peninsula and, more recently, South America. The history of Jewish communities in places such as Crete, Sicily, Sardinia, Spain and Portugal, and the eight hundred years in which Jewish people lived throughout the Ottoman empire, is similarly a rich seam barely mined. Also regrettably absent are objects that might give a flavour of the vibrant Ashkenazi culture that flourished in Eastern and Central Europe from the Middle Ages to the mid-twentieth century before being brutally destroyed by Nazi fascism and Soviet communism.

What *is* in the Ashmolean is nevertheless of immense value and interest, and covers a vast and varied terrain. Like the journey of the Jews themselves, the journey described by these 22 objects is both temporal and

geographical. It begins with the King List (1800 BCE) from ancient Iraq, where Abraham, the founding father of Jewish monotheism, is believed to have lived, and from there wends its way across the centuries and continents, taking in Egypt, Syria, Persia, Greece, Italy, France, the Caribbean, Israel, Russia, Poland, Germany and England en route. The last of the objects in this book, a pottery camel from Tang Dynasty China, brings us, appropriately enough, to Oxford and the present day. *The Jewish Journey* thus takes the reader on two journeys: a literal journey through the galleries of the Ashmolean Museum and a metaphorical journey that traces the steps of the Jewish people through time and space.

Why 22 objects? There are certainly far more objects than this relating to Jewish history in the Ashmolean, but 22 is a number of special significance in Jewish culture. As long as three thousand years ago, the Hebrew alphabet had fixed on the 22 letters it still uses to this day. The script and language have evolved during that time, but the letters are recognisably the same, symbolic of the blend of change and continuity that characterises the Jewish story itself. The number 22 is further charged with meaning according to Kabbalah, the medieval mystical branch of Judaism. In the tenth century, in the first written version of *Sefer Yetzirah* (Book of Formation), Rabbi Akiva described how the universe was created through 22 hidden paths on the Tree of Life, each path representing our movement from one state or condition to another. The 22 paths are our subjective experiences, while the Tree of Life as a whole depicts the descent of the Divine into the manifested world. For Kabbalists, the number 22 signifies the meaning of life. The objects in *The Jewish Journey* do not aim to reveal the meaning of life, but they certainly reveal something of what life has meant to Jewish people at different times in their history.

While many of the objects in this book attest to the creative and intellectual successes of the Jewish people, it cannot be ignored that throughout their four-thousand-year journey the Jewish people have experienced with depressing regularity the recurrence of 'man's inhumanity to man', characterised by outbreaks of anti-Jewish prejudice and eruptions of violent persecution, a murderous seam in human history that continues even beyond the unparalleled horror of the Nazi genocide in the mid-twentieth century. The snapshots in time provided by the objects in *The Jewish Journey* leave little room for complacency on this score, yet paradoxically they also offer some scope for optimism. Across the centuries, the frequent imperative for Jewish people to move from one place to another as refugees and immigrants gives their story a particular resonance at this moment in time, a reminder

that large movements of people are nothing new and have often proved highly beneficial to the countries in which they resettle. The mythical figure of the Wandering Jew, however entrenched in popular imagination, is misleading because, as these objects also remind us, Jewish people have lived for long stretches of time as settled citizens in almost every country in the world, partaking in and contributing to the cultures of those countries. The 22 objects in this book thus tell stories that sometimes pull in contradictory directions: separation and integration, tolerance and persecution, religion and state, kingship and slavery, continuity and change, destruction and survival. Taken as a whole, however, the story they tell is one of adaptability, resilience and the extraordinary and inspiring human capacity for renewal.

It was the great Hebrew prophet Isaiah who, in the eighth century BCE, described the enemies of the ancient Israelites as 'tumbleweed'. The Assyrians, Isaiah proclaimed, would be driven away 'like tumbleweed before a gale'. Tumbleweed serves also as a poignant metaphor for the Jews themselves, who have been blown about the world by their enemies, 'driven like chaff before winds' by persecution and poverty, as well as by the desire to make better and safer lives for themselves and their children. The Jewish people resemble tumbleweed in a further respect as they have wheeled through the centuries, gathering influences from other cultures along the way, part and parcel of the general chaff of human life.

Time-honoured and deep-seated in Jewish tradition is a more exalted version of this notion: the idea of each generation of Jews succeeding the last in an unending cycle. The word for generation in Hebrew is 'dor', and is related to the word for a ball, 'kadur', conveying the cyclical and circular nature of this generational chain. Even the determination of many Jews over the centuries to break with the past constitutes a kind of recognition of its weighty and often cumbersome influence. Around the world to this day the phrase from Psalm 100, 'dor vador', from generation to generation, is spoken and sung in synagogues in celebration and reverence for this ancient and ongoing connection between past, present and future, a connection that links the Jewish people from one generation to the next as they journey, in the words of the twentieth-century poet, Uri Zvi Greenberg, 'towards an endless beginning, far in the distance'.

A NOTE ON THE TYPEFACE

THE TITLE AND chapter headings in The Jewish Journey are set in Albertus, a typeface created by Berthold Wolpe. Born in Offenbach, near Frankfurt in 1905, Wolpe was a German-Jewish calligrapher, typographer and designer, who fled Nazi Germany in 1935 and spent the rest of his life in England.

Albertus was designed by Wolpe in the 1930s for the printing company Monotype, and was modelled to resemble letters carved in bronze. He named the font after Albertus Magnus, the thirteenth-century German philosopher and theologian, who took part in the trial of the Talmud in 1240, and whose own writings indicate the profound influence of the great Jewish philosopher, Moses Maimonides.

From 1941 to 1975, Wolpe worked for the London publisher, Faber & Faber, where he used Albertus in many of his famous book jacket designs in the 50s and 60s. Albertus was the typeface used on British coins for many years, and can be seen on street signs in several parts of London, including the Borough of Lambeth, where Wolpe lived until his death in 1989.

TEMPLE ERA

2000 BCE–70 CE

The Temple in Jerusalem was the sacred
epicentre of Jewish life for 1200 years.
According to the Bible, the first Temple was
built by King Solomon in the tenth century BCE,
probably on the site of far older cultic centre,
lasting until its destruction by the Babylonians
in the sixth century BCE. A second Temple, built
50 years later and greatly expanded by King
Herod in the first century BCE, was the religious
and political heart of the Jewish world for the
next 600 years, until its final destruction by the
Romans in 70 CE. The Temple site remains of
supreme importance to this day.

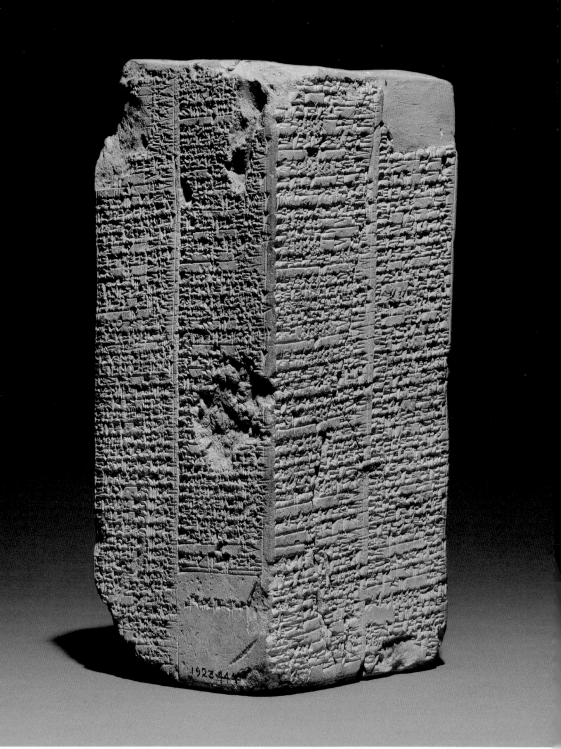

1 SUMERIAN KING LIST

א

LARSA, MESOPOTAMIA (NOW S. IRAQ), c.1800 BCE

'In olden times your forefathers – Terah, father
of Abraham and father of Nahor – lived beyond
the Euphrates and worshipped other gods.'
Joshua 24:2

ALL STORIES ARE journeys, and all journeys begin with a departure. From a biblical perspective, the Jewish journey begins 4000 years ago in ancient Mesopotamia. According to the Hebrew Bible, the two mighty rivers that fertilised Mesopotamia, the Tigris and the Euphrates, flowed out of the Garden of Eden, and it was from here that Abraham, the first great leader of the Jewish people and the founder of Jewish monotheism, set out for the land of Canaan. It was also here, at around the same time, that the Sumerian King List was made. While there is no historical evidence for the existence of Abraham, the King List provides important clues to the political and cultural context from which the early Hebrews and monotheistic Judaism emerged.

At first glance this small, chunky block of clay looks like a rather battered doorstop.

Standing 20 cm high and 9 cm wide, it is known as the Weld-Blundell Prism, after the man who gave it to the Ashmolean. It was made in the second millennium BCE in a region that today lies in central and southern Iraq, and comes from a site believed to be the ancient city of Larsa, which was then the capital of one of several kingdoms vying for supremacy in southern Mesopotamia. The tiny, scar-like ridges and grooves that cover all four faces of the prism are a form of writing called cuneiform. This developed to record the Sumerian language from around 3400 BCE, and is the earliest known writing system in the world. Pierced lengthwise through the middle, the King List was probably intended to be mounted on a rod and rotated, enabling the script on all four sides to be read with ease. That the prism can be rotated is, to the modern eye, a pleasing detail

| 3000 BCE
Nomads settle in
Mesopotamia | Sumerians develop
cuneiform, the oldest
writing system in
the world | Domestication
of the camel | Copper mining and
smelting in Zagros
mountains | The city of Troy
is founded in
Asia Minor |

because the King List is, in effect, an ancient version of 'political spin'.

The script lists a succession of kings, the cities they ruled and the lengths of their reigns. This 'history' has been carefully constructed in order to present the recent kings of Larsa in a seamless succession from the mighty rulers of Ur, the ancient Sumerian city-state on the west bank of the Euphrates river, which had dominated southern Mesopotamia between 2100 and 2000 BCE. From Ur the list of leaders extends further back still, in an unbroken line believed to reach to the dawn of time. Fact, legend and myth have been carefully arranged and blended to 'prove' that the gods themselves had chosen these kings to rule over all other city-states in the region.

The concept of divinely ordained leadership was probably well established in ancient Mesopotamia by the time the King List was made. In shaping their story in this particular way, however, the rulers of Larsa in 1800 BCE appear to have had two goals in mind. On the one hand they sought to place themselves above other rulers in the region, and on the other to demonstrate that kingship is ephemeral – passed from one city to the next at the whim of the gods. Real power, in other words, was not human but divine.

The King List brings together two elements that are central to the earliest stages of the Jewish journey: the idea of divinely appointed leadership and the once mighty city-state of Ur. Both are linked to one of the most decisive moments in the Jewish story: the rejection of polytheism.

Ur is named in the Book of Genesis (*Bereshit* in Hebrew) as the 'native land' of Abraham's father Terah, who then moved to Haran, 700 km north of Ur, where he lived with his family until his death. According to the biblical account Abraham, or Abram as he was called at this point, was living in Haran when he received God's command to leave Mesopotamia with his wife Sarai, his nephew Lot and the rest of his clan, including slaves and livestock, and set out on a 500 km trek to the land of Canaan, where he and his offspring were to settle and become 'a great nation' (Genesis 12:1–3). In return for possession of Canaan (then a region of small city-states) and everlasting divine favour and protection, God commands Abraham and his descendants to worship God alone and to circumcise their male children as a mark of this covenant (Genesis 17:1–15).

Ur and Haran in 1800 BCE were established cult centres for the worship of the Sumerian moon god, which has led to speculation that Abraham's immediate ancestors may have been moon worshippers. In addition, in Hebrew the name 'Terah' is closely related to the word for moon, '*yareah*'. Caution is called for, however, when drawing conclusions of this kind. Terah and his sons may have been drawn to Ur and Haran for quite other reasons than moon worship as both were also important locations for international trade and, by the standard of the day, had large, mixed populations which followed diverse religious practices.[1] Those parts of the Bible relating to Abraham's conversion

to monotheism were not written down until the late Bronze Age and Iron Age, many centuries after the period they allude to. It is therefore equally possible that Ur and Haran were assigned as destinations retrospectively because of their significance at this later date.

For Jewish people in the centuries to come, Abraham would be seen as the uncontested founder of monotheism, the first of their great leaders to reject the worship of other gods. The rejection of polytheism in favour of a single, formless, nameless, all-powerful deity was a theological shift of immense significance, although early monotheism was not exclusive to the ancient Hebrews. The Egyptian king Akhenaten, father of Tutankhamen, who reigned from around 1353–1334 BCE, briefly imposed a form of monotheism in ancient Egypt, consisting of the worship of one supreme god, Aten. Akhenaten tried to erase references to other gods, although this process was reversed after his death. By the first millennium BCE some theologians in Babylon were also speculating that the important gods of the Mesopotamian pantheon, each with their own responsibilities, should be understood as aspects or manifestations of the single god Marduk – who, according to the Babylonian *Epic of Creation*, had created humans as his servants.[2] Nevertheless, this single religious innovation would play a pivotal role in shaping the lives of Jewish people, as well as being

The King List is linked to one of the most decisive moments in the Jewish story: the rejection of polytheism

hugely influential in the political, cultural and spiritual development of the Western world. It remains one of Judaism's most significant contributions to Western civilisation, underpinning not only the Jewish faith but also Christianity and Islam, both of which developed out of Judaism and retained monotheism as their central tenet.

Dating biblical figures is controversial and speculative, but according to Jewish tradition and biblical chronologies Abraham lived between 2000 BCE and 1800 BCE, around the same time as the King List was made. The parallels between the King List's account of divinely appointed rulers of southern Mesopotamia and the Bible's account of Abraham as the divinely appointed human leader of the Hebrew people suggest that the two texts share the same roots.

The King List further reminds us that the Jewish journey began not in some primitive rural backwater, but in the large and sophisticated city-states of Mesopotamia. With populations of 30–40,000 people, these were the urban epicentres of the ancient world and the birthplace of modern civilisation. Mesopotamians worshipped an extensive array of gods and goddesses, spoke a variety of languages and worked in diverse trades and professions. Religion, culture, law and the economy were all well developed, as was a rich cultural tradition of fables, epics, poems and mythic tales. A highly inventive society, the ancient

2150–2000 Sumerian civilisation centered on city-state of Lagash

Founding of Kingdom of Ur

c.2000 Ur destroyed by the Gutians. Amorites infiltrate Mesopotamia

Last wooly mammoth population (on Wrangel Island) becomes extinct

Period of the Hebrew Patriarchs and Matriarchs

Mesopotamians made many important technological advances. They were skilled astronomers, mathematicians, architects and engineers, and they developed arches, columns, domes and even glass. They are credited with the invention of the wheel and were among the first people to use sails to harness the energy of the wind. As noted above, they also created the world's earliest writing system, cuneiform, which revolutionised communication. It was this remarkable culture that provided the geographical starting point for the Jewish journey.

But there is a further reason why the King List earns its place at the start of the Jewish journey: it alludes to a prototype for one of Judaism's best-known and most important founding stories, that of Noah and his floating ark.

On one face of the prism the text refers to a great flood that swept over the land:

> The flood swept over. After the flood swept over, when kingship had come down from heaven, kingship was at Kish.

Other cuneiform texts from ancient Mesopotamia relate the story of the flood in more detail and describe how the Sumerian god Enki chose one man, Ziusudra, to survive the terrible inundation. The story bears a striking similarity to the famous account of Noah's Ark told in the Book of Genesis. In both versions a universal flood is sent from Heaven to engulf the land, after which human life begins again from scratch. Like Noah, Ziusudra is instructed to build a boat in order to escape the rising waters. When the waters of the flood subside Ziusudra, again like Noah, makes a burnt offering of an animal and incense to express gratitude to his divine saviour. He and his family are the only people to survive the flood, as are Noah and his family.

Stories and myths are fluid and mutable. They take shape across generations and cultures, with politics, religion and geography all playing a part in their evolution. While the King List has been dated to around 1800 BCE, the oldest parts of Genesis were probably not written down until the eighth century BCE, more than a thousand years after the King List was created. By this time a number of different versions of the Flood story were in existence in the Ancient Near East, including the famous Sumerian version found in the *Epic of Gilgamesh*, one of the oldest written stories in existence.

Jewish scholars may have encountered some of these much older versions of the flood story in the early sixth century BCE, while living in exile in Babylon. In *The Ark Before Noah*, Dr Irving Finkel posits that during this period of exile, '... certain crucially placed Judaeans learned to read and write cuneiform, and so became directly familiar with the Babylonian stories for themselves, which they recycled for their own purposes with new messages ... We can see explicitly that at least part of the biblical text was distilled out of existing written sources, and extracts were put to new purposes within the context of the biblical message'.[3]

Exiled Judaeans at this time were rapidly assimilating into Babylonian society, in response to which their leaders may have perceived the need to strengthen a distinctive Jewish history and identity. Finkel argues that this provided the impetus for adopting the story of the flood and shaping it into a narrative that showed their own God saving an ancient ancestor from extinction in return for unwavering faith and devotion. The Jewish version of the story was also given a new, moral twist, with God sending the flood to punish humans for their sinful ways in contrast to the older Mesopotamian versions, which depict them as merely caught in the crossfire of warring gods. At a time when the Jewish people were living in forced exile in a foreign land, confronting the possibility of cultural and religious extinction, this moral angle provided an additional motivation for the Jews to obey divine commands and stay faithful to their own religion.

In much the same way that the King List portrays the recent kings of Ur and Larsa as direct descendants of Ziusudra, the lists of genealogies in the Hebrew Bible present Abraham as directly descended from Noah. Both the King List and the Bible connect the flood story with divinely chosen human leadership. In the Bible God makes a covenant with Noah, after saving him from the flood, which is then repeated and expanded in the covenant that God later makes with Abraham. The compilers of Genesis may have made this linkage for their own specific purpose, but, as the King List makes clear, the roots of this linkage can be traced back to the second millennium BCE and grew out of a culture the Jewish people shared with many others.

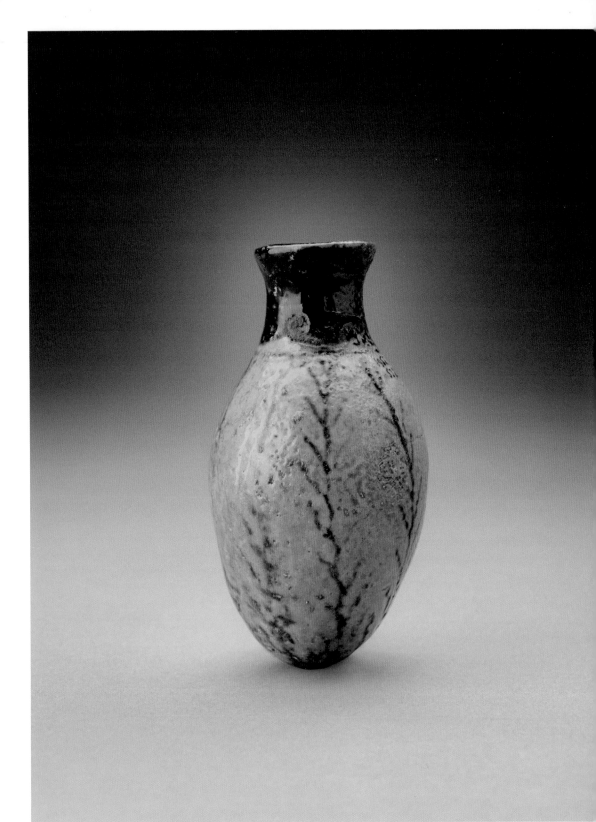

PERFUME FLASK

2 ｜ JERICHO, CANAAN, 1650–1550 BCE ｜ ב

'I have perfumed my bed with myrrh,
aloes and cinnamon.'

Proverbs 7:17

FAMED FOR THOUSANDS of years for its fresh water springs, orange groves and persimmon trees, the city of Jericho derives its name in both Hebrew (*Yeriho*) and Arabic (*Ariha*) from the same Canaanite word, *reah*, meaning 'fragrant'. This exquisite little perfume flask, with its iridescent glaze of peacock greens and blues, was found in a tomb of the second millennium in Jericho. The city plays a prominent part in the Jewish journey on a number of occasions and was an important settlement in Bronze Age Canaan, enjoying an ancient heyday between 1700 and 1550 BCE, around the time this perfume flask was made. The first settlements at Jericho date to 10,000 BCE, making it one of the oldest continuously inhabited cities in the world, and its numerous springs may well have made the site popular with nomads even before that time. Among a number of other finds from Neolithic Jericho on display in the Ashmolean is a 9000-year old skull, plastered and carefully decorated with cowrie shells, an example of early portraiture and evidence of Canaanite ancestor worship.

The term 'Canaanite' refers to all the people living in the southern and coastal region of the Levant in the second millennium BCE. The Hebrew language emerged out of a Canaanite dialect, and the forebears of the Jews were part of this diverse Canaanite population. The word 'Hebrew' may be related to the Egyptian word *Habiru*, which appears in Egyptian documents to refer to groups of outsiders, ranging from nomads to brigands, who lived in Canaan but were outside the authority of Canaanite rulers. The early Israelites may have been part of this Habiru population.

Many aspects of life and death in Canaan in the second millennium BCE would have

| 1595 BCE Hitites invade Babylon and adopt Babylonian cuneiform and culture | 1500 Chinese develop wheeled vehicles | 1350 Iron production by Hitites | 1350–34 Sun god deity Aton in Egypt. Possible source of Jewish monotheism |

The battle of Jericho

The Book of Exodus (*Shemot* in Hebrew) recounts how a period of famine in Canaan drove Jacob, the grandson of Abraham, and his family to resettle in Egypt. Jacob's name is changed by God to Israel and, on his death, his twelve sons become the heads of the twelve Israelite tribes. An initial period of prosperity in Egypt for Israel's descendants is followed by four centuries of slavery, until the Israelites eventually escape, led by Moses and his brother Aaron, and slowly make their 40-year journey back to Canaan. Before re-entering Canaan Moses takes a census of the Israelite tribes, appoints leaders and generals for each of the twelve tribes, and prepares the people for a military campaign to reconquer their former territory.[4] The first city to be attacked and captured by the Israelite army is Jericho. The biblical account of the battle for Jericho[5] relates how the Israelites, led by Joshua, march around the city walls, shouting and blowing rams' horns, or shofars. On the seventh day the walls collapse, the Israelites storm the city and Jericho is vanquished.

Evidence to support elements of the Exodus story comes from an Egyptian stele that refers to groups of escaped slaves and farmers newly settled in the highlands of Canaan, but archaeological findings cast doubt on the biblical account of Joshua's conquest of Jericho. While archaeologists have confirmed the existence of very impressive defensive walls at Jericho in the Bronze Age (3000–1200 BCE), other evidence suggests that the city was destroyed in around 1550 BCE, and would therefore have been uninhabited at the time Joshua was meant to have been conquering it. Walls of the thickness of those in Canaanite Jericho could not, in any case, have been destabilised merely by the blowing of shofars. An alternative suggestion is that the racket made by the shofars was actually a decoy, intended to mask the sound of Joshua's army digging under the walls to undermine the city's defences.

After the destruction of Jericho, according to the Bible, Joshua laid a curse on anyone who tried to rebuild the city. Despite the curse the city was rebuilt in the ninth century BCE by Ahab, the king of Judah. The subsequent deaths of Ahab's sons were regarded by the biblical prophets as fulfilment of Joshua's curse. In the second century BCE the curse was again invoked after the sons of the Hasmonean kings, Simon Maccabeus and Jonathan Hyrcanus, were killed, two of them in Jericho itself.

been common to the various peoples who lived there. This perfume flask therefore tells us something about how the ancient Israelites may have viewed the world.

At the time this perfume flask was made, Canaan was a polytheistic society. Cult objects found in Jericho from this time are those of the Canaanite god El, and the pottery is in keeping with local Canaanite tradition. Canaanite literature from places such as Ugarit has parallels with parts of the Hebrew Bible, further suggesting a shared heritage,

and Jewish festivals such as Tabernacles and Passover have roots in much older, pagan Canaanite festivals. The elegant shape and beautiful glazing of the perfume flask also reflect the influence of Egyptian culture on the Canaanites, who by the Late Bronze Age enjoyed a thriving trade with their Mediterranean neighbours. As Paul Collins, Jaleh Hearn Curator for Ancient Near East at the Ashmolean, explains: 'From around 1500 BCE we enter an age that contemporary texts reveal as one of intense interaction, during which powerful rulers from across the wider Middle East engaged in war and diplomacy to acquire valuable resources and exquisite works of art. In these centuries Egypt expanded into the southern Levant and many Canaanite states became vassals of the Egyptian Pharaoh.'[6]

Like the ancient Egyptians, the Canaanites worshipped many gods and goddesses and firmly believed in an afterlife. In parts of Canaan people buried their dead in communal tombs, with family members being added from one generation to the next. In Jericho the tombs were underground man-made caves, accessed by deep vertical tunnels. This perfume flask was excavated, along with numerous other objects, from one such cave by Kathleen Kenyon in the 1950s. A remarkable woman by any measure, Kenyon's work in Jericho from 1952–8 and in Jerusalem from 1961–7 sealed her reputation as one of the greatest archaeologists of the twentieth century and a world authority on the Bronze Age Levant.

The tombs excavated by Kenyon contained wooden bowls, clay jars, baskets, tables, jewellery, garment pins and combs, as well as plenty of food and drink. Other finds from the Jericho caves on display in the Ashmolean Museum include a bronze ring, complete with the human finger bone of its Canaanite owner, the blade of a bronze dagger, faience beads, scarab seals and a particularly lovely group of small, milk-white, stone vases. Small vessels, such as these and the turquoise flask, would have held perfume or oil to sweeten the dead person's hair and skin.[7]

A considerable amount of care went into the selection of objects to accompany a burial. Some may have been intended for the deceased to use in his or her next life; others may have been offerings to ancestors or gods. What was left out of the tombs is as intriguing as what was put in. No traces of cooking pots or weaving equipment were found, suggesting that the tombs were for relatively wealthy Canaanites, who envisaged an afterlife free from some of the physical cares of the living.

Jericho held its place as an important location on the Jewish journey for many centuries. Just 25 km from Jerusalem, it occupied a prime site strategically and commercially, and enjoyed a vantage point on the edge of the Judaean mountains, overlooking the plains below. Over a thousand years after this perfume flask was made the Hasmoneans, the last dynasty of Jewish kings and queens, built themselves a spectacular winter palace just west of the warm desert oasis of Jericho. This expanded into a flourishing garden-city, famous for its balsam resin, date palms and persimmon groves. In the words of

the Jewish Roman historian Josephus, 'One could fairly describe as divine a place like this which engenders the rarest and most exquisite plants in such abundance'.[8]

While male rulers and leaders are frequently associated with the destruction of Jericho, the city is more positively associated with not one but two great queens. The first is Shelamzion Alexandra, who reigned as the Hasmonean queen of Judaea from 76 to 67 BCE, following the death of her husband. According to Josephus, Shelamzion Alexandra was 'a skilful player on the larger stage … and made foreign powers wary of her'.[9] Her reign was a period of peace and prosperity for Judaea, and she was apparently much loved by her subjects.[10] In Jericho Shelamzion expanded the existing palace complex with two new palaces for each of her sons, Aristobulus and Hyrcanus II.

When the Hasmonean kingdom was conquered by the Romans in 63 BCE, Jericho came under Roman rule. Mark Antony gave the city to his lover, the Egyptian queen Cleopatra, who allegedly coveted its persimmons, used in a perfume that 'drove men wild'. Cleopatra later leased it back to Herod the Great, the client-king of Judaea, for a colossal sum said to have been equal to half the entire revenue of the country. After the suicides of Mark Antony and Cleopatra in 32 BCE, the Romans granted Herod ownership of the city. A prolific builder, Herod built himself

The first settlements at Jericho date to 10,000 BCE, making it one of the oldest continuously inhabited cities in the world

a new palace in Jericho in 35 BCE and later expanded the royal complex with two more winter palaces overlooking the Jericho oasis, adding an impressive hippodrome-theatre, aqueducts and pools. Jericho became firmly established not only as an important agricultural centre, but also a fashionable winter resort for Jerusalem's aristocracy.

The story does not end quite so happily. Herod was an Idumean Jew, whose grandfather had converted to Judaism during the period of Hasmonean expansion and whose father served as Chief Minister to the Hasmonean king, Hyrcanus II. Idumea was the Greek name for Edom, originally an independent territory in what is now modern Jordan. From around the sixth century BCE the Edomites migrated into parts of southern Judah and, under the influence of Hellenisation, became known as Idumeans. Annexed by the Hasmoneans in the second century BCE, many Idumeans converted, either by force or choice. Although Herod was raised at the Hasmonean court and had married into the Hasmonean royal family, he remained sensitive about his identity as an Idumean convert and was deeply suspicious of his Hasmonean relations, seeing their direct claim to the throne as a threat to himself. In 35 BCE, during a banquet at the winter palace at Jericho, Herod took the opportunity to deal with his wife's handsome and popular seventeen-year-old brother, Aristobulus III,

1000 Evidence of a written Caananite alphabet, linked to Hebrew

1000–961 Reign of King David. Jerusalem becomes his capital

970 Reign of King Solomon (in David's lifetime)

967 Death of David. Solomon executes opponents and consolidates his power

c.965 Solomon builds the Temple in Jerusalem

the High Priest of Jerusalem and one of the last Hasmoneans in direct line for the throne, by having him drowned in the palace swimming pool. The increasingly paranoid king went on to murder his Hasmonean wife Mariamne, her two sons, her grandfather and her mother, and many other people besides.

Herod himself died at his Jericho palace in 4 BCE, racked by terrible pain, with 'intolerable itching all over his body, constant pain in his gut, dropsy-like swelling in his legs, inflammation of the lower abdomen, and gangrene of the genitals, which bred worms',[11] attributed by some of his contemporaries to divine retribution. He clung on in this dire condition long enough to execute his son Antipater before succumbing to death himself. His eldest surviving son, Archelaus, laid on a magnificent funeral. The king's body lay in state in the palace throne room on a lavish bier:

The bier was of solid gold studded with precious stones, draped with a cover of embroidered sea-purple cloth. On this the body lay wrapped in purple, with a diadem on the head surmounted by a golden crown, and the scepter placed by the right hand.[12]

The dead king was then carried on a 25-mile procession to the splendid mausoleum that he had built for himself at Herodium. Not to be outdone even in death, Herod had designed his final resting place on a grand scale. The *tholos*, the uppermost chamber of the mausoleum, stood around 25 m high and weighed a staggering 30 tons.

A Jewish presence in Jericho continued intermittently until the late twentieth century. There is evidence of synagogues at Jericho dating to the late sixth or early seventh century CE, one of them Byzantine, its mosaic floor decorated with the Hebrew inscription '*Shalom al Yisrael*' ('Peace unto Israel') and Jewish symbols, including the shofar and menorah. In 1994 Jericho was placed under the control of the Palestine Authority. A small sleepy town, its main income today comes from Christian pilgrims and tourists.

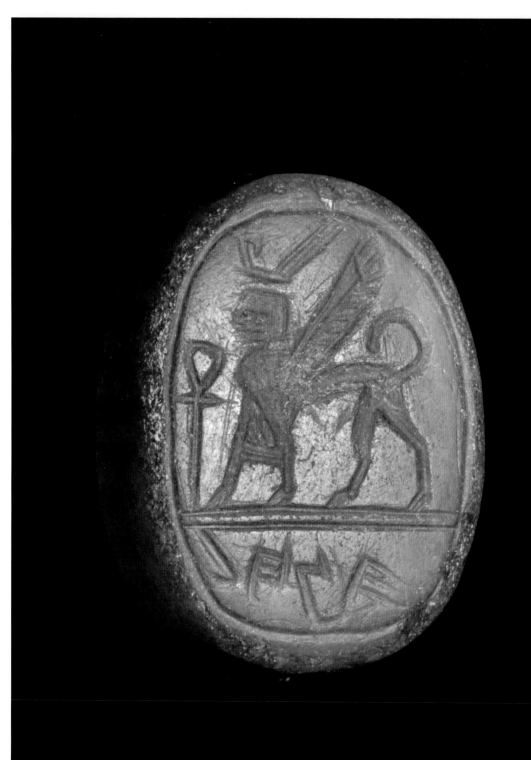

3 JASPER SEAL ג

LACHISH, KINGDOM OF JUDAH (NOW ISRAEL), 750–700 BCE

'Set me as a seal upon thy heart,
as a seal upon thine arm.'
Song of Songs 8.6

A PIECE OF CHISELLED jasper, no bigger than a thumbnail, inscribed with a winged sphinx and a woman's name, takes us from Canaanite Jericho forward in time by almost a thousand years to the eighth century BCE, by which time the Israelites were the established rulers of two kingdoms in the Ancient Near East: the Kingdom of Israel and the Kingdom of Judah. This jasper seal was found in the twentieth century in Tell el Duweir in central Israel, which has been identified as Lachish, one of the most important cities in ancient Judah. It was purchased in 1945 by Rev. A. H. Gibson from a local farmer.

Made from an oval of light red jasper, which allows the light to shine through its surface, the seal is pierced through the middle and would most probably have been strung on a cord of some kind and worn as a brooch or necklace. It has been made with considerable care, skilfully inscribed on the front and smoothly polished on the back. A winged sphinx strides across the seal, its tail curving in a nearly complete circle over its back. The sphinx wears a skirt and a single crown – the red crown of Lower Egypt – rather than the more usual double crown for both Upper and Lower Egypt. The significance of this omission is not known for certain. One suggestion is that the seal maker simply forgot, or left the seal unfinished for some reason.[13] In front of the sphinx is an *ankh*, the Egyptian symbol of life. The sphinx has a square haircut and its mouth and square jaw are clearly executed, but it has no eye. This may reflect a local tradition, or even an individual local craftsman, as it is similar in this respect to other seals from Lachish. Firm straight lines are used for the crown, face and lettering, while delicate

753 BCE Rome founded; Zechariah becomes king of Israel

*c.*750–700 Prophesies of Micah and Isaiah

Ionia emerges as a political entity, forming league of twelve Greek cities in Asia Minor

Italy's first civilisation, established by Etruscans, in the area between the Arno and the Tiber

curving lines are used for the legs and tail, indicating the maker's craftsmanship.[14]

The inscription below the sphinx is in Paleo-Hebrew and reads 'belonging to Hannah'. This immediately reveals its significance, throwing a fascinating light on the position of women in Judaean society at this time. Hundreds of Hebrew seals and bullae (the impressions made on seals) have been found belonging to men in the Ancient Near East, but seals belonging to women are rare.

Seals such as this one support scholarly opinion that as long as 3000 years ago Hebrew women also took part in official correspondence, held positions of authority, accumulated wealth and exercised economic and political power. What we cannot know is whether the owner of this particular seal used it as a mark of her authority in professional transactions or simply as a personal amulet.

The name of the seal's owner is also of interest. The only other known reference

The two Kingdoms of Israel

In around 1200 BCE the twelve Israelite tribes unified to form the Kingdom of Israel, ruled in turn by Saul, David and Solomon. Under Saul and David territorial dominance was secured and under David, who defeated the Jebusites, Jerusalem became the capital city. Solomon's reign was characterised by the rapid expansion of trade and wealth in Israel, often achieved through strategic marriages, one of which was to the daughter of Hiram, the fabulously wealthy king of Tyre. Famed and later censured for his many foreign wives, Solomon is also credited in the biblical account with building the first great temple in Jerusalem.

Following the death of Solomon, in around 924 BCE,

the Israelite tribes split into two kingdoms. The Kingdom of Judah in the south incorporated the territories of the tribes of Judah and Benjamin, and included the holy city of Jerusalem. The Kingdom of Israel in the north belonged to the remaining ten tribes, with Samaria as its capital city. Modern archaeology challenges aspects of this narrative, but the existence of both kingdoms can be dated with some certainty from c.800 BCE. Assyrian records from the ninth century BCE refer to the kingdom of Israel, and modern excavations at Samaria (the capital of ancient Israel) have revealed extensive and impressive remains.

In 1993 a ninth-century BCE stele was excavated at Tel

Dan, celebrating the king of Aram's victory over the king of Israel and the 'House of DWT [David]'. In 2003 excavations at Khirbet Qeiyafa, 30 km southwest of present-day Jerusalem, found evidence of a significant Judaean settlement, with building blocks 3 m in length and weighing 5 tons each in places.

By the eighth century BCE, the Kingdom of Israel, composed of ten tribes and weakened internally by decades of in-fighting, was highly vulnerable to invasion by foreign powers. The Kingdom of Judah, by contrast, was composed of just two tribes and its leadership was far more stable. This may have helped to withstand Assyrian attack in 701 BCE.

c.750–700 Sicily colonised by Greeks and Phoenicians

The Homeric texts, the *Iliad* and the *Odyssey*, are written

Spartan society organised on military lines

734 Corinthians found Syracuse, which over the next few centuries will become a powerful city-state

to the name 'Hannah' from this time comes from the Bible and refers exclusively to one the most important women in biblical history.[15] Devout but barren, Hannah prayed to God for a son, promising to give the child back to God to be raised as a priest. Her prayers were answered and she gave birth to a boy, whom she named Samuel. Hannah kept her promise, and when Samuel was weaned she gave him to Eli, the high priest at Shiloh (close to present-day Shiloh in the West Bank). A painting depicting this famous moment, *Samuel brought by Hannah to Eli*, by the seventeenth-century Dutch artist Gerbrand van den Eeckhat, is on display in the Ashmolean Museum. Samuel went on to become a great priest, judge and prophet. He was the last leader of the Israelites before the creation of the monarchy and it was Samuel, in his position as High Priest, who anointed Saul, the first king of Israel.

The heat from the flames that consumed the city was so intense that the mud-bricks, dug up 2500 years later, were nearly baked

While we know nothing about the woman who owned this seal other than her name, we know a great deal about the turbulent period in which she lived and about the city of Lachish where her seal was found. The Kingdoms of Israel and Judah were sandwiched at this time between the two great powers of Egypt and Assyria, and absorbed elements from both of these cultures. The winged sphinx inscribed on Hannah's seal was originally an Egyptian symbol, but by the eighth century BCE it was commonly found on seals and carved ivories throughout the eastern Mediterranean world. The winged sphinx featured on Hannah's seal illustrates the influence of Egyptian culture on the ancient Hebrews, and of the lively trade that took place between the two.

The end of the eighth century BCE, however, was a tense time for the inhabitants of both Israel and Judah. Neither the Egyptians on the southern border of Judah nor the Assyrians to the north of Israel were peaceful neighbours. By 700 BCE the powerful Assyrian empire was expanding its presence throughout the Levant in an attempt to reduce the power of Egypt. Israel and Judah were caught between these two warring empires. In around 721 BCE Hoshea, the king of Israel, decided to throw in his lot with the Egyptians. In a secret pact with the Pharaoh, Hoshea withheld payments promised to the Assyrians. When this was discovered, the Assyrian army retaliated by invading Israel. Hoshea was killed and Samaria, the capital city of Israel, destroyed. Much of the population was taken into captivity and forcibly deported. Broken up and dispersed to other parts of the Assyrian empire, the ten tribes that had formed the Kingdom of Israel were lost forever. This was a serious territorial blow for the Hebrew people, and a symbolic loss that would echo through the Jewish narrative in centuries to come.

723 Assyrians invade Israel and kill King Hoseah. Emperor Shalmaneser V exiles ten northern tribes of Israel

722 Destruction of Northern Kingdom – Israel rebels against Assyrians

Sargon II becomes Assyrian king. Samaria falls. The ten tribes of Israel go into captivity

719 Cushite dynasty established

With the destruction of the northern kingdom of Israel, the safety of Judah now looked highly precarious. Hezekiah, the king of Judah from *c.*715 to 686 BCE, was as keen as Hoshea had been to cut loose from Assyrian rule. In 705 BCE, soon after the new Assyrian king, Sennacherib, came to the throne, Hezekiah rebelled. This decision may seem somewhat foolhardy, given what had happened to the Kingdom of Israel only two decades before, in 721 BCE, but at the time Hezekiah must have deemed the Egyptians preferable allies to the Assyrians. Sennacherib was not prepared to lose Judah without a fight, however, and in 701 BCE the Assyrian army and proceeded to invade.

After destroying a number of other settlements in Judah, Sennacherib turned his attention to the city of Lachish. A thriving centre of commerce, culture and art, Lachish was located 40 km southwest of Jerusalem on the main trade route from Mesopotamia to the coast and the Mediterranean countries beyond. One of the most heavily fortified cities in Judah, Lachish was second in importance only to Jerusalem. Well aware that its destruction would be both militarily and symbolically decisive, Sennacherib dispatched a huge army of Assyrian charioteers, archers and infantry to capture the city.

First a siege ramp was built from vast boulders and stones. A formidable structure, 70 m wide, 50 m long and over 13,000 tons in weight, the ramp would have taken considerable manpower and time to construct,[16] and one can only wonder what was in the minds of the city's inhabitants while this was taking place. But worse was to follow. Up this massive ramp came the Assyrian soldiers with their four-wheeled siege machines, each carrying a fearsome battering ram, reinforced with a sharp metal point and suspended from ropes to create a lethal pendulum, which smashed repeatedly into the city walls. Down below Assyrian sling-shooters barraged the walls with heavy balls of flint and limestone, punching holes in the city's defences, while archers let loose wave after wave of arrows at the inhabitants fighting for their lives on the city ramparts above.

Excavations of the site during the course of the twentieth century by Starkey, Ussishkin and most recently Garfinkel uncovered close to a thousand arrowheads of iron, bronze and bone. Many of them were embedded in the mud-brick debris and bent out of shape, suggesting they had been fired with powerful bows from close range. The people of Lachish fought back as best they could, hurling flaming torches and stones suspended on ropes at the wooden siege-machines, but to no avail. The city could not withstand such an onslaught. The Assyrian army succeeded in breaching the walls, stormed the city and set fire to everything in its path. Lachish was razed to the ground. The heat from the flames that consumed the city was so intense that the mud-bricks, dug up 2500 years later, were nearly baked.

Delighted by his conquest, Sennacherib commissioned a set of magnificent 2.5 m high friezes for his palace in Nineveh (near modern

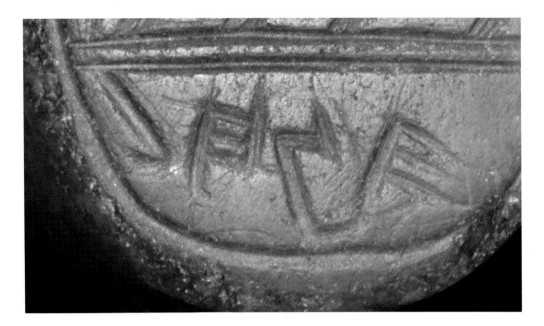

Mosul in Iraq) to commemorate the battle in all its gory detail. Now in the British Museum in London, one of these panels depicts the Assyrians building their siege ramp, while another shows the Assyrian troops advancing up the ramp and into the city. The friezes also portray the captured men, women and children of Lachish being deported from the city, carrying their meagre belongings in ox-drawn carts. The women's heads and shoulders are covered with long shawls that reach down their backs. The men have short beards, perhaps cropped by their captors, and their heads too are draped in scarves with fringed tassels. All are barefoot. It is a pitiful scene of a defeated people, driven from their home and country to be forcibly resettled in other parts of the Assyrian empire. In total Sennacherib's

campaign in Judah lasted for about a year and, according to the Assyrian account, saw the capture of 'forty-six...strong cities, walled forts and...countless small villages' and over 200,000 people taken as plunder, 'young and old, male and female, along with horses, mules, donkeys, camels, big and small cattle beyond counting'.[17]

Whether Hannah was among the captives of Lachish or had died long before, we shall never know. Yet for one reason or another, her jasper seal remained behind in the wreckage. The city itself was slowly rebuilt, probably by those Judaeans who escaped capture and inhabited the city once more until the sixth century BCE, when it was again besieged and destroyed, this time by the invading Babylonians.

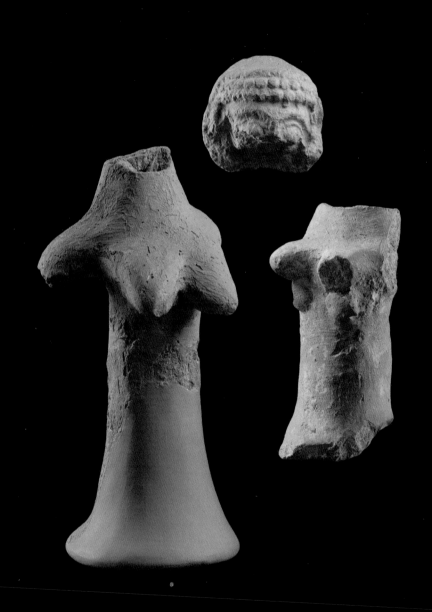

4 FERTILITY FIGURINES

T

JERUSALEM, KINGDOM OF JUDAH (NOW ISRAEL), 750-650 BCE

'They bow down to the work of their hands,
To what their own fingers have wrought.'
Isaiah 2:8

LACHISH WAS NOT the only settlement to fall to the Assyrians when they invaded Judah. Many other Judaean towns and villages were also destroyed and in 701 BCE Jerusalem, the capital city of Judah, was besieged. These clay statuettes of female figures, known as pillar figurines, were made around the time of these devastating Assyrian attacks. In a period of major religious and political change for the inhabitants of ancient Judah, these enigmatic little figurines played their part in the unfolding drama – silent witness to momentous events in Jerusalem itself and within the region as a whole.

Excavated in Jerusalem in the 1960s by the archaeologist Kathleen Kenyon, the figurines were found in a series of caves on Ophel Hill in Jerusalem, which in the eighth century BCE was well established as Judah's capital city and political heartland. Jerusalem was also of supreme religious significance for the Jewish people, home to the Holy Temple and the epicentre of Jewish worship.

Figurines such as these have been found all over Judah, but the discovery of these ones in Jerusalem indicates that even here, in the capital of Judah, monotheistic worship did not simply or easily replace idol worship. In many parts of the kingdom idol worship existed alongside monotheism for hundreds of years, and the persistence of idol worship is portrayed in the Hebrew Bible as a recurrent problem. Centuries after Abraham and Moses embraced monotheism, Hebrew prophets such as Ezra and Jeremiah were still berating the people for repeatedly backsliding into idolatry. These figurines probably came from a household or pottery shop and would most likely have been used in domestic worship. Their prominent breasts suggest

| c.700 BCE Paved roads between Babylon, Assur and Tall al-Admar | Greek Bireme ship developed | Invention of coinage by Lydians | 688 Boxing included in Olympic Games | 686 Manasseh becomes king of Judah |

that they were made for fertility rites linked to idol worship, more specifically to the cult of Asherah, consort-wife of the god Yahweh. Judah was still a pluralistic society at the time the figurines were made, and goddess worship was widespread. Figurines such as these, however, were a new phenomenon, suggesting an upsurge in polytheism at this time.

From 715 BCE Hezekiah, king of Judah from 715–686 BCE, launched a drive to unify religious belief and practice along strictly monotheistic lines. A religious hardliner, Hezekiah clamped down on other forms of worship and instigated stringent religious reforms, including the smashing of religious idols. The imprecise dating of these figurines means we cannot be sure whether they were made before Hezekiah's reforms, when idol worship was still common, or during his reign, either in outright defiance of the king's religious reforms or, equally possible, destroyed in accordance with them. Some scholars have proposed that the figurines were destroyed by Josiah, king of Judah from 640–609 BCE. The Bible Book records his reforming zeal in lavish detail:

> Then the king instructed Hilkiah the high priest and the priests of the second rank and the Temple gatekeepers to remove from the Lord's Temple all the articles that were used to worship Baal, Asherah, and all the powers of the heavens … Josiah also got rid of the mediums and psychics, the household gods, the idols, and every other kind of

detestable practice, both in Jerusalem and throughout the land of Judah.[18]

Another theory is that the figurines were abandoned by their owners as they fled Jerusalem in the tumultuous last years of the eighth century BCE, when the city came under attack from the Assyrians. Jerusalem somehow managed to escape the fate of other Judaean towns and cities, although how exactly is unclear. The Assyrian account of the siege is related in *Sennacherib's Annals,* written around 690 BCE. These Annals were inscribed on many different artefacts, one of the most famous being the *Taylor Prism* (691 BCE) now in the British Museum in London. In this version Sennacherib boasts:

> As for the king of Judah, Hezekiah, who had not submitted to my authority, I besieged and captured forty-six of his fortified cities, along with many smaller towns, taken in battle with my battering rams … I took as plunder 200,150 people, both small and great, male and female, along with a great number of animals including horses, mules, donkeys, camels, oxen, and sheep. As for Hezekiah, I shut him up like a caged bird in his royal city of Jerusalem.[19]

The precise fate of Jerusalem is neatly sidestepped in the Assyrian account, but the Bible gives a rather different version of events, presenting Hezekiah as an active and resourceful opponent.[20] As well as building defensive

towers and fortifying the city walls in preparation for a siege, he also constructed an extraordinary underground tunnel, 643 m in length, to divert the city's water supplies from the Gihon spring, which lay outside the city, to the Siloam Pool in the east of Jerusalem and within the city walls, thus ensuring the besieged population were supplied with fresh water. By blocking up the water sources outside the city walls, Hezekiah simultaneously deprived the Assyrian forces of clean water.

An unparalleled feat of engineering at the time it was made, the tunnel was rediscovered in 1838 by Edward Robinson, an American explorer. In 1880 Jacob Eliyahu, a sixteen-year-old Jewish boy from Ramallah, decided to explore the tunnel and made an astonishing find: an inscription in Paleo-Hebrew from the eighth century BCE, chiselled into the limestone wall of the tunnel by one of Hezekiah's workmen. The inscription explains how the tunnel was made, with men working from opposite ends and calling to one another to get their bearings in the darkness:

And while there were still three cubits to go there was heard a man's voice calling to his fellow for there was a fissure in the rock on the right and [on the left]. And on the day it was broken through, the hewers struck [the rock], each man towards his fellow, axe against axe. And the water flowed from the spring towards the pool for one thousand and two hundred cubits.[21]

If you do not mind getting your feet wet, you can still wade through the tunnel and read a replica of the inscription, exactly where Hezekiah's workman first inscribed it 28 centuries ago.

Despite Hezekiah's engineering and strategic ingenuity, the siege was so intense that defeat seemed inevitable. But then, so the Bible tells us, God intervened. He delivered a timely plague which killed 185,000 Assyrian troops overnight. The Greek historian Herodotus, writing some two centuries later in around 450 BCE, gives an imaginative account of 'a multitude of field-mice, which devoured all the quivers and bowstrings of the enemy, and ate the thongs by which they managed their shields'.[22] More prosaic explanations are that an Egyptian army, possibly led by the Pharaoh Taharqa, came to the aid of the besieged city,[23] or that the Assyrian soldiers could have been killed by an epidemic of cholera, spread by drinking contaminated water.[24]

The propaganda of warring kingdoms aside, the fact remains that Jerusalem did not fall to the Assyrians. Hezekiah eventually gave in and paid the tribute, and he and Sennacherib made their peace. In 681 BCE, after reigning for 24 years, Sennacherib was murdered by his sons while praying at the Temple of Nisroch. Judah continued to be ruled by Jewish kings until 586 BCE.

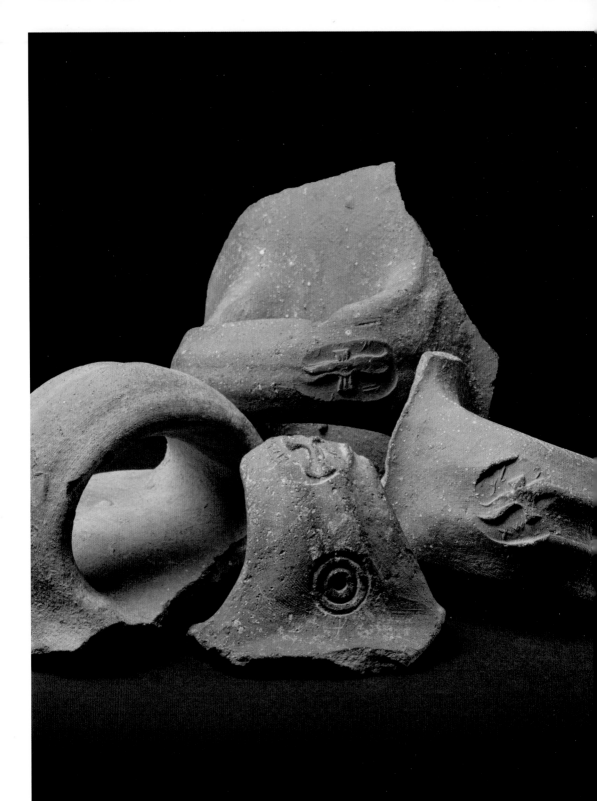

5 ROYAL JAR HANDLES ה

JERUSALEM, KINGDOM OF JUDAH (NOW ISRAEL), c.700 BCE

'A land of grain and vineyards, of bread and wine, of olive oil and honey, so that you may live and not die.'

2 Kings 18:32

IN 700 BCE Judah was a self-governing kingdom and a small but important buffer state between the powerful empires of Assyria and Egypt. Trade, both within Judah and with other countries, was vital to the prospering Judaean economy, and brought with it a need to define and protect the kingdom's borders. An enormous quantity of pottery fragments, including a number of royal storage jars, excavated from sites in the ancient Kingdom of Judah, provide a glimpse into how the Judaean state was then organised, and what it produced.

These particular fragments are jar handles, dating back to *c.*700 BCE. Most jars and handles of this kind were found in Lachish, but around 300 were excavated in Jerusalem. The handles themselves tell us exactly who the jars were made for. Each is clearly stamped with a seal impression bearing the Hebrew inscription *lmlk,* short for *lemelech* which means '[belonging] to the king'. The handles were stamped before firing, so the proof of ownership could not be changed later. This indicates a royal monopoly on trade, and reflects the considerable authority of the Judaean monarch at this time.

The stamps on the handles also name four cities: Sokoh, Ziph, Hebron and a fourth, unknown location called *Mmsht*. All the known locations were significant cities during the reign of King Hezekiah and delineate the border regions of Judaean territory. Sokoh lay to the west between the mountains and the sea; Ziph was in the southeast, on the edge of the Judaean desert; and Hebron bordered an area inhabited by nomadic tribes. The seals on the handles depict either a four-winged scarab beetle or a winged solar disc. Like the winged sphinx on Hannah's seal, these were

642 BCE Amon becomes king of Judah

640 Josiah becomes king of Judah

634 Zephaniah begins to prophesy

627 Jeremiah begins to prophesy

626 Nabopolasser becomes king of Babylon

common symbols at the time, used by many rulers in the Ancient Near East as a visual *lingua franca* to indicate power and authority. The combination of Egyptian symbols, Hebrew words and the stamp of royal ownership reflect the extent to which King Hezekiah's rule was established and respected in and beyond Judah.

The jars were probably used to collect taxes in the form of goods, most probably oil and wine from the royal vineyards. Ziph was known for its olive oil and Hebron for its grapes. All four cities were probably major distribution centres for these products. Wine was a valuable trading commodity in the eighth century BCE and Judah was famous for its vineyards and wine production, as we know from numerous references in the Hebrew Bible. Fruit of the vine was also of importance in the religious life of the early Jews. One of the seven species said to have come from the Garden of Eden, it symbolised the bounty of the earth and human hopes for fertility, prosperity and joy. A blessing over the wine remains part of most religious Jewish festivals today, and is recited weekly on the Sabbath and at Jewish weddings.

The northern Kingdom of Israel had been conquered by the Assyrians just 20 years earlier (see Chapter 4), and the southern Kingdom of Judah was now in turn under serious threat of invasion, although we do not know for sure if these jar handles were made

One of the seven species said to have come out of the Garden of Eden, wine symbolised fertility, prosperity and joy

pre- or post-invasion. They may have been part of the normal distribution methods employed at the time, with the identification of jars by their seals a routine administrative measure, needed for keeping track of royal resources and levying taxes on royal produce. An equally plausible theory is that the jar handles were manufactured by the government of Judah under Hezekiah as a direct result of the threat posed by the Assyrians, in anticipation of a military confrontation.

If the winged solar disc and scarab beetle on the jar handles' seals were part of a common visual language across the region, the use of Hebrew to identify the ownership and destination of the jars' contents is important evidence of verbal and written methods of communication in 700 BCE. Hebrew originally emerged out of the Canaanite-Phoenician language and is thought to have become a distinctive spoken language in the Ancient Near East from c.1200 BCE. The earliest biblical texts are in Hebrew and date to the tenth century BCE, by which time all 22 letters of the modern Hebrew alphabet were in use. By the eighth century BCE Hebrew was well established across the region, and it continued to flourish in the sixth and fifth centuries BCE. By the fourth century BCE, however, Hebrew had been largely replaced as an everyday language by Aramaic. Yet even in places where Hebrew was no longer the primary spoken tongue of the Jews, it remained the spoken

622 Revival in Judah

620 King Josiah introduces religious reforms

619 Habakkuk begins to prophesy

612 Nineveh is sacked by Babylonians. Emergence of Neo-Babylonian empire

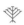

and written language of the Jewish religion – existing alongside Aramaic, but never entirely eclipsed by it. Seven hundred years after these jar handles were made, Hebrew was still a vibrant language. Documents found in Judaea dating from the first century CE show Hebrew being used for letters, legal matters, business contracts and other communications.

From the sixth century BCE, as the Jewish people increasingly dispersed throughout the Near East and the Mediterranean, moving later into other parts of the world, Hebrew was spoken and written alongside other languages. These included Aramaic, Greek, Latin, Arabic and Spanish, depending on where different Jewish communities were living, who was the ruling power and what the vernacular tongue of the region might be. In the many Arabic-speaking countries where Jewish people settled, they routinely wrote in Judeo-Arabic, i.e. the Arabic language written in Hebrew script. From the Middle Ages on Yiddish, a Germanic dialect spoken by Ashkenazi Jews in many parts of Europe, was likewise written using the Hebrew alphabet, a significant and enduring link to the language of their ancient ancestors. In the late nineteenth and early twentieth centuries Hebrew was reclaimed by the Zionist movement, who modernised and revived the language for everyday use. Hebrew has thus travelled with the Jewish people in spoken and written form for over 3000 years, and is today one of the oldest languages in continuous use. As these jar handles remind us, Hebrew was not solely for religious worship; it was also used by ordinary Jews in their daily lives and commercial transactions. Trade and the 'glue' of a shared language have been closely linked for the Jewish people from antiquity on.

609 Neco II becomes pharaoh of Egypt

Jehoiakim becomes king of Judah

605 Nebuchadnezzar becomes king of Babylon

The Babylonians invade Judah. Daniel begins to prophesy

6 STONE SHEKELS

JERUSALEM, KINGDOM OF JUDAH (NOW ISRAEL), 650–587 BCE

'Our pursuers were swifter
Than the eagles in the sky;
They chased us in the mountains,
Lay in wait for us in the wilderness.'
Lamentations 4:19

BEFORE THE INVENTION of coinage by the Lydians in Anatolia in around 700 BCE, shortly after which their kingdom fell to the Persians, trade was conducted through the direct exchange of goods or on the basis of their value in weight. These six small limestone domes, with their softly speckled colours ranging from buttery cream to pinkish red, appear ornamental to a modern eye, but their original function was entirely practical. Excavated in the 1960s in Jerusalem at the same time as the fertility figurines (see Chapter 4), they are the ancient precursors of the modern Israeli shekel. Stone shekels were one of the earliest forms of 'currency' in the Ancient Near East before coinage gradually caught on across the region, becoming widespread under Alexander the Great from the fourth century BCE.

The word *shekel* simply means 'weight', which is exactly what these ancient shekels are. Used to facilitate bartering, the value of each of these stone domes was based on its equivalent weight in silver. The linguistic root of the term *sh-k-l* is also found in the Hebrew words *shakal* (to weigh), *mishkal* (weight) and *shikkul* (consideration), and over time the word has acquired rich metaphorical weight of its own over time, linked to concepts of justice and judgement. Frequently referred to as a system of currency in the Bible, its use as a weight is much earlier, dating back to 3000 BCE and referring originally to a weight of barley rather than silver.

The semicircular shape of these stones is typical of shekel weights from the seventh and sixth centuries BCE. Rectangular and cube-shaped shekels have also been found, as well as some in the form of animals. A bronze

weight from this period in the shape of a turtle was discovered in the coastal plain of modern Israel; an inscription on its underside read 'one quarter shekel'.

But what exactly was the shekel? And how much did it weigh? The Hebrew Bible mentions seven weights, of which the three most important are the *talent, shekel* and *gerah*. The *talent* was the largest unit of weight, equivalent to about 3000 shekels. The precise value and relationship of these different weights was not standardised, but varied in different times and places. To complicate matters further, the Bible mentions at least three different kinds of shekels: in Genesis 23:16 we find a shekel of silver 'at the going merchant's rate' (*over la-socher* in Hebrew); in Exodus 30:13 there is the 'shekel by the sanctuary weight' (*ha-kodesh* in Hebrew); and in II Samuel 14:26 reference is made to 'shekels by the king's stone' (*ba'even ha-melech* in Hebrew). These last were shekels stamped by the royal treasury as proof that they were weight-perfect.

Unlike modern coins, whose size and weight bear only a symbolic relation to monetary value, the physical weight of a stone shekel in the seventh and sixth centuries BCE was related to a fixed value. Because most shekels found in excavations were unmarked, however, exactly how much a shekel weighed was a long-standing mystery. These particular weights are of especial historical worth because they are helpfully inscribed with their exact shekel value. The red stone dome shown here weighs 45.3 grams and is

inscribed with a value of four shekels. The largest of the six domes is inscribed with a value of sixteen shekels.

How can we date these weights to no later than 587 BCE? The answer is because in 586 BCE catastrophe once again struck Jerusalem and the Kingdom of Judah. Since the Assyrian siege of Jerusalem 115 years earlier, the inhabitants of Judah had lived reasonably peaceably as a vassal-state of Assyria. But in the early sixth century BCE the Babylonians were taking over as the major power in the region. In 597 BCE the Babylonian king Nebuchadnezzar captured Jerusalem and killed Jehoiakim, the king of Judah. Jehoiakim's successor, Jechoiachin, lasted just three months and ten days before being unceremoniously exiled to Babylon and replaced by his uncle, King Zedekiah. Ten years later, in 587 or 586 BCE, the Kingdom of Judah rebelled. Nebuchadnezzar retaliated by destroying Jerusalem and its holy Temple. According to the Bible, Zedekiah was taken captive and forced to watch his sons being murdered. He then had his own eyes put out and, loaded with chains, was carried off to Babylon, where he remained prisoner until his death. In a tragic repeat of the Kingdom of Israel's destruction 135 years before, a large number of Judaeans, including almost all of its educated and wealthy elite, were either forcibly deported to Babylon or fled into exile. The neighbouring country of Busayra or Edom (now Jordan), mentioned in the same display case as the shekels, helped the Babylonians in their war against Judah. They became major

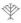

beneficiaries of the conquest, taking over the land and property of the exiled Judaeans. Four centuries later the Hasmonean dynasty took their revenge by forcibly converting the Edomites to Judaism.

The destruction of Judah and the Babylonian exile was a defining moment in the Jewish journey. With their temple and capital in ruins and the royal court in exile, it was the start of a deeply challenging time for the Jews, now a dispersed and kingdomless people. The lines of Psalm 137, 'By the rivers of Babylon, there we sat, yes, we wept as we remembered Zion', were almost certainly written not long after the exile of 586 BCE. The words of the psalm powerfully convey the passionate yearning of the Jewish people for their former homeland. They have been taken up as an anthem of longing and hope by other dispossessed peoples since, most notably the African slaves in America in the eighteenth and nineteenth centuries. In Jewish communities to this day Psalm 137 is recited in synagogues on Tisha B'Av, the annual day of mourning to commemorate the destruction of the Jewish Temple in Jerusalem. Parts of the psalm are also recited during the service for Rosh Hashanah (the Jewish New Year) and in Jewish wedding ceremonies, when the groom traditionally breaks a glass as a symbolic act of mourning for the destruction of the Temple.

At one fell stroke the Jews had lost their independence, monarchy, capital city and most sacred site, the Temple in Jerusalem

The Babylonian exile began a critical period for the Jews. At one fell stroke they had lost their independence, monarchy, holy city and most sacred site, the great Temple in Jerusalem. As well as facing a theological crisis involving the nature, power and goodness of God, they were also threatened culturally, scattered throughout the Babylonian empire and thrown into proximity with other peoples and religious groups.

The Bible was still a work in progress at the time of the Babylonian exile. As noted in Chapter 1, it was probably during this period in exile that the foundations were laid for a seamless religious narrative connecting the Jews back to the stories of Noah and Abraham, firmly yoked to the concept of divinely appointed leadership and monotheism. This narrative would successfully serve its purpose of strengthening Jewish identity and helping to unify Judaic worship at a time when the Jewish population was dispersing over a wide geographical area and was no longer under the close control of religious and political leaders in either Jerusalem or Babylon. However, this process did not happen overnight. The text of most of the books of the Hebrew Bible only began to take the form familiar to us today in the fourth and third centuries BCE.

Babylonian dominion, in any case, was short-lived. In 539 BCE, only 50 years after Nebuchadnezzar had conquered Judah, the

553 Belshazzar becomes regent in Babylon

550 Cyrus becomes king of Persia

Confucius begins to teach

539 Babylonians defeated by Persians

538 King Cyrus of Persia allows Jews to return to Jerusalem

Babylonians were conquered by the Persians. The Aramaic word for shekel, *teqel*, makes an appearance in the biblical account of that historic moment in a famous scene related in the Book of Daniel, in which King Belshazzar, co-regent of Babylon, and his guests are feasting and drinking from golden vessels stolen from the Temple in Jerusalem. In the middle of the banquet a mysterious message appears on the wall written by an invisible hand. The terrified king sends for the imprisoned prophet Daniel, who reads the message for him: '*Mene, mene, teqel, u-farsin*' ('You have been weighed and found wanting'). As for the hapless Belshazzar, he was murdered later that same night when the Persians stormed the city. The scene was depicted centuries later by Rembrandt in his famous painting *Belshazzar's Feast*. Composers ranging from Handel to Bob Dylan and writers including Byron and Emily Dickinson have been equally inspired by the story.

King Cyrus of Persia was more tolerant than his Babylonian predecessors of diversity in the peoples of his vast empire, and in 538 BCE Cyrus allowed around 40,000 Jews to return to Jerusalem. Two years later they were granted permission to start rebuilding the remains of their once magnificent Temple. According to the Book of Ezra, in the second month of the second year after the return from Babylon (i.e. 535 BCE), the foundations of the Second Temple were laid amid great public excitement and rejoicing. By 516 BCE the Temple was complete. Under Persian rule, which lasted from 539 to 332 BCE, the Jewish

population in Judah, led by *zugot* ('pairs of') leaders, began to flourish once more. It was also during this Second Temple Period, which lasted from 530 BCE to 70 CE, that the biblical narrative of the Jewish people began to be consolidated in the form we know today. The Midrash, a compendium of rabbinic oral commentaries on the Bible, also began to be written down during this time.

It was during the Second Temple period that the shekel, so long a part of Jewish economic and cultural life, became a coin in the modern sense of the word and began to play a part in the shaping of Jewish national identity. In the early fourth century BCE a number of silver coins known as Yehud coins were minted, many of them in Jerusalem, for use as local currency. Stamped with the letters YHD in Aramaic or YHDH in Paleo-Hebrew, they depict flowers, animals and human figures and faces. A few rare Yehud coins are stamped with an ear, in reference perhaps to the opening words of Psalm 17, 'Hear, O Lord!' (in Hebrew, '*Shema Yisrael!*')

After the fourth century BCE no Jewish coins were struck in Judaea until the end of the second century BCE. A coin from this date bearing the words 'half-shekel' in paleo-Hebrew was excavated in the late 1990s at Hurvat Itri in modern Israel by archaeologists from the Israel Antiquities Authority. The half-shekel was the annual 'tax' that Jews living in and beyond Judaea were expected to pay to the Temple authorities for its upkeep.

In 132 BCE the Hasmonean ruler John Hyrcanus I struck the first of a new generation of

536 Rebuilding
of the Temple

530 BCE–70 CE
Second Temple period

525 Egypt becomes
part of Persian empire

520 Construction of
the Jerusalem Temple
resumes; completed
four years later

510 Foundation of
the Roman empire

Jewish coins, marked with a lily on one side, a common symbol for Judaea, and on the other an anchor, a symbol of the Seleucid dynasty (derived from the anchor-shaped birthmark on the leg of the first Seleucid king). Within three years the Hasmoneans had gained full control of Judaea and with it the freedom to mint coins wherever they wanted and with whatever symbols they chose. These later Jewish coins bore inscriptions in Hebrew as well as Greek, and complied with the biblical prohibition on making graven images. Instead of faces and heads the Hasmoneans stamped their coins with helmets, wreaths, double cornucopias, stars and diadems. Some of these symbols were borrowed from Greek coinage, but, apart from the helmet, all became strongly identified during the Hasmonean era as Jewish symbols. The star on Hasmonean coins, for example, stood for the Jewish messiah, an allusion to the phrase from Numbers, 24:17, 'A star shall come from Jacob'.[25]

Under the Herodians, from 37 BCE, other symbols were added to Judaean coins, such as the palm branch, a symbol of victory, the pomegranate, a symbol of fertility and one of the seven species of plants mentioned in the Bible as blessings to the land of Israel; the galley and the shofar. Taking care to balance the sensitivities of his Jewish subjects with the tastes of his Roman masters, Herod the Great chose symbols that were in general use in the first century BCE, but from these he selected ones that emphasised continuity with the Hasmoneans. Although Herod completely dropped the use of Hebrew on his coins and instead used only Greek inscriptions, at the same time he eschewed pagan symbols and graven images, the one exception being a low-value coin stamped with a conspicuously Roman-looking eagle. Herod's sons Archelaus (ethnarch of Judaea, Samaria and Idumea from 4 BCE–6 CE) and Antipas (tetrarch of Galilee and Perea from 4 BCE–39 CE) likewise avoided graven images on their coins. Later Herodians, all highly Romanised, combined pagan and Jewish symbols, as well as portraits of themselves and other members of their households.[26]

Few people nowadays could begin to say what images are stamped on the coins they use, or why, but in the ancient world the visual language of coins was well understood and politically potent. In the first century CE and early second century CE, during the Jewish revolts against Roman rule, Judaean rebels struck coins with defiantly Hebrew inscriptions and Jewish symbols (see Chapters 8 and 9). Many of these symbols, including the lily, the menorah, the palm tree and the double cornucopia, are still in use today on modern Israeli coins.

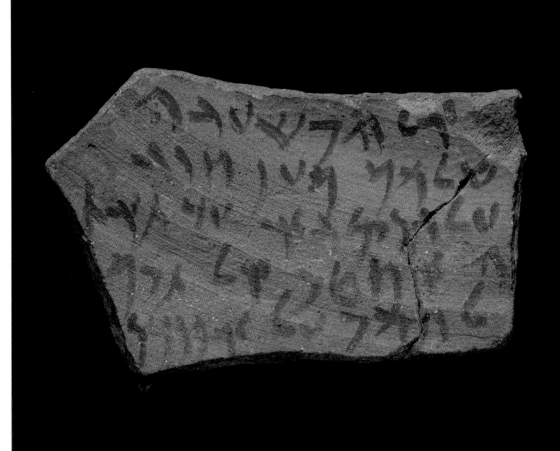

7 PASSOVER POTSHERD ٢

ELEPHANTINE, EGYPT, 475 BCE

'You too must befriend the
stranger, for you were strangers
in the land of Egypt.'
Deuteronomy 10: 17–19

NINE HUNDRED MILES south of Jerusalem, close to the border between Egypt and Nubia, the River Nile slaps against the shores of the little island of Elephantine, so called because boulders on the island's banks resemble the rounded backs of wallowing elephants. In the fifth century BCE the island went by the name of Yeb. Under Persian rule at that time, it was home to a small, close-knit Jewish community. This potsherd, or *ostracon*, was found on the island, along with sixteen other *ostraca* and several hundred papyri, the majority written in Aramaic. Made from rust-red clay and measuring 5 cm x 8.1 cm, the potsherd is about the size of a modern mobile phone. The bold, black writing is as exquisitely legible as if it were penned yesterday, not 25 centuries ago.

One of the most important objects in the Ashmolean's collection of Jewish artefacts, this modest pottery fragment opens a window onto the domestic lives of ordinary men and women living in the early Jewish diaspora (i.e. outside of Judaea). It also contains one of the earliest non-biblical references to the Jewish festival of Passover and shines an unexpected light on the evolution of the Jewish religion.

At the time this potsherd was made, Egypt was part of the enormous first Persian empire (also known as the Achaemenid empire) founded by Cyrus the Great. As impressive in its temporal duration as its geographical sweep, the empire covered 5.5 million square metres and lasted for over two hundred years, from around 550 to 330 BCE. This small pottery fragment tells us a number of important things about life in the region at that time, not least the highly efficient postal service. Pieces of broken pottery provided a cheap and readily available alternative to papyrus and

| 461–04 BCE Peloponnesian Wars | c.458 Ezra leads second wave of Jewish exiles back to Jerusalem | 447 The building of the Parthenon commences | 443 Beginnings of the Midrash. Ezra and Nehemiah canonise Pentateuch (Torah) | 419 Codification of Jewish religious law |

leather, and were ideal for writing short messages. This beautifully preserved fragment is essentially a fifth-century postcard, sent to a close friend or relative living on Elephantine. The sender dictated the message in Aramaic, the lingua franca of the Persian empire, to a professional scribe from Syene (present-day Aswan), who wrote it down in ink on a piece of pottery and then gave it to a boatman to deliver to the island of Elephantine. The messages on all the *ostraca* from Elephantine are informal in style – quick communications between people who were in regular contact and already knew the details of each other's lives, providing us with wonderfully evocative snatches of daily conversations, heard in mid-stream. One refers to a frightening dream; another offers to repair a garment. 'Send me some salt right away – today!' one especially bossy message reads. 'If there isn't any salt in the house, then buy some from Alpay the ferryman at Elephantine.'[27] Women wrote and received messages as well as men, telling us that literacy was by no means a male preserve on the island. The message on this particular potsherd reads:

> To Hoshaya. Greetings! Take care of the children until Ahutab gets there. Don't trust anyone else with them! If the flour for your bread has been ground, make a small portion of dough to last until their mother gets there. Let me know when you will be celebrating Pascha [Passover]. Tell me how the baby is doing![28]

The concern for the children's wellbeing and safety is poignantly universal and timeless, but a number of other elements in this message are more puzzling. While Hoshaya is clearly a Jewish name, Ahutab sounds Egyptian. Who might Ahutab have been? The name occurs in several of the Elephantine *ostraca*. Was he an Egyptian slave? A close friend of the family? Or perhaps a relation of Hoshaya by birth or marriage, as we know from other documents from Elephantine that Jews, Persians and Egyptians lived alongside one another on the island and intermarriage was not uncommon.

More striking still is the reference to Passover. Then, as now, Passover was an important event in the Jewish calendar, commemorating how, hundreds of years earlier, the ancient Israelites escaped from slavery in Egypt and were led by Moses through the wilderness back to the land of Canaan. The festival of Passover as observed today by Jewish people all over the world incorporates an older Festival of Matzot (unleavened bread). The reference to Passover on this potsherd is one of the earliest known non-biblical references to this key Jewish festival. We have no idea exactly how Passover was observed by the Jews of Elephantine, but it must have been a somewhat odd occasion, given that they were celebrating an escape from the very country in which they had chosen to make their home. Stranger still, the sender of the potsherd asks *when* Hoshaya will be celebrating Passover, suggesting that the date of the festival was not fixed. This is mentioned very casually in the message on the potsherd, as if uncertainty

over when Passover was to take place was an entirely normal state of affairs. It is this throwaway question that makes the sherd so interesting as a historical source.

Ever since the Persians permitted the Jews to return to Jerusalem in 538 BCE, the question of exactly how they should practise their religion had been a concern for Jewish leaders. By the mid-fifth century BCE religious worship was becoming standardised and, as part of this process, the times of festivals were being fixed. The sherd's apparent vagueness about the precise dates of Passover has therefore aroused scholarly interest. Had religious reforms instigated in Jerusalem not yet reached Elephantine? Or was there local resistance to bossy decrees from Judea? Maybe there was another reason altogether, an entirely personal reason, such as a delay for the sake of ritual purity. Or perhaps Jews living in Egypt simply did things differently and celebrated Passover in their own distinctive way.

Whatever the answer, just over 50 years later, in 419 BCE, the Jews of Elephantine were sent unambiguous instructions by the Jewish religious authorities to toe the line. A document known as the *Passover Papyrus* (now in the Egyptian Museum in Berlin) set out the required rituals, specifying abstention from work and prohibiting the eating of leavened food and the drinking of a local beverage, most probably beer, showing their intention

In 419 BCE, the Jews of Elephantine were sent unambiguous instructions from Jerusalem to toe the line

to unify the communities within and beyond Judaea under the authority of the High Priest. From now on Elephantine Jews were left in no doubt: they too were to observe the festivals according to the rules set in Jerusalem.[29]

This potsherd reminds us that religions have always had to evolve to survive. It also highlights a distinctive aspect of Judaism: that in the absence of territorial power and security, the cohesion and continuity of the religion itself was increasingly important for the survival of Jewish collective identity. But the Jews of Elephantine reveal another facet of Jewish life that would paradoxically prove equally important for its durability and resilience across the centuries: a capacity for adaptability and regional diversity.

The Jewish community on Elephantine probably began as a military outpost, created in 650 BCE by Menasseh, the king of Judah, to assist the Egyptians in guarding their southern border with Nubia. When Egypt became part of the Persian empire in 525 BCE, the inhabitants of Elephantine duly adapted to serving a new master. Over time the military colony developed into a fully-fledged town with flagstone streets and brick houses, some of them possessing kitchens and stables. The ancient Persians were generally tolerant of their subjects' religions, and on Elephantine the Jews freely observed the Sabbath, kept the Jewish festivals, circumcised their sons and gave their children Hebrew names. Jewish

274 Hinduism codified in India	**200** The Mishna begins to appear among the Jews	*c.***200** Establishment of the religious community at Qumran	**168** Antiochus pollutes the Temple in Jerusalem and suspends sacrifices	**166–60** Hasmonean Revolt, led by Mattathias and his five sons

women on Elephantine enjoyed legal and social rights; they could divorce their husbands and own property. At the same time, however, the Jews of Elephantine were far from being a closed society. They lived cheek by jowl with their non-Jewish neighbours, spoke and wrote Aramaic as their everyday language and, as mentioned earlier, appear to have been relaxed on the question of intermarriage. Besides worshipping the Jewish God, YHWH, they also worshipped a female deity, a consort of God, called Anat-Yahum, and there are a few cases of Jewish coffins decorated with the Egyptian goddesses of mourning, Isis and Nephthys.[30]

In one of their most flagrant displays of independence, the Jews of Elephantine built their own temple on the island, modelled on the original Temple in Jerusalem, which had been destroyed by the Babylonians just over a century before in 586 BCE. No other Jewish community had done anything similar outside of Jerusalem. In addition, to do so was explicitly proscribed in the Hebrew Bible.[31] Nor was the Elephantine temple a modest affair. Quite the contrary. It was a magnificent building with a spacious courtyard, bronze hinges on the doors, a cedarwood roof and no fewer than five stone gateways. Located within the military fortress, the Jewish temple on Elephantine stood alongside an Egyptian temple dedicated to Khnum, the local ram-headed god. According to Egyptian mythology, Khnum was the god of the cataracts and controlled the River Nile from caves situated directly under the island. The location of these two religious sites led to a somewhat bizarre situation in which sheep were being worshipped as deities by the Egyptians in one temple while routinely being slaughtered, burnt and eaten as ritual sacrifice in the Jewish temple next door (and notwithstanding the fact that the Bible, in Deuteronomy 12:13–14, expressly forbids animal sacrifice anywhere but the Temple in Jerusalem). In a nice piece of modern-day curatorial synchronicity, only a few paces away from the Passover potsherd in the Ashmolean there is a glass case containing a statuette of Khnum from Elephantine.[32]

This somewhat inflammatory state of affairs may have contributed to the events of 410 BCE, when shortly before Passover a mob from the temple of Khnum, sanctioned by the Egyptian priests and the local governor, attacked the Jewish temple. A contemporary report described the attack:

> They forced their way into the temple, razed it to the ground, smashing the stone pillars ... the five gateways of hewn stone were wrecked; everything else burned: the doors and their bronze hinges, the cedar roof. The gold and silver basins and anything else they could find they looted for themselves.[33]

There are cases of Jewish coffins decorated with the Egyptian goddesses of mourning, Isis and Nephthys

Bowed but not broken, the Jews of Elephantine appealed to their co-religionists in Judaea and Samaria to intervene on their behalf with the Persian authorities, and set about raising funds to rebuild. Somewhat surprisingly permission was granted, money was donated and the Jewish temple on Elephantine was rebuilt, albeit on the strict condition that there must be no more animal sacrifice. For reasons that are unclear, but were probably linked to increasing instability in Egypt as a whole, within a few decades the new temple had fallen into disuse, and it was eventually absorbed into the Temple of Khnum. By the mid-fourth century BCE, the Jewish community on Elephantine had disappeared.

Remarkable in and of itself, this little potsherd forms part of a huge collection of *ostraca* and papyri from the island. Taken as a whole, they paint a captivating portrait of one of the many Jewish communities that had set down roots outside of Judaea by the fifth century BCE. This particular potsherd also preserves in vivid detail a critical moment in the development of the Jewish religion and the evolution of Judaic monotheism.

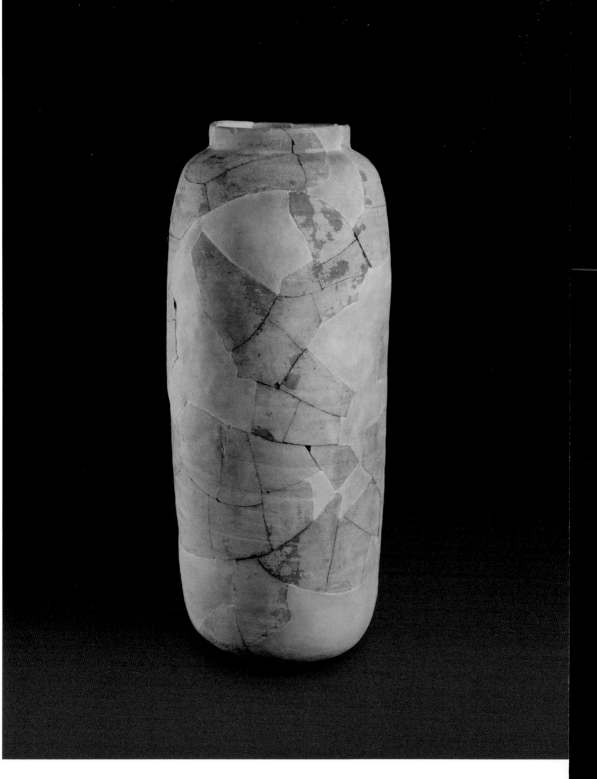

8 DEAD SEA SCROLL JAR

ⴖ

QUMRAN, JUDAEA (NOW ISRAEL), 68 CE

*'The heavens shall be rolled
up like a scroll.'*
Isaiah 34.4

HIGH ABOVE THE salt-dense waters of the Dead Sea, the jagged cliff-line marks the edge of the Judaean Desert, a wild expanse of arid and rocky terrain. It was here that this jar and others like it were found, carefully hidden 2000 years earlier in the caves that studded the cliffs. They contained some of the most important Jewish literary treasures of all time, and one of the greatest archaeological discoveries of the twentieth century: a cache of ancient texts that revolutionised modern understanding of early Jewish beliefs and hugely enriched our knowledge about the religious roots of Western civilisation.

The discovery came about entirely by chance one day in 1947. Three Bedouin shepherds were searching for a lost goat in the cliffs around Qumran, at the northern end of the Dead Sea, when one of them noticed a cave sealed with boulders. Venturing inside, he found ten cylindrical clay jars, each sealed with a lid. Eight of the jars were empty and the ninth was full of earth, but the tenth contained three parchment scrolls. The discovery of this first cave excited the attention of the world, but more finds were to come. Between 1949 and 1956 extensive excavations of other caves around Qumran uncovered hundreds more scrolls and thousands of scroll fragments. Their discovery constituted historical gold dust.

One cave contained the earliest surviving versions of all five books of Moses, which form the core of the Hebrew Bible, dating from a thousand years before those previously identified and close to the form in which we know them today. Another contained a copy of the Book of Leviticus, written in the ancient Hebrew script used in First Temple times (960–586 BCE). An

almost complete scroll found in another cave included a version of Deuteronomy, written down in the first century BCE and setting out the Ten Commandments, a central dogma in both Judaism and Christianity. And in yet another cave was found a version of the Book of Psalms, with one of the oldest known references to King David as the composer of the psalms. Some scrolls consisted of familiar biblical texts in unusual versions, suggesting that an accepted 'official' version was still a 'work in progress'. Others contained wholly original texts, unknown before their discovery in the mid-twentieth century. These revealed for the first time the immense diversity of Jewish thought and practice in the Second Temple era (538 BCE–70 CE), when the foundations of modern Judaism were taking shape. The majority of the texts were written in Hebrew. Others were in Aramaic and a few were in Greek.

It is little short of miraculous that the scrolls survived at all. This was due in part to the exceptional aridity of the Judaean Desert and in part to the care with which they were originally stored in these unusually shaped jars, then hidden away in remote and inaccessible caves above the Dead Sea. As Paul Roberts, Keeper of Antiquities at the Ashmolean Museum, explains: 'Organic writing materials only survive in very dry or very wet conditions. Nowhere else could these texts have survived, and not just scraps of texts, but in some cases whole texts.'[34]

The Romans controlled the largest empire in the world at this time

After the initial discovery at Qumran in 1947, it was a race against time for archaeologists to find and safeguard these treasures before they disappeared again, this time on the black market. Many were irrevocably damaged by careless handling and sudden exposure to light and humidity. One entire scroll was found hidden under the floor of an antiques dealer's home in Bethlehem, where it had been concealed for the past eleven years. Over the course of the next few decades experts gradually succeeded in recovering many of these fragments and painstakingly piecing them back together. In all, more than 800 scrolls and tens of thousands of scroll fragments were recovered. The process of restoring, preserving and deciphering them is ongoing and new scrolls are still being discovered, the most recent in early 2017.

The Dead Sea Scroll jars, like their contents, were valuable objects. Relatively few jars were found and still fewer have survived, making this particular jar as rare as it is famous. The Ashmolean began trying to buy a jar from the Palestine Archaeological Museum in Jerusalem in November 1949. The times were not auspicious for such a purchase. The modern State of Israel had been created in 1948 and Jerusalem was now divided between Israel and Jordan, the two halves of the city separated by barbed wire, concrete walls, minefields and bunkers. Some of the Qumran caves now also fell in Jordanian territory. Selling antiquities

to the British was for the time being out of the question.[35]

Two years later the political atmosphere was slightly less charged, however, and the Palestine Archaeological Museum was keen to do business. Up for sale for the price of £50 were 'a jar (made up and partly restored), a cover, and a specimen of linen'.[36] The Ashmolean seized its chance. On 26 November 1951 a box containing an unspecified 'jar' was loaded onto an Air France flight from Jerusalem to London. The precious delivery arrived in Oxford on 6 December. The jar, however, was in pieces, as Donald Harden, then Keeper of Antiquities at the Ashmolean, pointed out, somewhat grumpily, a few weeks later:

> The jar and its cover arrived some time ago. It was not too well packed and some of the recent mends had broken again … As you know, I always felt the price was excessive and now that we have it in our possession, I am afraid I feel it all the more, but I did it out of kindness.[37]

Today the price looks more like a bargain. The jar was finally put back together in 2013 and in 2017 went on display for the first time.

During the four centuries in which most of the Qumran scrolls were written, the Jewish heartlands of Judaea were frequently caught up in the territorial battles between the Greek and Roman empires and Jewish life was inevitably shaped by this turbulent backdrop, rife with conflict and political change. While there is evidence of Jewish assimilation into Graeco-Roman culture during this period, Jewish identity was also strengthened by foreign domination, in particular in relation to its religion. Judaism at this time was practised very differently by different groups of Jews, which included the Essenes, Pharisees, Sadducees and Zealots, and struggle for dominance between these sects was at times intense. Some strands of early Jewish thought became established in mainstream Jewish worship and have survived intact to this day. Others were discarded by Jews, but found their way into early Christianity. All the different Jewish sects in the Second Temple period regarded the Torah (the first five books of the Hebrew Bible) as central and sacred, but there was wide variation in how they interpreted the biblical texts and applied them in their daily lives.

The settlement at Khirbet Qumran, close to the caves in which the scrolls were discovered, appears to have been home to an ultra-religious sect, thought by many scholars to have been Essenes, although this is a matter of continuing debate. A number of the Dead Sea manuscripts relate specifically to the rules and beliefs of the Qumran community, for whom every aspect of daily life was structured around strict religious observance. The community chose to live in semi-isolation, pursuing a simple existence focused upon their religion. They deliberately distanced themselves from other Jews, whom they regarded as corrupt and impure, and used a solar rather than lunar calendar, which meant their religious festivals fell

Judaea under the Greeks and the Romans

The majority of scrolls found at Qumran were composed during the Hellenistic period (332–63 BCE). Others were created between 40 BCE and 70 CE, when Judaea was ruled by Herod and his descendants and a series of Roman provincial governors. Following the defeat of Persia by Alexander the Great in 332 BCE, the area came under the control of the Ptolemaic dynasty of Egypt. In 200 BCE Ptolemy V of Egypt was defeated at the battle of Panion, and the region of Judaea from that time came under the rule of the Seleucid empire of Syria.

Greek culture and language spread rapidly through the empire, including Judaea, during the Seleucid era. In 167 BCE the Second Temple in Jerusalem was looted, its religious services were banned and Jewish worship was effectively outlawed. Antiochus IV erected an altar to Zeus in the Temple, ordered pigs to be sacrificed there and banned circumcision.

A year later, in 166 BCE, Judah Maccabee led a successful Jewish uprising, known as the Maccabean Revolt, against the Seleucid occupation. The Temple in Jerusalem was rededicated in 164 BCE and once more became the religious pillar for Jews in Judaea, an occasion celebrated each year to this day with the Jewish festival of Hanukkah.

The Maccabean victory over the Seleucids was crucial for the Jews and Judaism. It ensured the preservation of the structures of a Jewish state organised around

on different days from their co-religionists. The Essenes prayed communally and purified themselves before every communal meal by immersing themselves in the *mikveh*, the Jewish ritual bath. In contrast, for most Jews at that time prayer was a private activity with ritual immersion a weekly or monthly routine. The Sabbath too was strictly observed by the Essenes:

No man shall speak any vain or idle word on the Sabbath day. He shall make no loan to his companion. He shall make no decision in matters of money and gain. He shall say nothing about work or labour to be done on the morrow. No man shall walk abroad to do business on the Sabbath.[38]

This tallies with a detailed description of the Essenes by the Jewish historian Josephus, lending some support to the idea that the Qumran community may have been an Essene sect:

And they are stricter than all other Jews in their abstinence from work on the seventh day. Not only do they prepare their food a day in advance, to avoid lighting a fire on the Sabbath, but they do not allow themselves even to lift a kitchen utensil, or to evacuate their bowels.[39]

The scrolls reveal intriguing similarities between the Qumran community and the early Christians, many of whom were initially Jewish. Their doctrines, for instance,

high priests, temple worship, observance of Jewish dietary laws, festivals and the Torah. Under the Jewish Hasmonean dynasty (descendants of the Maccabees), Judaea enjoyed a large degree of political and religious autonomy for nine decades, from 135–63 BCE. Fully independent for the last 50 years of their reign, the Hasmoneans hugely expanded the Jewish kingdom into Samaria, Galilee, Iturea, Perea and Idumea, roughly corresponding to the area of modern Israel. Jewish coins were minted for the first time in Jerusalem by the Hasmoneans between 128 BCE and 76 BCE, inscribed in Paleo-Hebrew as well as Greek. Examples from the reigns of John Hyrcanus I and Alexander Jannaeus can be seen in the Ashmolean's coin collection.

In 63 BCE the Roman general Pompey conquered Judaea and neighbouring Syria. Fifteen years later, in 48 BCE, Pompey was defeated by Julius Caesar and assassinated in Egypt. Herod the Great was installed as King of Judaea and Samaria in 40 BCE, with the support of and answerable to the Roman Senate. On Herod's death in BCE the Romans allowed his kingdom to be divided between his sons, one of whom was deposed in 6 CE. Judaea was then placed under the direct control of Rome for a while, before being restored to Herod Agrippa I (the grandson of Herod the Great) from 41 CE. His death, in 44 CE, led to the region's return to the status of a province ruled by Roman governors.

held that an apocalyptic 'End of Days' was approaching, in which the Messiah would appear and the forces of good and evil would engage in a final battle. Some of the scrolls found at Qumran refer to the 'Prince of the Congregation, the Branch of David', a common term for the Messiah. Many of these texts were written at the same time that Jesus was living and preaching, spreading his vision of a reformed Judaism.

The people of Qumran, like the Essenes, did not regard Jesus as the Messiah, but they would almost certainly have known about him – and perhaps also about John the Baptist, whose later preaching seems to show signs of an Essene training. Jesus, in turn, would have known about the Essenes and the existence of such beliefs.

Archaeological finds show that the people living at Qumran in the first century CE, whether Essenes or otherwise, were skilled in many practical ways. They grew barley, made honey, cultivated date palms and herded flocks. They wove textiles and mats and made their own cooking pots, eating utensils and storage jars. They also made the leather needed for their parchment scrolls and other uses, including religious apparel such as *phylacteries* (leather straps worn by Jewish men on their heads and arms), a religious custom still observed by modern Orthodox Jews. Some of the religious texts found in *mezuzot* and *tefilin* at Qumran were identical to those used by Jews today.[40]

The discovery of several inkwells, along with the remains of long plastered surfaces,

which may have been writing tables, suggest that Qumran may have been an important scribal centre for the copying and creation of sacred texts.⁴¹ Whether or not the texts all belonged to or originated from the Essenes, the sheer size and range of the collection suggests that at least some of the scrolls may have come from Jerusalem and been given to them for safekeeping. In any case, by the middle of the first century CE the people living at Qumran were the *de facto* keepers of this huge and extraordinary collection of scrolls. In all likelihood it was they who decided to hide the scrolls in response to the recent outbreak of rebellion against the Romans.

Nor was the danger was imagined: this was a period of exceptional turmoil in Judaea. The region was seething with unrest and the predominantly Jewish population was rebelling against Roman occupation in a series of uprisings known as the Great Revolt or the First Jewish–Roman War (66–73 CE). The Romans were not an enemy to be made lightly. They controlled the largest empire in the world at this time, commanding all the countries around the Mediterranean and stretching across North Africa, the Near East and large swathes of Europe. Early in 67 CE, after several months of increasingly violent Jewish rebellion, the formidable Roman general Vespasian, a veteran of the conquest of Britain, was sent by Emperor Nero to crush the uprising. The next two years saw brutal battles in Judaea, during which thousands of Jews were killed in battle, captured and crucified or taken into captivity, and many towns and villages were destroyed. In 68 CE the inhabitants of Qumran, fearing for their own fate, hid the precious scrolls, sealed the caves and fled. Not long after, the Romans occupied the settlement and turned it into a military garrison.

The Qumran scrolls are of immense importance, theologically, archaeologically and historically, not least in revealing the complexity and diversity of Jewish thought and philosophy during the Second Temple era. The emergence of Christianity, initially as a branch of Judaism and then as a distinct religion, was an additional challenge. Assimilation and integration in some aspects of Jewish life in Judaea were matched by extreme discord and resistance in others, particularly in relation to political and religious autonomy. The scrolls hugely enrich our knowledge of the religious beliefs, daily customs and social structure of the Jewish people at this pivotal moment in their journey and development. The biblical 'End of Days' so keenly anticipated by the Qumran sect would not come quite yet – but in the course of the next 60 years Jewish life in Judaea as people then knew it would indeed come to an end. Hidden away in jars like this one, in the dry, dark aspic of the caves above the Dead Sea, the scrolls would preserve the memory of that world for the next 2000 years.⁴²

Opposite Photograph of the Dead Sea Scroll jar taken in Jordan *c.*1950, when the jar was being offered to the Ashmolean Museum. When the jar arrived in Oxford the modern joints had come apart and it was in pieces.
© ASHMOLEAN MUSEUM, UNIVERSITY OF OXFORD, AN1951.477

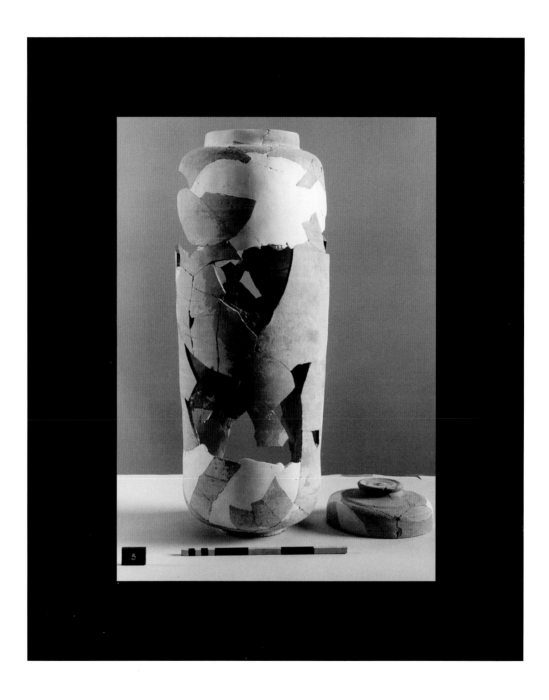

68–9 Rabbi Yochanan
ben Zakkai founds first
yeshiva at Yavne

'Year of the Four Emerors'
(Galba, Otho, Vitellius,
Vespasian)

69 Vespasian proclaimed
ninth Emperor of the
Roman Empire

70 Destruction of Jerusalem
and the Second Temple by
Roman army, commanded
by Vespasian's son Titus

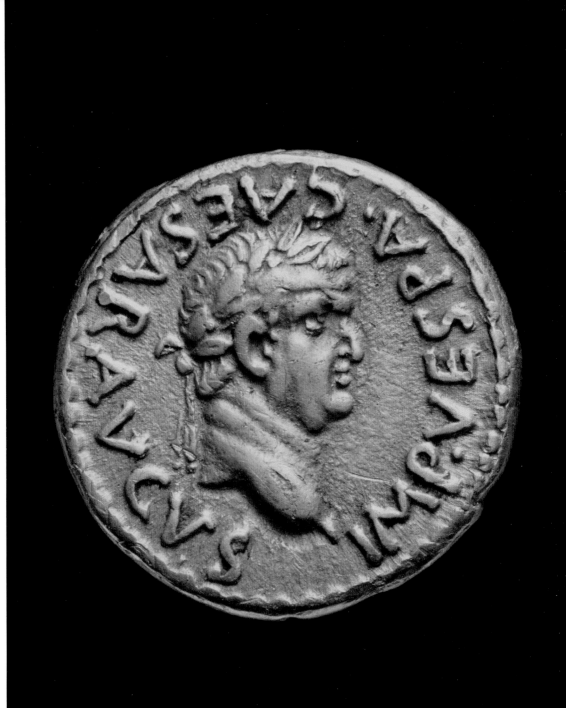

9 TEMPLE GOLD COIN

U

JERUSALEM, JUDAEA (NOW ISRAEL), 70 CE

*'Buried in the bowels of the earth, rugged
and obscure, lies the ingot of gold.'*
Emma Lazarus, *By the Waters of Babylon*

THE PRECIOUS SCROLLS were safe for the time being, but for the Judaeans the immediate future was far from bright. This small, beautifully preserved gold coin may be one of the rare remains from the terrible events that were about to engulf the Jewish people: the destruction of Jerusalem and the Holy Temple.

Rome had been battling the Jewish rebels since 66 CE. As the towns and villages of Judaea and Galilee succumbed to the might of the Roman armies, the surviving rebels retreated to Jerusalem, Judaea's capital and its Jewish stronghold. Jerusalem had held out against the Romans up until this point, and in 68 CE the Jewish rebels even issued a Jerusalem shekel as a symbol of their defiance. In 70 CE Vespasian, now the Roman Emperor, ordered his son Titus to lay siege to the city. For five long months, from February until August, the rebels resisted, infuriating the Romans with their reckless courage and determination to fight to the bitter end. Inside the city walls life quickly became desperate due to overcrowding and chronic shortages of food and water, with increasingly violent conflict breaking out between the Jewish factions trying to keep hold of the city.

An eyewitness to the destruction was the Jewish historian, Josephus. Only three years earlier Josephus (whose Hebrew name was Yosef ben Matityahu) had been military commander of the Jewish rebels in Galilee. Captured by Vespasian at Jotapata (Yodfat), Josephus narrowly escaped with his life by defecting to the Romans. He came to the siege of Jerusalem on the side of the Romans and, by his own account, repeatedly urged the Jews to see sense and surrender.[43] His descriptions of the gruesome conditions inside the city

| 70 Jerusalem captured by Titus | 73 Romans take the fortress of Masada | 75 Hero develops first types of steam engines | Luke writes the *Acts of the Apostles* | 79 Roman Emperor Vespasian dies. His son Titus takes his place |

during the siege, written in Rome some years later, are as vivid as they are heart-rending:

> There was pitifully little to eat, and you would have wept to see the strong taking more than their share and the weak reduced to whimpering despair … So wives would snatch food from their husbands, children from their parents and, most pitiable of all, mothers would take food from the very mouths of their babies and not scruple, when their dearest ones were wasting away in their arms, to rob them of those drops of nourishment which could keep them alive.[44]

Anyone daring to leave the city in search of food or in an attempt to escape was instantly arrested, tortured and crucified in front of the city walls, at the rate of 500 or more a day, if Josephus is to be believed. He assures his Roman readers, somewhat implausibly, that Titus was appalled by this steep rate of crucifixions, but reluctantly allowed them to continue in the hope of encouraging the Jewish rebels to submit. However, the Roman brutality only strengthened the rebels' determination to resist.[45]

After months of intense fighting, the city walls were finally breached in August 70 CE. The battle now continued not just inside Jerusalem, but in the heart of the Temple itself:

> The slaughter was massive – no pity shown for age, no regard for rank: children, old men, laymen, priests were killed indiscriminately, and war extended its grip to encompass people of every class and condition, no matter whether they were begging for mercy or trying to resist. As the fires spread ever further, the roar of the flames mingled with the groans of the dying … And as for the noise, it would be impossible to imagine anything more dominant or more terrifying. There were the war cries of the Roman legions as they went into action; the yells of the rebels surrounded by fire and sword; the screams of the civilians trapped up there as they ran panic-stricken straight into the enemy and met their fate … The temple hill, one huge mass of fire, seemed to be boiling over from its very roots, but you would also have seen rivers of blood outrunning the flames and the killed outnumbering the killers. Nowhere could the ground be seen for the corpses covering it, and the soldiers had to clamber over piles of bodies to pursue those still trying to escape.[46]

The destruction of the Second Temple was a loss of immense practical and symbolic significance for the Jewish people. Based on the site of King Solomon's original temple, the building had been substantially and lavishly rebuilt and expanded by Herod the Great. The Temple was made of local stone and decorated with imported white marble; architects from Greece, Rome and Alexandria probably

79 Mount Vesuvius erupts, burying the cities of Pompeii and Herculaneum

80 The Colosseum is completed

Mark writes first of the Christian gospels

Titus inaugurates the Coliseum in Rome

planned its construction. The vast Temple complex included beautiful colonnades, grand stairways, huge double-gated doorways and multiple courtyards. The ceilings were intricately carved with vines and acanthus leaves. At Passover, when Jerusalem was packed with Jewish pilgrims, the city's population increased dramatically and the Temple complex also included numerous *mikvaot* (ritual baths) for purification of the worshippers. The exterior, according to Josephus and other sources, was more splendid still:

> The exterior aspect of the sanctuary building made an absolutely stunning impact, both spiritual and visual. Covered all over in massive plates of gold, as soon as the sun rose it radiated such a fiery blaze of light that anyone necessarily facing in that direction had to avert his eyes, as if from a direct glance at the sun. To foreigners on their way to the temple, it looked from the distance like a snow-clad mountain, as all not covered by the gold was pure white in colour.[47]

Renowned throughout the ancient world for its size and beauty, the Temple dominated the cityscape in both scale and importance. Before its destruction it had not only been the epicentre of worship and pilgrimage for the Jews, but a locus of Jewish legal and political power. Now it was gone, and the city with it.

It took more Roman troops to capture the city of Jerusalem in 70 CE than it had to conquer all of Britain in 43 CE.[48] As many as half a million people may have been killed in the process. The Romans celebrated their hard-won victory with a series of coins stamped with Vespasian's head on one side and on the other the words IUDAEA CAPTA (Judaea Conquered) along with a figure symbolising Judaea, her head bowed in mourning, and a bound male captive. The coins are large and heavy, weighing over 25 g, and are clearly meant to convey the might of the Roman empire. Back in Rome itself, two arches dedicated to Titus were erected in the Forum after his death, depicting his magnificent triumphal procession home. The surviving arch famously portrays the victorious Roman soldiers bearing aloft a seven-branched menorah and other precious objects looted from the Jewish Temple. Josephus, by then a Roman citizen, witnessed that great triumphal procession, which included 700 of his captive fellow Jews.

An enduring mystery is what happened to the rest of the Temple's countless treasures. Josephus makes much of just how phenomenal and extensive these treasures were. As well as housing a huge quantity of sacred and decorative objects, many of them made of gold, the Temple also functioned as a kind of bank in which the Jews deposited personal property and money for safekeeping.[49] While a few of these treasures were carried off to Rome, prominently displayed in Titus's triumphal procession and then in the Temple of Pax, and others may have contributed to funding the construction of the Colosseum, this still cannot possibly account for the whole.[50]

This particular Roman gold coin may be evidence of another explanation. Discovered in England in 1850 the coin was dug up in a field near Finstock, about three miles from North Leigh in Oxfordshire, by a local farmer, who then sold it on to a local collector called Martha Spriggs. But it was minted 2000 years before and, more remarkable still, it was made in Judaea in 70 CE, immediately after the Romans conquered Jerusalem. On one side of the coin is the stern face of Vespasian; on the other, the figure of Justice. The Latin inscription reads 'IVSTITIA IMP', meaning 'Justice of the Emperor', a reminder to victors and vanquished alike that the conquest of Jerusalem was a just and fair outcome, upheld by the authority and power of the Roman empire.

When Vespasian's soldiers sacked the city, they not only crushed a troublesome regional rebellion, but also hit a financial jackpot. The features of this particular gold coin, and comparisons with others minted at the time, indicate that it was made in Judaea itself, very soon after the conquest of Jerusalem, and that the metal in all likelihood came from gold either melted down accidentally in the fires that destroyed the Temple, or from the huge hoard of gold objects and fittings deliberately looted from it, and subsequently melted down and turned into much-needed currency. As Professor Chris Howgego, Keeper of the Heberden Coin Room at the Ashmolean, explains, 'Titus required funds to pay his large body of troops who needed rewards both for their services against the Jews and for their loyalty during the civil war. Presumably some of the gold was minted for disbursement on the spot, but much of it, either in coined or uncoined form, may have accompanied the more spectacular treasures to Rome'.[51]

But a puzzle remains: how did this particular gold coin find its way from first-century Judaea to nineteenth-century England? The most likely explanation is that it was carried there directly by a Roman soldier. Judaean rebellions were only one of the problems facing the Romans in the first century CE and, having dealt with Jerusalem, Vespasian's immediate concerns now lay in the west. Very soon after the conquest of Jerusalem, a large number of Roman troops were transferred straight from Judaea to deal with unrest in Germany and in Britain, where Boudicca had recently led a large uprising against Roman rule. Beginning in 71 CE, the Romans renewed their goal of a whole-scale conquest of Britain. As well as troops this required a great deal of money, to the tune of two metric tons of gold a year.[52] Nearly all the coins minted in Judaea at this point in Vespasian's reign have been found in Britain, suggesting that they were made in order to fund this campaign, while the excellent condition of this particular coin suggests that it arrived in Britain very soon after it was made. The location of its discovery in the nineteenth century – about three

It took more Roman troops to capture the city of Jerusalem in 70 CE than it had to conquer all of Britain

miles from North Leigh, close to the village of Wilcote, which in the first century CE was a military staging post on the Roman road from Cirencester to St Albans – further supports the theory that it came with a deployment of soldiers, fresh, or not-so-fresh, from the gruelling battle for Jerusalem.[53]

A single gold coin of this kind was a considerable amount of money in the first century, representing a full month's pay for a legionary. Whether it was lost by accident, or hidden deliberately, we will never know. From the perspective of Jewish history, however, the fact that gold from the destroyed Temple in Jerusalem in 70 CE and new-minted as a Roman coin should have made its way to England, been preserved in the ground for almost 2000 years, been struck for a second time by a farmer's plough and then had its extraordinary origins gradually revealed, is, in its own way, little less than miraculous

Returning to the first century CE, the destruction of Jerusalem by Titus was not quite the end of the story for Jewish Judaea. Pockets of resistance continued to cause trouble for the Romans for 60 more years. An outpost of Jewish rebels took refuge in the remains of Herod's fortress palace on Masada, where they held out until 74 CE. Besieged by the Romans, the rebels and their families, over 900 men, women and children in all, then chose to kill themselves rather than be murdered or enslaved. One woman and five children survived by hiding in a cave.[54]

Elsewhere in the Roman empire Jewish unrest continued to simmer, coming to a head in 115 CE, when rebellions erupted in Roman territories across a wide swathe of the eastern Mediterranean. The uprisings were brutally suppressed by Trajan in 115–117 CE. Jewish communities in Libya, Egypt and Cyprus suffered horrifying massacres, looting and arson attacks; many were wiped out altogether. The Judaeans stayed quiet for the moment, but they were not yet defeated.

Jerusalem had lain in ruins since 70 CE, but in 130 CE the Emperor Hadrian announced his intention to rebuild the city as a Roman colony and rename it Aelia Capitolina. Coins were minted bearing this incendiary name for the former Jewish capital. Deep resentment among the Jewish population may in part have prompted a new generation of rebels to rise up against Roman rule in 132 CE. Led by the charismatic military commander Shim'on Bar Kosiba, the self-styled 'Prince of Israel', popularly known as Shim'on Bar Kokhba, the rebels succeeded in reclaiming parts of Judaea, including Jerusalem. Letters to and from Bar Kokhba, discovered in the mid-twentieth century, make frequent reference to years 'of the Redemption of Israel' and 'of the Freedom of Israel'; they also indicate that Bar Kokhba was operating an efficient chain of command stretching over a wide geographical area. In defiance of the Roman authorities Bar Kokhba even minted his own coins, possibly using mobile mints, stamped with his name 'Shim'on' and the words 'For the Freedom of Jerusalem' and explicitly Jewish images, including the façade of the Temple, a *lulav* (bundle of branches), an *etrog* (a citrus

122 Construction begins on Hadrian's Wall in northern England	**132** Judea depopulated and the Jews denationalised by the Romans	**132–5** Bar Kochba Revolt against the Romans	**136** With Jews banned from Jerusalem, Yavneh becomes centre of Judaism

fruit) and a seven-branched palm tree.

For the Romans this rebellion posed a serious military threat, and it was dealt with harshly. Casualties were heavy on both sides and hundreds of towns and villages were destroyed in the conflict. Thousands of people died in the fighting or from hunger and disease as a result of it; many others were captured and sold as slaves. In the 1950s excavations of caves between Ein Gedi and Masada at the southern end of the Dead Sea uncovered hundreds of documents belonging to both rebels and refugees. Among them were personal letters and keys of the houses they had been forced to abandon, but still hoped to return to. One cave contained 40 skeletons, civilian victims of the war.

It took three years and 50,000 troops for the Romans to suppress Bar Kokhba and his guerrilla army. In 135 CE Hadrian sent additional forces led by Julius Severus, another successful veteran of campaigns against Britain, and finally succeeded in crushing the rebellion. Much of the remaining Jewish population of Judaea was massacred, crucified or taken forcibly from their homeland into slavery in other parts of the Roman empire, and Jews were banned from living in or around Jerusalem. To drive home his victory, Hadrian annexed the province of Judaea to Syria and renamed the whole region 'Syria Palaestina', thus erasing any reference to Jewish Judaea from the map. Over time it came to be known simply as Palaestina and eventually Palestine, until in 1948, a large part of it became the new state of Israel.

A small Jewish population continued to live in former Judaea after 135 CE, and indeed for most of the next 2000 years. In the immediate aftermath of the Bar Kokhba Revolt, however, Jews were very much in the minority as Palaestina under Graeco-Roman rule rapidly became a predominantly pagan, and later Christian, province. While the area around Aelia Capitolina was strictly off-limits to Jews until the third or fourth centuries CE, there were Jewish communities elsewhere in Palaestina, albeit in town and cities that were highly Hellenised.[55] Remains of synagogues dating from the second to the sixth centuries CE have been found in the south and north of the country, further evidence of the survival of Jewish life in Palaestina, and Hebrew and Aramaic continued to be spoken alongside Greek. The north of the province, in and around Tiberias and Sepphoris, would gradually emerge as established centres for rabbinic learning during these centuries. The Mishnah, the compendium of rabbinic oral commentaries on the Torah, composed in Galilee in around 200 CE, would become the foundation for the Talmud (see Chapter 11), a work that for Jews is second only to the Bible.

The destruction of Jerusalem and the Temple, one small relic of which is this gold coin, brought Temple-based Jewish worship to a conclusive end and was the catalyst for profound changes to Jewish religious life, shifting religious authority from high priests to rabbis and worship from the Temple to synagogues. The only visible remains of Herod's

138 Antoninus Pius
becomes Roman emperor

150 Tertullian born

161–80 Marcus Aurelius is
emperor of Rome

170–80 Marcus Aurelius
writes his philosophical
meditations

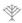

magnificent building was part of one of the walls, which had supported the vast courtyard on which the Temple stood, known today as the Western Wall. But the ancient connection to the city of Jerusalem and the holy Temple, although physically severed from daily life for most Jews, was kept vibrantly alive in Jewish memory through religious texts and practices. Images of the menorah and shofar in early synagogues throughout the eastern Mediterranean, built between the third and

ninth centuries CE, were visual reminders of the lost Temple. Its destruction was – and still is – commemorated annually with fasting and mourning on Tisha b'Av (the ninth day of the Hebrew month of Av). Under successive and varying regimes Jerusalem continued to be a sacred destination for Jewish pilgrims and scholars, and the connection with Jerusalem and the Temple remained symbolically vital to the Jewish people, wherever their journey took them in the centuries to come.

TEMPLE ERA

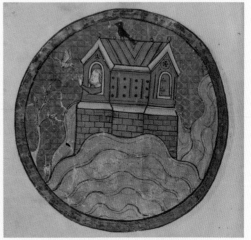

Fig.1 Late Babylonian clay tablet depicting a map of the world. Dating from the sixth century BCE, it shows the world as a disc, surrounded by a ring of water called the 'Bitter River'.

Fig.2 Full-page miniature of Noah's Ark from *The Northern French Miscellany*. Northern France, 1277–86.

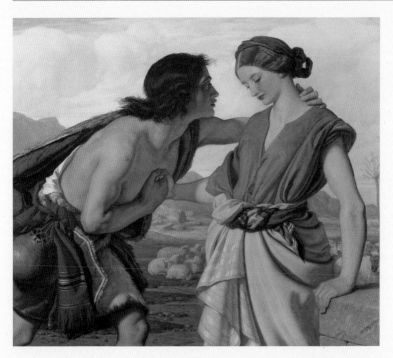

Fig.3 William Dyce (1806–1864) *The meeting of Jacob and Rachel, 1857*. Oil on canvas, signed and dated *WD1 1857*. Currently on loan to the Ashmolean Museum.

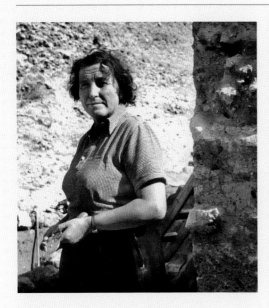

Fig.4 Kathleen Kenyon on site during an archaeological dig in Jericho, 1958.
© UCL, INSTITUTE OF ARCHAEOLOGY

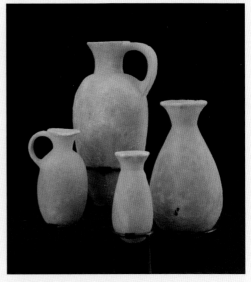

Fig.5 Gypsum stone vessels from tomb in Jericho, *c.*1800–1650 BCE.
© ASHMOLEAN MUSEUM, UNIVERSITY OF OXFORD, AN1954.594–597

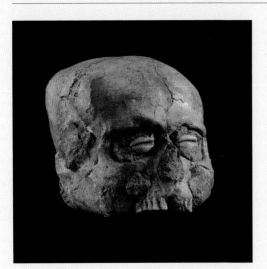

Fig.6 Plastered human skull from Jericho, one of the oldest inhabited settlements in the world, *c.*7000–6500 BCE.
© ASHMOLEAN MUSEUM, UNIVERSITY OF OXFORD, AN1955.565

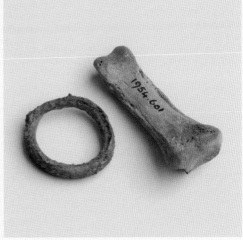

Fig.7 Bronze ring and finger bone from tomb in Jericho, *c.*1800–1650 BCE.
© ASHMOLEAN MUSEUM, UNIVERSITY OF OXFORD, AN1954.601

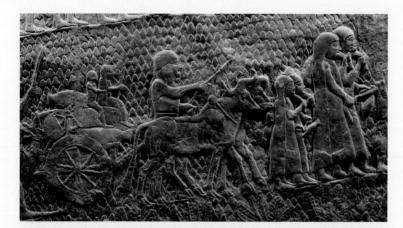

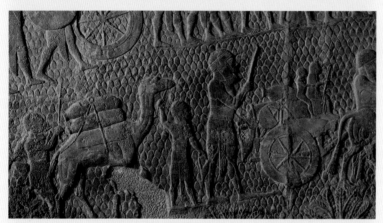

Fig.8a & 8b Gypsum wall panel relief showing Judaean prisoners from Lachish being taken into exile by the Assyrians along with their belongings and animals.

© THE TRUSTEES OF THE BRITISH MUSEUM, 1856,0909.14

Fig.9 Black limestone obelisk of Shalmaneser III, depicting the Jewish king of Israel, Jehu, bowing down to him and paying tribute, *c.*825 BCE. The obelisk provides the earliest preserved depiction of an Israelite.

© THE TRUSTEES OF THE BRITISH MUSEUM, 1848,1104.1

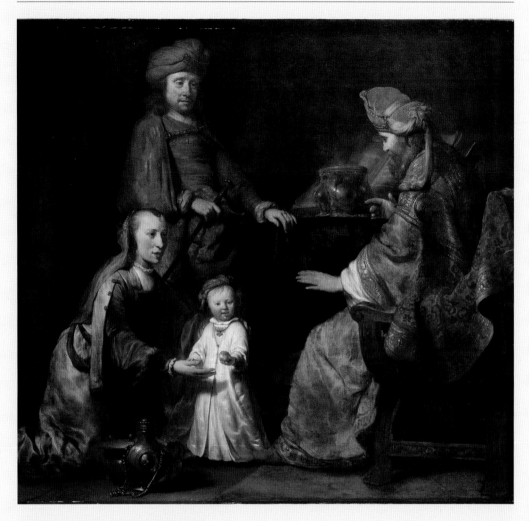

Fig.10 Gerbrand van den Eeckhout (1621–1674)
The Infant Samuel brought by Hannah to Eli.
Oil on canvas, 110.8 x 137 cm.
© ASHMOLEAN MUSEUM, UNIVERSITY OF OXFORD, WA1945.73

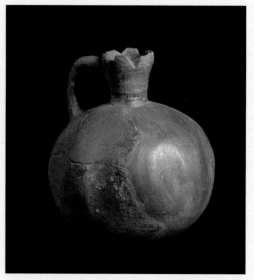

Fig.11 North wall of the Shrine of Taharqa, depicting King Taharqa, who was said to have come to the Judaeans' rescue during the Assyrian siege of Jerusalem in 722 BCE.

© ASHMOLEAN MUSEUM, UNIVERSITY OF OXFORD, AN1936.661

Fig.12 Red slipped and burnished vase in shape of a pomegranate, dating from 750–587 BCE and excavated in Jerusalem by Kathleen Kenyon. Pomegranates are traditionally eaten at Rosh Hashanah (Jewish New Year) as symbols of fruitfulness. The seeds are said to represent the 613 commandments in the Torah.

© ASHMOLEAN MUSEUM, UNIVERSITY OF OXFORD, AN1968.1371

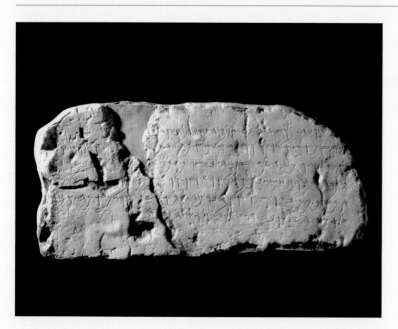

Fig.13 Siloam inscription in Hebrew, dating from the eighth century BCE, describing the construction of Hezekiah's tunnel. The original is in the Istanbul Archaeology Museum, and a replica on the site of the original is now in the tunnel in Jerusalem.

WWW.BIBLELANDPICTURES.COM /
ALAMY STOCK PHOTO

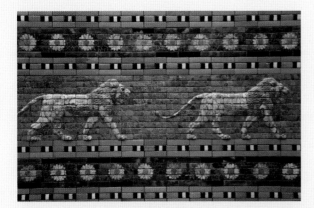

Fig.14 Detail from replica of the Ishtar Gate in Babylon, now in the Pergamon Museum, Berlin. The captured Judaeans would have been marched through these gates into the city of Babylon after their exile from Jerusalem in 586 BCE.
TIBOR BOGNAR / ALAMY PHOTO STOCK

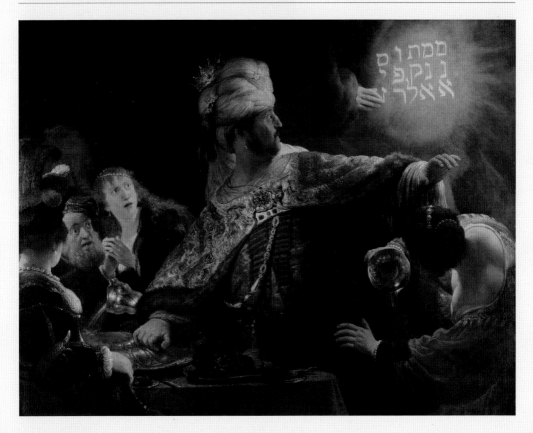

Fig.15 Rembrandt van Rijn (1606–69) *Belshazzar's Feast*, 1635. Oil on canvas, 168 x 209 cm. Rembrandt's depiction of the famous scene from the Book of Daniel shows Belshazzar, King of Babylon, serving wine to his banquet's guests from sacred vessels looted from the Temple in Jerusalem.
© THE NATIONAL GALLERY, LONDON, NG6350

Fig.16 Detail of a miniature from the *Golden Haggadah*, northern Spain, *c.*1320, depicting Miriam, the sister of Moses, and her women dancing and playing the tambourines after the ancient Israelites' escape from slavery in Egypt.

Fig.17 Detail of a miniature from the *Golden Haggadah*, northern Spain, *c*.1320, depicting the slaughtering of lambs and ritual cleansing of dishes in preparation for the Festival of Passover, which celebrates the ancient Israelites' escape from slavery in Egypt.

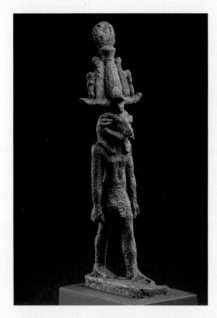

Fig.18 Model of the ram-headed god, Khnum. According to mythology, he created people from the mud of the Nile on a potter's wheel. Late Period (Egypt) c.715–343 BCE.

© ASHMOLEAN MUSEUM, UNIVERSITY OF OXFORD, AN1931.586

Fig.19 Air France consignment docket for the shipment of the Dead Sea Scroll jar, 1951. The contents are simply noted as 'jar with lid'.

© ASHMOLEAN MUSEUM, UNIVERSITY OF OXFORD

Fig.20 Part of the Great Isaiah Scroll, c.150-100 BCE. The longest and oldest of the Dead Sea Scrolls found in the Qumran caves in 1947. The scroll is written on seventeen sheets of parchment, 730 cm x 28 cm.

WWW.BIBLELANDPICTURES.COM / ALAMY STOCK PHOTO

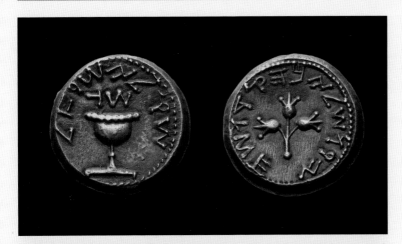

Fig.21 Jerusalem Shekel, made of silver and weighing 14.18 g. Minted in Jerusalem in 68–9 CE by Judaean rebels during The Great Revolt against the Romans. The obverse shows the Cup of Omer and the Hebrew inscription reads 'Shekel of Israel'. The reverse shows three pomegranates on a stem, and reads 'Jerusalem the Holy'.

© ASHMOLEAN MUSEUM, UNIVERSITY OF OXFORD, TJC202

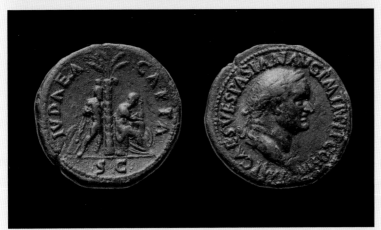

Fig.22 Roman coin, made of brass and weighing 25.30g. Minted in Rome in 71 CE after the conquest of Jerusalem and Judaea. Inscribed with the head of Vespasian, seated figure of Judaea and two standing male captives. The Latin inscription reads *IUDAEA CAPTA* (Judaea captured).

© ASHMOLEAN MUSEUM, UNIVERSITY OF OXFORD, HCR21449

Fig.23 Bar Kochba coin, minted 134–36 CE, silver tetradrachm weighing 13.80g. Minted in the last year of the Bar Kochba Revolt. The obverse has a rare image of the facade of the Temple in Jerusalem. The reverse shows a *lulav* bundle and *etrog*, associated with the Jewish Festival of Sukkoth. The Hebrew inscription reads 'for the freedom of Jerusalem'. The coin has been struck over an older Roman piece.

© ASHMOLEAN MUSEUM, UNIVERSITY OF OXFORD, HCR6354

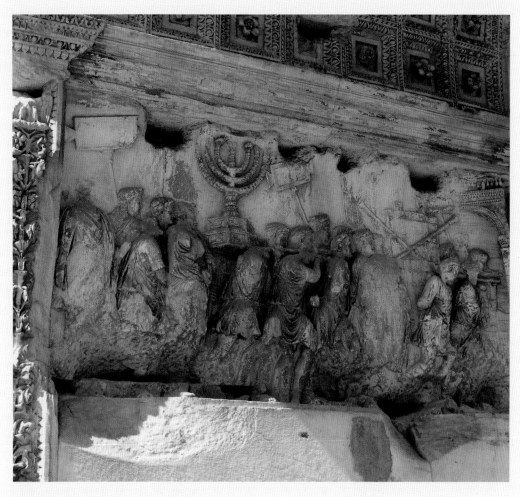

Fig.26 Scene from the Arch of Titus in Rome,
82 CE, showing Roman soldiers carrying the
Menorah from the destroyed Second Temple back
to Rome after the Siege of Jerusalem in 70 CE.
BY DNALOR 01 VIA WIKIMEDIA COMMONS

DIASPORA

After the conquest of Judaea in 70 CE, the
Jewish people were dispersed, by force
and choice, to other countries, forming new
communities around the world. Jews living in
the Diaspora (meaning 'dispersed') maintained
close links but also developed regional differences
through interactions with other cultures. In
following centuries, war and persecution
continued to drive Jewish people to migrate.
The Spanish and Portuguese Inquisitions in the
fifteenth and sixteenth centuries, anti-Semitic
pogroms in the Russian Empire in the late
nineteenth century, and Nazism in the twentieth
century all led to Jewish mass migrations.

10 ROMAN GOLD-GLASS

ROME, ITALY, c.350

I

*'You are to make a
menorah of pure gold.'*
Exodus 25:31

A MARKER OF THE social and economic stability of a society is the way in which it cares for its dead. This glass fragment, ethereal in its delicacy and precious for its rarity, dates back to the fourth century CE and comes from one of several Jewish catacombs in Rome. The Jewish community in Rome was large and well-established by this date. Many were the descendants of Jews transported there as prisoners-of-war or slaves in the course of Jewish revolts against Roman rule from 66 to 135 CE. Others had come to Rome in earlier centuries as merchants, notably from Alexandria in Egypt, because of trading links between Rome and the Levant. Some had come as Jewish delegates on diplomatic missions and never left. Once settled in Rome, those who had come as slaves could eventually be set free by their Roman masters, or could buy their freedom, or have it bought for them by fellow Jews.

While the Romans appear to have viewed the Jews as followers of peculiar, backward religious customs, they nevertheless recognised and in general respected the antiquity of the Jewish religion. Julius Caesar, who ruled from 49 to 44 BCE, favoured the Jews, confirming their rights both in Judaea and in their diaspora communities elsewhere in the empire. His successor Augustus, who came to power after the battle of Actium at which Mark Antony and Cleopatra were defeated, and ruled from 31 BCE to 14 CE, re-organised the distribution of grain so that it did not take place on the Jewish Sabbath.

In the early centuries of the first millennium CE, Jews in Roman Italy were for the most part tolerated and accepted. In addition to the large community in Rome,

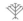

significant Jewish communities existed throughout southern Italy, in Sicily, Calabria and Apulia.[56] Inscriptions of various kinds provide evidence of a small Jewish population living in Pompeii at the time of the eruption of Vesuvius in 79 CE, possibly brought there as slaves both before and after the destruction of Jerusalem nine years earlier. Pompeian Jews appear to have been mostly of low social rank and many were women. One was a prostitute called Maria who worked in the via del'Abbondanza. There is also evidence of a wine merchant called Youdaikos, as well as an unnamed Jewish gladiator, whose impressive bronze helmet is now in the National Archaeological Museum in Naples. The helmet is decorated with the seven-branch palm tree, a symbol of Jewish Judaea also found on the Iudaea Capta coins and those minted by Jewish rebels during the First Jewish Revolt (see Chapter 9), supporting Josephus's account that many Judaean prisoners-of-war were forced to fight as gladiators in other parts of the Roman empire.[57]

The catacombs in Rome were man-made underground cemeteries built for Jews, Christians and pagans, and were tunnelled out of the soft *tufa* rock, sometimes on the site of old quarries. In addition to sarcophagi, tombstones and burial niches covered by memorial plaques, the catacombs contained grave goods, including the world's largest collection of Roman gold-glass. Made exclusively in Rome, gold-glass was commissioned by pagans, Christians and Jews

for funeral banquets, weddings and other important occasions.

This particular fragment came from one of six Jewish catacombs in ancient Rome and was bought in the nineteenth century by Charles Wilshire, a passionate collector of Roman antiquities.[58] Wilshire (1814–1906) was a wealthy Catholic landowner from Hertfordshire, whose long life spanned the reigns of three British monarchs. An ardent supporter of the Oxford Movement, he was deeply committed to the advancement of knowledge about early Christian art and archaeology, as well as its Jewish roots, and through his Catholic connections in England, he formed close relationships with leading Vatican and Jesuit scholars in Italy, who would in turn prove crucial in the often complicated process of acquiring pieces for his collection.

He first began buying items specifically related to his religious interests in the early 1860s, and over the next three decades built up a very important collection of Roman gold-glass, funerary inscriptions and sarcophagi. As Wilshire himself wrote in 1869, in response to an offer to buy part of his collection:

> I value my Christian glass so highly that it is likely to remain in my possession a very long while [it being] unique in some of its specimens…and there being positively no specimens of value at all approaching mine in any national collections out of Italy except at the British Museum, where, as you know, there is nothing nearly so fine.

Wilshire's final collection included 36 fragments of Roman glass objects, and eight funerary plaques to members of the Jewish community in Rome, which he personally chose in 1870 from the Jewish catacombs at Vigna Randanini. This fragment was originally part of a circular disc, or medallion, which would have formed the base of a shallow glass bowl. The fragment shows the left half of a menorah, the Jewish seven-branch candelabra, which tells us that it would once have belonged to a member of the Jewish community in Rome. Only around 500 gold-glass medallions have survived, of which only fourteen have explicitly Jewish motifs, making this fragment and others like it extremely rare. They are some of the earliest examples of objects with Jewish symbols that date from after the expulsion of the Jews from Judaea.

Formulaic phrases and mispelled words indicate the glass makers were not always native Latin speakers

The menorah was thought of as a tree, and the coloured blobs of enamel paint you can see on the branches represent its fruits. Each branch was topped with a little lamp containing oil. Beside the menorah in this fragment you can see the taper used to light the lamps. The taper, decorated with black bands, is a very unusual feature, appearing on no other surviving gold-glass pieces. The menorah itself symbolises the light of God spreading throughout the world, and its use on funerary objects may have been intended as a reminder to live by God's laws. It was also a reference to the menorah of pure gold which once graced the Second Temple in Jerusalem. The ancient Jewish sages took from this that we should aim for the purest gold in our internal thoughts and feelings, guided by the light of Torah (Jewish law). On either side of the menorah on the gold-glass fragment is a sprig leaf and other small decorative features, perhaps part of an etrog or lulav bundle, ritual items used in the Jewish festival of Sukkot. A double band of gold leaf around the outer rim of the medallion contained an inscription, now mostly lost. The upper part of the picture is missing, but it may have illustrated the ark, the special cabinet found in synagogues where the Torah scrolls were kept. A unique feature of Jewish Roman gold-glass was that the ark was always shown with the doors open, revealing the Torah scrolls inside.

The menorah had an additional and painful resonance for Roman Jews, who had to endure the familiar and imposing landmark of the Arch of Titus at the entrance to the Forum, commemorating the conquest of Judaea and depicting triumphant Roman soldiers holding aloft the sacred menorah looted from the Temple in Jerusalem in 70 CE (see Chapter 9). In this context, the frequent image of the menorah in the catacombs on funerary objects and on the walls themselves gives it additional potency as an enduring symbol of Jewish identity.

*c.*350 Huns invade Sassanid Empire

376–82 Gothic War

378 Visigoths defeat Romans at Adrianople. Beginning of Roman decline

380 Christianity becomes state religion of Roman Empire

381 First Council of Constantinople

Crafting these gold-glass medallions was a skilled job requiring three separate stages. A circle of gold leaf was first glued to a glass base, after which the image and text were cut and engraved onto it. The glassmaker then blew the glass for the shallow bowl that formed the upper part of the finished piece. Finally the base and bowl were fused together. The gold leaf was usually set in clear glass, but some have blue or green backgrounds, and the fine detail produces a lovely, jewel-like quality. The Romans imported the raw glass – and in some cases, the glassmakers themselves – from other parts of their empire, including Syria, Palestine and Egypt. To make the glass clear, it was melted down and mixed with manganese to remove iron from the sand. The most likely location of the workshops where the gold-glass was produced was the multi-ethnic, multi-lingual district of Trastevere, many of whose inhabitants came from the eastern parts of the empire. Monteverde, one of the city's Jewish cemeteries, was nearby. The use of formulaic phrases, Latinised Greek and misspelled words on many of the texts of these gold leaf medallions further indicate that the glass makers were not always native Latin speakers.

The finished pieces were used as serving platters on special occasions. They were most commonly used for funeral banquets, called *refrigeria*, and commemorative feasts (*parentalia*) for the person who had died, a custom still observed by pagans, Christians and Jews at this time. The images on the medallions varied according to the beliefs of the people commissioning them, but the words were always the same: 'PIE ZESES', a Greek expression meaning 'Drink! Live!', the equivalent of 'Cheers!' or 'Good health!' and written either in Greek or Latin. After the feasting, the gold leaf bases were broken off and set into the sealing wall of the deceased person's tomb. The glass was turned inwards so that the dead could read the scene.

These banquets often took place at, or even inside, the catacombs. Among Charles Wilshire's purchases from Rome is a section of a marble panel carved with a scene from one of these notoriously lively affairs. The panel originally decorated the lid of the sarcophagus of a young man and dates from the early fourth century. It shows a group of men sitting outdoors around a small table enjoying a meal of fish and wine. Four of the men are entirely taken up with the business of eating and drinking. Two of them are reaching over to the table to grab more food, while two others are about to bite into what look like hunks of bread. A couple of servants carrying jugs of wine are hurrying to refill their tankards. But on the right of the panel, on the edge of the group, sits a fifth man, who is neither eating nor drinking. Clean shaven and with a serious expression on his face, he has turned away from his companions and is looking, instead, towards a brick building with a small open window. The building is most likely his own tomb, and the meal his friends are enjoying with such gusto is the funeral banquet held after his death, which the deceased were believed to attend.

390 Jerusalem
Talmud completed

395 Roman empire
permanently divided
into East and West

405 Latin translation
of Christian Gospel

410 Rome is sacked
by the Visigoths

413 St Augustine of
Hippo begins writing
The City of God

Because of their pagan associations, and reputation for rowdiness, these funeral banquets were frowned upon by the Christian church in the fourth century and frequently criticised as immoral and un-Christian. Surviving gold-glass fragments from the period reflect this, with those found in Christian tombs gradually moving away from remembering the actual person who had died to commemorating martyrs and saints instead. As Susan Walker, former Keeper of Roman and Greek Antiquities at the Ashmolean, explains: 'One of the most striking differences between Jewish and Christian memorials in fourth-century Rome, including gold-glass vessels such as these, is the Jewish insistence on the cohesion of the community, whereas Christian memorials, in contrast, focused upon the spiritual salvation of the individual.'[59]

These gold-glass medallions and other finds from the catacombs suggest that in many areas of their lives fourth-century Roman Jews were sufficiently integrated with mainstream society to do as other Romans did, while at the same time remaining faithful to their own beliefs and customs. Some were wealthy enough to commemorate their dead in style, commissioning special glassware to mark significant occasions, but most made do with more modest memorials. Whatever their financial means, they adapted at least some of their funeral practices to Roman fashions, combining them with Jewish customs and iconography. Besides the use of Jewish symbols, such as the menorah, on funerary objects and inscriptions, the physical design of the tombs in the Jewish catacombs in Rome is similar to burial chambers, called *kokhim* or 'oven tombs', found in pre- and post-Second Temple Judaea and Galilee, indicating the continuity of Jewish practice in the diaspora. This kind of cultural interaction is a pattern that emerges in many different countries around the world. Jews living in the Diaspora seldom existed in isolation from their host nations, and while these communities frequently maintained their religious distinctiveness, they also played a part in the daily life of the towns, cities and villages in which they lived, influenced by their neighbours and influencing them in turn.

ALEXANDER
DVLMARVSDEMA
CEILOQVIATANNIS
XXXANIMABONOROM
NIORVMAMICVS
DOTWELIOTVAINTER
DICAEIS

11 MEMORIAL TO A SAUSAGE SELLER

ROME, ITALY, 400–500

'Man comes from dust and to dust returns ...
Like a puff of wind, like vanishing dust
Like a dream that flies away.'
Anon, Piyut

B Y THE MIDDLE of the fourth century CE, life throughout the Roman empire was becoming harder for Jews. This was true even in Rome itself, where this striking circular funeral plaque was made. It comes, like the gold-glass fragment in Chapter 10, from one of six known Jewish catacombs in ancient Rome, in this case the Vigna Randanini catacomb on the Via Appia. Dating back to the second century CE, and in continual use for the next two to three hundred years, the Vigna Randanini catacomb originally lay about two km outside the city walls. It consisted of a huge labyrinth of underground tunnels, extending over 18,000 square metres at depths of 5 to 16 metres. Of all the Jewish burial sites in Rome, Randanini surely has the most chequered and eventful history.

Officially discovered in 1859 beneath a vineyard owned by the Randanini family (hence its name), the tombs had been repeatedly pillaged even before the nineteenth century. They continued to be so afterwards by the Randanini themselves, who at one point set up a small shop on the site, advertising tours of the cemetery and flogging Jewish antiquities to foreign tourists and collectors. Initially designated a 'profane' site, i.e. not Christian, the Randanini cemetery, conveniently for its owners, fell outside the remit of the Roman authorities. For the next 50 years excavations were carried out without proper regulation, with many precious artefacts destroyed in the process or sold before they could be catalogued. In 1870 a lawsuit was filed by the Papal State against the Randanini family for illegally selling off Jewish artefacts. They retaliated by applying for compensation for the costs of excavating and maintaining the catacombs. A few years later, in 1867, the

*c.*500 Battle of Mons Badon. Anglo-Saxon advance halted by Britons.

Baptism of Frankish King Clovis, with 3000 of his soldiers

The Cerne Giant cut in turf in Dorset

Randanini family tried to put the whole site up for sale. One interested buyer was the Jewish banker, Baron James de Rothschild, who offered 60,000 scudi, but died in 1868 before the sale was secured.[60]

Even before the Vigna Randanini catacomb was officially 'discovered' and began to attract international attention, the graves were yielding precious finds. Excavations from 1859 onwards gradually revealed more and more of its treasures. Jewish Romans of all social standings were buried here, some in family *cubicula*, others in *kokhim*, or 'oven tombs', stacked one above another and used for multiple burials. Hundreds of epitaphs were found, many bearing an image of the menorah. Wealthier individuals were buried in grand marble sarcophagi, the walls of their *cubicula* decorated with faux marble panelling, floral borders and exquisite depictions of flowers, animals and birds. Much was doubtless lost or stolen in the course of careless and piecemeal excavations, but still-bright frescoes of peacocks, dolphins, horses, rams and cockerels continue to adorn the walls and arched ceilings in places. There are also paintings of human figures related to non-Jewish worship, suggesting the site might have originally been pagan before it became a place for Jewish burials. Funeral inscriptions in Greek, Latin and Hebrew reveal the names, jobs and status of the dead. Different parts of the catacomb were reached by stairways from ground level, and

Human figures suggest the site might have been pagan before it became a place for Jewish burials

were also linked underground by internal stairways and galleries. A building at the entrance to the catacombs may originally have been a synagogue, with separate areas for men and women and a black and white mosaic floor.

This particular plaque, like the gold-glass fragment, commemorates a Roman Jew, who lived in Rome itself in the fifth century CE. The plaque is made from marble veneer, probably recycled from an abandoned building, and it would originally have been painted red. One of eight Jewish memorial plaques purchased by the Victorian collector Charles Wilshire, who brought it to England in the nineteenth century, it provides a vivid glimpse of the vitality of Jewish life in late-antique Rome, and is evidence of the interaction of cultures and social groups present in Roman society at the time.

The inscription on the plaque is in Latin, and it is dedicated to a man with a Greek name, Alexander. The menorah beneath the inscription leaves us in no doubt that Alexander, despite his Greek name, was a Jew. The Latin inscription reads:

Alexander, sausage-maker/butcher from the market, who lived thirty years. Good soul, friend of all. You sleep among the just.

The Latin word for sausage-maker, *butularius*, is difficult to read as the letters were crudely cut. Rather than *butularius*, some

c.500 Mayans begin to use cocoa in drinks

Babylonian Talmud completed

Beginning of the Masoretic standardisation of the Hebrew Bible

Ostrogoth King Theodoric the Great gives Jews freedom to worship in Italy

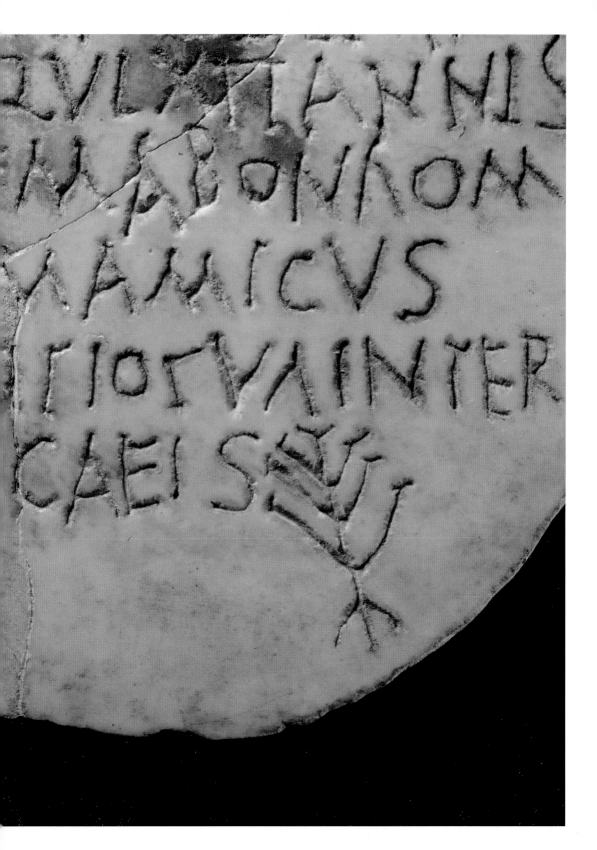

scholars have translated it as *bubularius*, a beef butcher, others as *bucularius*, a cowherd, and yet others as *bublarius*, a large-scale dealer in cattle or high-class butcher. Dr Susan Weingarten, historian of Jewish food at Tel Aviv University, makes the case that by the fourth century CE the word *butularius* may have come to refer to makers of high-quality sausages. In any case, it derives from the words for bull or ox in Latin, indicating that Alexander was almost certainly involved in making or selling some kind of beef products (rather than pork or lamb). Jewish butchers at that time would have sold kosher and non-kosher meat, catering for both Jewish and gentile customers. The market where Alexander worked was similarly for everyone; it was probably either the Macellum Liviae, near the church of Santa Maria Maggiore, or the Macellum Magnum, a large indoor market on the Caelian Hill in Rome, built by the Emperor Nero in 59 CE. Most funeral plaques from this period were made of grey stone and were square or rectangular in shape. But, as Susan Weingarten has pointed out, 'Alexander's epitaph is inscribed on a round piece of pink marble, looking for all the world like a slice of sausage'. A final Jewish joke, perhaps, from Alexander's friends or family.

Of the eight Jewish memorial plaques in the Ashmolean's Wilshire Collection, all except Alexander's are in Greek. Seven of the eight are decorated with Jewish symbols, including menorahs with curved and straight branches, lulav and etrog which also marks them out as unusual because although

hundreds of Jewish funerary texts have survived from Rome the majority do not contain symbols. Those with symbols appear to have belonged to individuals who held positions of importance within the community, or who were members of their immediate family. The Latin inscription on Alexander's plaque suggests he may have been relatively wealthy, and the use of his name and the symbol of the menorah raises the further possibility that he may have performed some kind of official role in the community, perhaps as a trusted supplier of kosher (ritually pure) meat. Like the Passover Potsherd (see Chapter 7) the inscriptions on the Vigna Randanini plaques, while brief, are also warm and personal. An epitaph on one reads 'Justus the secretary [of the synagogue], father-loving and brother/sister-loving. Maron, archon for the second time, for his beloved child, aged 37 years.' Another reads 'For her dearest mother Melition, Dulcitia her daughter set [this] up. She lived 29 years.' A third, with succinct poignancy, reads 'Venerosa aged 17, and [she lived] with her husband 15 months'. The brief inscription on the tombstone is overshadowed by a picture of a menorah, which fills the plaque from top to bottom, almost as if the husband of Venerosa were lost for words.

The inscription on Alexander's plaque is warm and informal in tone. The phrase 'friend of all' speaks for itself, while 'You sleep among the just' is commonly found on Jewish funeral inscriptions. But 'good soul' is a Latin translation of a Greek phrase, more typically used on Christian tombs. These

c.500 Controversial introduction of hymns into synagogue worship in Palestine

507 Battle of Vouillé. Visigoths defeated by Franks, under the command of Clovis; retreat into Spain

518 The Slavs cross the Danube, towards Moesia and Thracia

c.520 Jewish institutions allowed again in Babylonia

Greek elements on Alexander's memorial plaque might seem odd to us, but they would not have surprised his contemporaries in the least, as Greek was widely spoken and written in many parts of the Roman empire by many different people. This was in part a reflection of Greek influence on Roman culture, but it was also a result of the huge movement of slaves from Greek-speaking regions into the western Roman empire, which occurred during the first century BCE and from the second century CE onwards. Roman Jews, too, were strongly influenced by Greek culture in and before the fourth century CE, and Greek remained their standard daily language until the fifth century. They often had Greek first names and many spoke Greek as their first language, as was usual for everyone in the eastern provinces of the Roman empire. The Jewish funeral plaques from Rome also reveal that by the fourth century CE, while adults still tended to have Greek names, Latin names were becoming increasingly popular for children.

`The word 'synagogue' is itself a Greek word, meaning 'assembly'. Jews not only translated the Hebrew Bible into Greek, known as the Septuagint (or Greek Old Testament), but also used this Greek version themselves in many parts of the eastern Mediterranean. The fact that the Latin lettering on Alexander's plaque is clumsily cut and uses

By the time Alexander's funeral plaque was made, Christianity was spreading rapidly throughout the Roman empire

Greek expressions may reflect that Jews in fourth-century Rome were a tight-knit community and slower than other immigrant populations to take up Latin. The engraver who immortalised Alexander was, like many artisans in Rome, probably far more familiar with Greek than Latin.

Around the same time as Alexander the sausage seller was plying his trade in Rome, rabbis in the religious academies in Tiberias and Caesarea in Palaestina (now in Israel) were putting the finishing touches to what would become one of the most important Jewish texts ever created: the Palestinian Talmud, also known as the Jerusalem Talmud or the Talmud of the Land of Israel. Completed in around 390 CE, the Palestinian Talmud, along with its slightly later counterpart, the Babylonian Talmud, completed in 520 CE, bring together hundreds of years of early scholarly debate and argument about the meaning and application of biblical and other sacred Hebrew texts. Over the centuries both versions of the Talmud have had an enormous influence on Jewish life, defining what it means to be Jewish in theory and in practice. The Babylonian Talmud is more extensive and often 'improves' on material known in an earlier form in the Palestinian-Talmud, and ultimately it would become the more influential of the two. The core of both is the *Mishnah*, compiled at the beginning of

the third century CE by Judah ha-Nasi, which gathers together the teachings of Jewish sages in Palestine. Transmitted orally for centuries before being finally redacted, both versions of the Talmud consist of commentaries on the *Mishnah*, and record the debates that took place in the Jewish schools of learning in Palestine and Babylon between the first and fifth centuries CE. They take the form of discussion, questions and argument on issues of *halacha* (Jewish law derived from biblical commandments), and how it is then to be applied in specific contexts. They also draw on parables, proverbs and anecdotes, known as *aggadah* (from the Hebrew root for the word 'to tell'). Elements of the Palestinian Talmud made their way into the liturgy of Italian Jews and are still used today by a few Italian Jewish communities, a unique and enduring link with the rabbinic sages of ancient Judaea.

By the time Alexander's funeral plaque was made, Christianity was spreading rapidly throughout the Roman empire. The Romans under Julius Caesar had declared Judaism a *religio licita*, a permitted religion, and by and large, as long as they did not challenge Roman rule, the Jews were left in peace, both in life and in death. But this religious eco-balance was about to undergo profound changes. In 312 CE Emperor Constantine legalised Christianity and began to promote its development, an event that would gradually but decisively change the course of the entire Western world. At first Constantine advocated religious tolerance for all. 'We resolved to grant both to the Christians and to all men freedom to follow the religion which they choose,' declared the Edict of Milan in 313 CE. But as time passed Constantine introduced measures which promoted the distinctive status of Christianity. He played a key part in moving the Sabbath from Saturday to Sunday, and in 325 CE the Council of Nicaea decreed that Easter should not be celebrated on the same date as Passover. These two decrees alone consolidated a clear distinction between Christian and Jewish practice, which had been an issue for the past two centuries. They would also have serious implications for the Jews in centuries to come.

Christianity began as a Jewish sect. During and immediately after the time of Jesus many early Christians still regarded themselves as Jews and followed Jewish religious practices. Jesus himself had explicitly not rejected Judaism, but sought to reform it. For several hundred years after his death there was considerable overlap between Jewish practice and the practices of some Christians. While there were Christians who distinguished themselves very clearly from Jews by the first century CE, for many early Christians it was not a contradiction to follow Jewish rituals and festivals and keep Jewish dietary laws, while at the same time believing Jesus to have been the Messiah. This view

> *During and immediately after the time of Jesus many early Christians still regarded themselves as Jews*

527 Justinian founds
St Catherine's monastery
in Sinai

Justinian closes schools
of Athens, ending pagan
philosophy

529–34 'Code of Civil Law'
published by Justinian I

c.530 St Benedictine
founds monastery at
Monte Cassino

of Christianity changed dramatically over time. John the Evangelist, a Jewish convert to Christianity in the first century CE, vehemently insisted that Judaism and Christianity were distinct religions: to be Jewish was wholly incompatible with being a Christian. For John a choice had to be made and there was no middle way. His teachings, which were deeply influential, present Judaism and the Jews as dangerous, repugnant and immoral.

As Christianity spread, so did outbreaks of hostility towards the Jews, some of whom chose to convert to Christianity as a result. Over time, antipathy towards the Jews became increasingly focused on Judaism itself. Jewish communities increasingly found themselves prey to forms of discrimination that were inescapably attached to the fundamental fact of their existence, their way of life, their spiritual world view and their religious practices, no matter where or how they lived.

In 388 CE Christianity became the authorised state religion, and by the century's close, within the space of just 100 years, Christianity had replaced paganism as the official religion of the Roman empire. While the Roman state allowed Jewish communities to continue and protected their right to have synagogues, Christian emperors also employed violent rhetoric against Judaism (as well as paganism). A number of anti-Jewish decrees were issued, including bans on Jewish people marrying non-Jews, converting Christians and owning Christian slaves. In the fifth century CE Jews were excluded from the Imperial service, and the construction of new synagogues was forbidden at around the same time. In reality, construction of synagogues continued throughout the fifth to seventh centuries, not least in Palestine, but although the Emperors issued laws prohibiting attacks on synagogues, such attacks did occur.

The following centuries saw sporadic local outbreaks of hostility towards Jews, including forced conversions, and at various times there were bans on schools of Jewish learning, circumcision, kosher food and the observance of the Jewish Sabbath. Whereas Jews in the diaspora had originally gravitated towards urban centres, the emergence of rural Jewish communities at this time may reflect an increasing need to find more remote places where it was easier to live and worship in peace.

The memorial plaque for Alexander the sausage seller raises many questions. Was Alexander a Greek-speaking Jew who arrived in Rome in the fourth-century. Or was he from a long-standing Roman Jewish family, the descendant perhaps of Judaean captives? Does the combination of Latin, Greek and Jewish elements on a single plaque reflect the relaxed interaction of cultures in Rome at this time, or a growing anxiety about being Jewish, a desire to be all things to all people, to please all possible masters? Whatever the answer, Alexander seems to have lived and died in relative peace, a 'friend to all'. The Jewish community in Rome would manage to survive periods of great hardship over the centuries, and is today the oldest continuous Jewish community in Europe.

First Celtic monastery founded by St Finnian at Clonard

537 Santa Sophia completed, first Christian cathedral in Roman empire

538 Buddhism reaches Japan

c.543 Dongola (present-day Sudan) converts to Christianity

12 MAGIC BOWL יב

KISH, MESOPOTAMIA (NOW S. IRAQ), c.500

*'They are more numerous than humans, each person has
a thousand on his left and ten thousand on his right.'*
Babylonian Talmud on Demons, Berakhot

WHILE ROMAN EUROPE was becoming less hospitable for Jewish people, those who had made their homes further to the east in non-Christian regions were for the most part tolerated and accepted. By 500 CE, when this ceramic bowl was made, Jewish communities were well established throughout the Persian empire and Arabia in numerous different tribes and clans. The bowl belonged to a family of Babylonian Jews. It was found during excavations in southern Iraq between 1923 and 1933 conducted by a team of archaeologists from Chicago and Oxford University, at the site of the ancient city of Kish (Tell Barguthiat), situated 80 km south of Baghdad and 12 km east of Babylon, 1500 years after its owners had carefully buried it under their earthen floor. Despite appearances, the bowl had nothing to do with food. Instead it was designed to ward off evil spirits, and the black writing that coils around its inner surface is a spell.

Earthenware bowls with Aramaic script, such as this one, were made and used for magical purposes throughout Mesopotamia and some parts of what is now Western Iran between the 4th century BCE and 7th century CE. Common in both Jewish and non-Jewish homes, they were built into the walls, embedded under doorways and windowsills or buried beneath the threshold of the house. The bowls were always buried upside down, probably with the aim of trapping malevolent spirits on their way into homes and burial places, functioning rather like a supernatural mousetrap. One bowl was sometimes set inside another, perhaps for added potency. The spells covering the bowls generally plead for protection and healing for

542–95 Bubonic Plague throughout Europe, Asia, Africa ('Justinian's Plague')

597 Augustine arrives in Kent. Christianisation of Anglo-Saxon England begins

614 Jews assist Persian invasion of Palestine and regain Jerusalem

622 The prophet Muhammad founds Islam in Arabia

members of the household, although some spells seek to harm or inflict pain on others. The text on a similar bowl to this one, for example, asks for protection:

> … from demons, from devils, from bands of spirits, from satans, from curses, from liliths, and from monsters … frustrate and ban all familiars, counter-charms, necklace-charms, curses, invocations, knockings, rites, words … and everything bad, that they may depart and go away.

Magic, demonology and exorcism (the power to banish evil spirits) had deep roots in Jewish culture, as in all other cultures of the Ancient Near East. The fact that Jewish magic bowls also contain references to non-Jewish gods and features from other religions reminds us that their owners were people of their age and influenced by the wider culture of which they were a part. Demons were thought by the ancient Jews to be the offspring of cross-breeding between the sons of God and the daughters of men (Genesis 6:1–14), or else to be the ghosts of evil people. Over the centuries the Jews developed myriad complex spells and rituals for dealing with these troublesome spirits. Magic bowls were also used to ask for help with specific medical conditions, for example to protect women in childbirth or to act as love charms. As well as spells, the texts on magic bowls often included short magical

The Hebrew Bible does not discriminate between the sexes when it comes to verbal dexterity

stories, bits of lost Jewish lore, fragments of talmudic wisdom, and quotations from the Hebrew Bible and other sources.

The bowls were commercially produced by professionals and then sold to customers. The text was written in ink and applied with a fine brush, starting at the inside centre of the bowl and spiralling upwards in concentric rings to its outer rim, or else written in straight lines, like the rays of the sun. The writing in most magic bowls is in Aramaic, which then existed in several regional forms across the whole of the Near East. Jewish magic bowls, like this one, use Judeo-Aramaic (Aramaic written in the Hebrew alphabet), while bowls belonging to Christians and pagans used Mandaic and Syriac respectively. A small number of bowls used Pahlavi, an early version of Persian.

Jews had been living in Babylon (now in southern Iraq) for over a thousand years by the time this bowl was made. One of the most famous, if almost certainly fictional, of these early Babylonian Jews was Esther, queen of the Persian king Ahasuerus (probably Xerxes 1) and eponymous heroine of the Book of Esther (*Megillat Esther*) in the Hebrew Bible. Raised in Babylon with the Jewish exiles from Judah, she lived with her cousin Mordecai, one of the king's chief advisors, before being taken into the king's harem. At great personal risk and with considerable courage, Esther played a central role in defeating a plot to kill the Jews of Persia.

638 Islamic conquest of Jerusalem. Jews banned from Visigoth Spain

663 Synod of Whitby – Roman Christianity triumphs in England

691 Dome of the Rock built on Temple Mount site in Jerusalem

709–18 Arabian conquest of Spain

717–20 Caliph Omar II imposes rules on *dhimmis* (Jews and Christians)

'If I must die, so be it,' she declares before going unannounced and uninvited to make her appeal to the king. There is no historical evidence for the events described in the Book of Esther, but examples of tableware used at this time for the typically lavish Persian banquets can be seen in the Ashmolean's Ancient Near East Gallery.

The story of Queen Esther's victory is still celebrated today in the annual Jewish festival of Purim, and the history of the Book of Esther's establishment in Jewish tradition is noteworthy. It was first translated into Greek in around 78 BCE, shortly before the Hasmonean queen, Shelamzion Alexandra, came to the throne in Judaea (see Chapter 2). A delegation of Jerusalem Jews appears to have taken this Greek translation of the story to Egypt and asked the Jews of Alexandria to begin celebrating the festival of Purim, evidence of the close connections between Jews living in the diaspora and those in Judaea.[61] The timing of this visit could not have been more fortunate. Dr Tal Ilan, Professor of Jewish Studies at the Freie University, Berlin, has proposed that 'the decision to promote

The Jews of Babylon

Babylon played an important role in the Jewish journey for many centuries, with Jewish life in the geographical region that we now know as Iraq, lasting from the sixth century BCE up to the present day. A significant proportion of the Jewish population of Judah was first forcibly deported to Babylon between 597 and 581 BCE by the Babylonians. When the Persians conquered the Babylonians in 539 BCE, Cyrus the Great granted the Jews permission to return to Judah, but many instead chose to remain in Babylon. Their numbers swelled after the destruction of Jerusalem in 70 CE, and again after the collapse of the Bar Kokhba Revolt in 135 CE, when many Jewish refugees fled to Babylon.

During the intermittent wars between Persia and Rome in the centuries that followed, Babylonian Jews sided with the Persians, helping to ensure that the Romans did not succeed in conquering Babylon. During the reign of the Sassanid dynasty (224–651 CE) the Jewish population grew considerably. At the peak of the Persian empire it may have been as much as 20 per cent of the total population. Jewish beliefs were diverse and, with the spread of monotheism, conversions to Judaism and intermarriage were far from uncommon. Many Babylonian ideas related to mathematics, astronomy, philosophy and medicine, in turn, permeated Jewish culture. The modern Hebrew names of the month, to take just one example, derive from those used in ancient Babylon.

There were large Jewish communities in both Iran and Iraq right up until the mid-twentieth century. Even today many cities in modern Iran and Iraq, both once part of the ancient Persian empire, have sites related to Judaism. Tombs of a number of outstanding ancient Jewish scholars have also survived, notably that of Moshe Halevi in present-day Kashan in Iran.

the book of Esther could well be associated with the coronation of Shelamzion Alexandria … [as] part of a larger literary campaign designed to promote the leadership of women through dialogue with other contemporary points of view … which were hostile to the idea of women in power.'[62]

Like the Hasmonean queen, Esther deployed her skills of diplomacy and negotiation to achieve peace with foreign powers. In this respect, she resembles many of the other great women in the Hebrew Bible, which does not discriminate between the sexes when it comes to verbal dexterity, as has been pointed out by biblical scholar Tikva Frymer-Kensky: '[T]here is no "woman-speech" in the Bible: the form of women's argumentation, the nature of their logic and rhetoric are the same as men's … Both men and women can talk, argue, flatter, convince, and persuade.'[63]

Babylonian Jews saw themselves as the children of Abraham, who had come from Mesopotomia, and Babylon remained a major centre for Jewish life before and for centuries after the destruction of the First Temple, developing a culture that was largely free from the influences of the Greeks and Romans. Queen Esther was herself cast in the image of Deborah, the bold Biblical prophetess. To the present day, Persian Jews are still sometimes referred to as 'Esther's Children', and as a story that celebrates a young woman defeating the foreign enemies of her people against considerable odds, the Book of Esther has enjoyed an understandable degree of popularity down the centuries, with Jews and non-Jews alike. A painting of *Esther and Mordecai* by the seventeenth-century Dutch artist Aert de Gelder, one of Rembrandt's last pupils, can be seen in the Ashmolean's Art of the Netherlands Gallery.

Under Persian rule, Jewish life in Babylon flourished for several centuries, and from the early third century CE Babylonian Jews enjoyed a reputation for outstanding scholarship, with rabbinic centres developing in Babylon in parallel with those in Palestine. The single most important contribution to come from Persian Jewry was the Babylonian Talmud (also known as the Talmud Bavli), completed in around 520 CE, which spread throughout the Jewish diaspora in following centuries as the authoritative text on Judaic law. With detailed discussions on everything from how to draw up a business contract to how many times a week a wife could expect her husband to make love to her, the Talmud would have an immeasurably profound and wide-ranging influence on how Jewish people all over the world went about their daily lives.

But as this magic bowl reminds us, rabbis and scholars were not the only influence on Jews living in the Persian empire. Belief in the supernatural was equally part of the

> *As this magic bowl reminds us, rabbis and scholars were not the only influence on Jews living in the Persian empire*

rich texture of Jewish life, and bowls such as this provide a wonderful insight into the language, ideas, fears and desires of ordinary Jews at this time. Magic, then as now, was a cross-cultural currency, which the Jews adapted to suit their own particular needs.

This particular magic bowl has an additional story to tell because the inscription is not quite what it seems. The text covering the bowl appears to be an Aramaic incantation written in Hebrew letters, but is in fact pure gobbledygook. This may well have been intentional: speaking a magical language that could only be understood by supernatural beings was an established part of the magician's trade in the ancient world, much as words such as 'abracadabra' use familiar letters without holding a precise meaning, as Daniel Levene of Southampton University explains: 'This bowl has what we would call a pseudo-text. Various combinations of not very well written alphabetic characters are repeated throughout. It is, in a sense, a fake, but it was still intended to function as an incantation bowl in just the same way as one with a proper text on it was intended to function. Such bowls were not uncommon. What it means is that the scribe was possibly not entirely literate, if at all, but he would still have been able to impress the client sufficiently to believe that this was an effective amulet. We might even consider that the scribe, though not literate, nevertheless had a reputation of being an effective practitioner.' But it is also possible that whoever made this bowl was simply a charlatan, happy to pass himself off as a genuine scribe and cover the bowl in plausible-looking gibberish, take his fee and scarper, leaving his illiterate customer none the wiser. Crooks and scams were almost certainly as much a part of life in the fifth century CE as they are today.

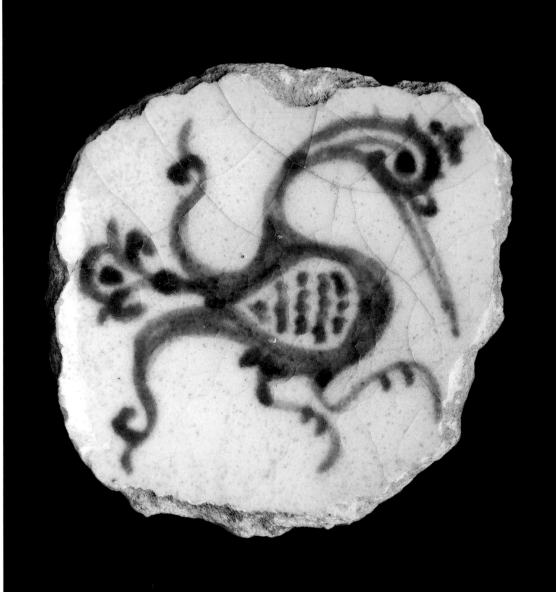

13 EGYPTIAN PLATE FRAGMENTS ג׳

FUSTAT (NOW CAIRO), EGYPT, c.1150

'Time was like clay in my hands, and the
Zodiac turned like a potter's wheel.'
Judah Halevi, *The Pure Lover*

'PLEASE BUY ME six painted platters, made in Misr' [Fustat]; they should be of middle size ... and twenty regular bowls and forty small ones. All should be painted, and the colours should be different.' This request was made in the early twelfth century in a letter sent from Aden in Yemen to Fustat, then the capital of Egypt. The recipient of the letter was a Jewish resident of Fustat, possibly a merchant or a producer of ceramics in the city's booming ceramics industry. These little plate fragments, decorated with delightfully animated images of birds and fish, are typical of what he might have sent back to his correspondent in Aden. International shipping was not a problem. Trade routes over sea and land linked communities and countries over hundreds of miles from North Africa to Arabia, India and the Far East. Egypt sat at a vital intersection on most of these trade routes, and Egyptian Jews played a crucial part in the business they enabled. Flourishing trade was both a means of making a living for many Jews and the social network of the day – an essential way of staying in touch with friends, family and business contacts in other countries.

Food and recipes travelled along these trade routes as well as bowls and plates. Jewish recipes recorded in manuscripts from twelfth-century Egypt were often identical to those used by Jewish communities in Damascus, Baghdad and Aleppo. Yet while Jewish cuisine was distinctively Jewish in many ways, it also incorporated local food customs. Egyptian Jews ate like the local population but gave the recipes a Jewish twist, as food historian Claudia Roden explains: 'The olive oil dressing that is now common in Egypt for the broad bean recipe Ful Medemmes is likely to have come originally

from Spanish Jews in the Middle Ages. Muslims at this time tended to cook with clarified butter and sheep's tail fat, and Christians with pork fat, whereas cooking with olive oil was associated with the Jews of Spain. During the Inquisition in Spain, the Inquisitors could smell from the street what everyone was cooking with and even Christians were afraid to use olive oil for fear of being taken for marranos (secret Jews).'[64]

Fustat had been the capital city of Egypt since the Arab conquest in the seventh century CE. By the twelfth century, when these plates were made, it was one of the wealthiest cities in the world, renowned for its prosperity, with shaded streets, beautiful gardens and busy markets. A major production centre for art and ceramics, Fustat was also a thriving early centre for the manufacture of paper, which replaced papyri and parchment in Egypt several centuries before it became widespread in Europe. Visitors to the city described houses rising up to fourteen storeys in height, topped with gorgeous roof gardens

Jews in Egypt

Egypt played a vital part in the Jewish journey from its very beginnings. According to the Hebrew Bible, Jacob, the grandson of Abraham, settled in Egypt with his family during a period of famine in Canaan, and his descendants continued to live there, first by choice and then as slaves, for the next 400 years, referred to collectively as the Children of Israel. The Merneptah Stele (c.1208 BCE) provides extra-biblical evidence for an Israelite presence in Egypt, at least by the end of the Bronze Age. Commissioned by the Egyptian King Merneptah to celebrate his victories in Libya, the stele also contains a reference to 'Israel'

and 'Canaan', then part of Egyptian territory: 'The Canaan has been plundered into every sort of woe: Ashkelon has been overcome; Gezer has been captured; Yano'am is made non-existent. Israel is laid waste and his seed is not'.

After the destruction of the Kingdom of Judah by the Babylonians in 597 BCE many Jews took refuge in Egypt, and never left. From as early as the third century BCE there was a widespread diaspora of Jews in many Egyptian towns and cities. In 332 BCE Alexander the Great invaded Egypt and it became part of the Greek empire. He built a new city, Alexandria, on the Mediterranean coast, which would remain Egypt's capital

for nearly a thousand years. Jews were an integral part of Alexandria's history from the outset and formed a sizeable portion of the city's population. Alexander's successor, Ptolemy I (ruler of Egypt from 323–283 BCE) took an estimated 120,000 Jewish captives to Egypt from the areas of Judaea, Jerusalem, Samaria and Mount Gerizim, and further waves of Jewish immigrants settled in Egypt of their own accord. The Ptolemaic dynasty ruled Egypt for the next three centuries, transforming it into a Hellenistic kingdom with Alexandria as its capital. Under the Ptolemies, Alexandrian Jews in particular enjoyed many privileges and considerable political independence.

complete with ox-drawn water wheels for irrigation. Fustat's markets were especially famous. The Persian traveller Nasir Khusrow wrote of the exotic and beautiful wares you could buy there: iridescent pottery, perfume, gemstones, fabric, crystal, spices and abundant fruits and flowers, even during the winter months. The great medieval traveller Benjamin of Tudela (1130–73), dubbed the Jewish Marco Polo, who visited Egypt in around 1165 as part of his epic, thirteen-year journey through Europe, Asia and Africa,

also remarked on the amazing array of plants in the Fustat markets, which came from all over the world, 'especially from the East and are used for coloring cloth, preserving food, curing illness, stimulating virility or decorating one's body'.

The three Jewish communities in medieval Fustat – Babylonian, Palestinian and Karaite – were fully part of this flourishing medieval city. Fustat Jews were not segregated in ghettos, as they would increasingly be throughout Europe in coming centuries, but lived

In the first century CE Egypt came under Roman rule. During the Jewish Revolt of 115–17 CE, which spread throughout the eastern territories of the Roman empire, many Jewish communities, including that of Alexandria, were completely destroyed. The Jewish population slowly recovered, and by the time the Arabs conquered the country in the seventh century there were 40,000 Jews living in Alexandria alone. Although there were restrictions on many aspects of Jewish life in the Arab world, these were often ignored or loosely interpreted. Jews were second-class citizens, but for long stretches

of time they were tolerated and in places flourished. The interaction of Jews and Arabs in Iraq and Spain in the Middle Ages enormously enriched the intellectual and social cultures of both countries. In Egypt Arab rule was also generally favourable to the Jews.

A large Jewish community survived in Egypt right up until the 1950s. Hostility to the Jews, as elsewhere in North Africa and the Middle East, increased dramatically during the 1930s and 1940s, in part related to the struggle for, and eventual creation of, the Jewish state of Israel. Around 800,000 Jews living in Arab countries when the State of Israel was declared in 1948

were forcibly expelled from those countries or chose to leave to escape escalating anti-Semitism. Around the same number of Arabs who were living in what had before then been British-ruled Palestine were similarly forced from or fled their homes. In 1956 the Egyptian government modified its laws in order to prevent Jews and other minorities from becoming Egyptian citizens. Hundreds of Egyptian Jews had their property confiscated and were expelled from the country. This led finally to the mass migration of Jews, who have now almost vanished from Egypt, a sad end to a long and vibrant Jewish presence in the country.

Eugenius III calls for second Crusade, after Edessa falls

c.1150 Construction starts on the temple of Angkor Wat in Cambodia

1163 Cornerstone of Notre Dame Cathedral laid in Paris

c.1170 *The Mystery of Adam*, the first mystery play, takes place in France

Thomas Becket murdered on 29 December in Canterbury Cathedral

alongside their Muslim and Christian neighbours. A literate, educated community, they enjoyed parties, poetry recitals, fine clothes, visits to the bath-houses and shopping in the bazaars. They worked in a wide range of trades and professions, often in partnership with Muslims. Jewish women, too, were often active outside the home, employed as teachers, scholars, weavers, embroiderers and stall-holders in the local markets. One was a fully-fledged banker.

A cultural and intellectual hub of the Arab world for five centuries, Fustat was a natural magnet for many Jews, one of whom, as mentioned earlier, was Benjamin of Tudela (1130–73), who visited over 300 Egyptian cities in all, describing them in his book *Travels of Benjamin (Masa'ot Binyamin)*, also known as *The Book of Travels (Sefer ha-Masa'ot)*. Tudela recorded Jewish life in Egypt in immense detail, documenting the Jews' customs, numbers, names, economic conditions and occupations, providing plentiful evidence for the significant Jewish population established in the country by the twelfth century.

Another famous Jewish visitor to Fustat was Judah Halevi, the renowned Spanish physician, poet and philosopher. The greatest of all the medieval Hebrew poets, Halevi wrote love poems, drinking songs, elegies and religious poetry. Born in Tudela in Spain, he had lived most of his life in Toledo and Cordoba, but was now on his way 'home' to the Holy Land, where he wished to die. Palestine at that time was in the grip of Christian Crusaders who were inclined to massacre any

Jews they encountered, so Halevi broke his journey in Egypt. Arriving in Alexandria on 8 September 1140, he was greeted enthusiastically by friends and admirers. Two months later he travelled on to Fustat, where he celebrated the Jewish festival of Hanukkah and wrote one of his last known poems, an elegy for himself and a love song to the beauty of the country and its young women:

> Wondrous is this land to see,
> With perfume its meadows laden,
> But more fair than all to me
> Is yon slender, gentle maiden.
> Ah, Time's swift flight I fain would stay,
> Forgetting that my locks are grey.

In May the following year, when the Mediterranean trade routes once again became navigable, Halevi boarded a ship bound for Acre in Palestine. The ship sat in the harbour for a week, then at last set sail, but what happened to Halevi is unknown. According to legend, he was knocked down and killed by an Arab horseman soon after reaching Jerusalem.

Twenty years later Moses Maimonides, one of the most important Jewish scholars of all time, settled in Fustat. Born in 1135 in Cordoba, Spain, Maimonides left with his family soon after the city was conquered by the Almohads in 1148, when both Jews and Christians faced forced conversion to Islam, death or exile. Maimonides (*Moshe ben Maimon* in Hebrew; also known by the acronym *Rambam)* first settled in Fez in Morocco, before moving permanently to Fustat in

1178 Maimonides writes *Mishneh Torah*

1185 First record of windmills

1187 Saladin recaptures Jerusalem

1190 York Massacre of Jews

1204 First synagogue in Vienna

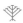

around 1168. It was here that he wrote two of his greatest works, the *Mishneh Torah* and *The Guide for the Perplexed*. The *Mishneh Torah* (completed in 1180) was an ambitious compendium of Talmudic law, in which Maimonides attempted to bring together all the rules about Jewish life. Written in beautifully clear and precise Hebrew prose, the work was intended as a practical and ethical handbook for Jewish daily life, both a response and a solution to the challenges of life in the Jewish Diaspora. The *Mishneh Torah* had a huge impact at the time and remains an enormously influential text for religious Jews to this day.

A phenomenally productive and brilliant man, Maimonides squeezed writing this and many other works around his daily workload as Rabbi of the Ben Ezra Synagogue in Fustat and, from 1171, the *Nagid*, or leader, of the entire Egyptian Jewish community. A skilled doctor, he was also court physician to Sultan Saladin and the royal family, as well as the author of numerous important medical treatises which would be studied by physicians for centuries.

Maimonides was not above complaining about the ceaseless demands on his time; he routinely got by on just three or four hours of sleep, rising at five in the morning and rarely going to bed until well past midnight. He died in Fustat on 12 December 1204. In accordance with his wishes, his remains were exhumed and taken to Tiberias in Palestine, where he was re-interred.

By the twelfth century, Fustat was one of the wealthiest cities in the world, renowned for its shaded streets, beautiful gardens and busy markets

Fustat itself fell into decline from the thirteenth to the sixteenth centuries. Although thousands of people continued to live there, the city gradually became a poor suburb and all-purpose rubbish tip for Cairo, the new capital of Egypt. But Fustat's demise would turn out to be history's gain. Layers of rubbish, accumulated over hundreds of years, acted as a protective blanket, miraculously preserving the remains of the ancient city. In the late nineteenth century its hidden treasures began to re-emerge, the most extraordinary and precious of which was the Cairo Geniza.

Described by historian Simon Schama as 'not just the richest and most remarkable of Jewish source collections; it may well be … the greatest of all medieval archives',[65] the Geniza was originally the storeroom of the great Ben Ezra Synagogue in Fustat, built in the ninth century CE. Rabbinic law dictated that texts bearing the sacred name for God could not be destroyed, and generally a *geniza* (from the Hebrew root meaning 'to store' or 'to hide') was a depository for damaged or discarded religious scrolls, prayer books and other texts awaiting proper burial. At the Ben Ezra Synagogue it became more than that: not just a religious storeroom, but a massive attic warehouse for a vast array of unwanted documents, religious and secular,

spanning 400 years from the tenth to the fourteenth centuries.

The true significance of the Geniza first became apparent in 1896 when twin sisters Agnes Lewis and Margaret Gibson decided to visit Fustat in Old Cairo. The sisters, known collectively as the 'Giblews', were passionate travellers and self-taught classical scholars, and were well-versed in Hebrew, Greek, Persian and Syriac, not to mention some five other languages. Agnes had authored three travel books and three novels and translated a Greek guide book by the time she was 50, and in 1892 had discovered a rare early Syriac version of the New Testament at St Catherine's Monastery in Sinai.[66] In the spring of 1896 the sisters made a trip to Palestine and then Egypt, where they bought a bundle of documents from a Cairo dealer.

On their return to England they asked their friend Solomon Schechter, a leading scholar of Talmudic and rabbinic literature at the University of Cambridge, if he could help to identify some of the fragments. Schechter quickly realised that one of the pieces he was looking at was extremely unusual and asked if he might take it away for further examination. In the space of an hour the Giblews received a telegram from Schechter: 'fragment very important; come to me this afternoon.' Schechter had recognised almost immediately that the unprepossessing scrap of paper was a segment from the apocryphal book of Ecclesiasticus (known to Jews as the *Wisdom of Ben Sira*), previously only found in Greek and thought to have been read only by Christians

in the Middle Ages. The fragment now before Schechter's own eyes was in the original Hebrew, and as such absolutely unique in the world, while the text from which it came had been read, self-evidently, by medieval Jews.

In 1897, within a few months of this discovery, Solomon Schechter was on his way to Cairo to inspect the Geniza's contents for himself. What he found went beyond even his wildest dreams, and from that moment on it became Schechter's life mission to collect and preserve the Geniza's contents for scholarship and posterity. 'The work is not for one man and not for one generation,' he wrote in a letter home from Egypt. 'It will occupy many a specialist, and much longer than a lifetime.'[67] For several weeks Schechter worked flat out, sifting through the hundreds of thousands of fragments in a windowless, doorless room, accessed only by ladder and 'nearly suffocated and blinded' by the dust, despite keeping his nose and mouth covered with gauze. With permission from the Chief Rabbi of the Ben Ezra synagogue to take whatever he liked, Schechter replied that he liked it all. In reality, he was faced with the agonising dilemma of what would have to be left behind. In the end he opted to salvage as many of the handwritten manuscripts as possible, on the grounds that these were likely to be the oldest and rarest items. Schechter returned to Cambridge with 30 sacks of 'rugged, jumbled, dirty stuff' and a huge task ahead of him.[68]

An eccentric and greatly respected figure around Cambridge, Schechter was instantly recognisable with his bushy red beard, wild

1215 Magna Carta

1222 Robert of
Reading burned
in Oxford

1242 Disputation of
Paris. Talmud burned
by decree of Louis IX

1244 Tartars
capture Jerusalem

1250 Foundation
of Mamluk Dynasty
in Egypt

hair and ill-matched socks, revered for his deep erudition and insatiable intellectual curiosity, and much-loved for his generous personality, brilliant conversation and ready humour. On his deathbed in 1915 he asked his wife Mathilde for something to read, insisting, 'I can't just lie down here doing nothing'. His close friend at Cambridge, James Frazer, author of *The Golden Bough*, described him as 'great in his intellect and learning, greater even in the warmth of his affections and his enthusiasm for every high and noble cause'.[69]

Born in a Moldovan village in the Russian empire and raised in the intensely religious world of the eastern European *yeshiva*, Schechter had been a child prodigy who was said to know the Pentateuch by heart by the age of five. Ordained as a rabbi in Vienna, he went on to study in Berlin before arriving in London in 1882 to teach Talmud to a young Claude Montefiore. Still only in his early thirties, Schechter was dismayed by the lack of interest in Jewish learning that he encountered among assimilated English Jews, declaring 'There is no spiritual life here … The manuscripts in the British Museum are my only consolation'.[70] Professional and personal friendships in London and then Cambridge provided further consolation in the years to come, and through his rescue of the Geniza fragments from oblivion and his subsequent tireless work deciphering its contents, Schechter vouchsafed his own

Among these precious finds are rare Talmud fragments, very few of which survived mass burnings of Talmud manuscripts

monumental contribution to Jewish learning. In the words of Dr Theodor Dunkelgrun of St John's College, Cambridge, 'Schechter's name will always, and justly, be associated with the Geniza, but he was much more than a Geniza scholar – he was a polymath who cared passionately for the entirety of the Jewish tradition, mystical and rational, from antiquity to his own time and beyond'.

Some 193,000 manuscript fragments from the Geniza are now in the University Library at Cambridge. A further 5000 items, comprising documents and fragments of exceptional quality (25,000 images in all), are in the safe-keeping of the Bodleian Library in Oxford. Among these incalculably precious finds are rare Talmud fragments (very few of which survived mass burnings of Talmud manuscripts in sixteenth-century Europe), poems in Judah Halevi's own hand and an entire quire of Maimonides's original handwritten manuscript of the *Mishneh Torah*, complete with his late-night corrections and crossings out.

The Geniza also contained a fantastic wealth of social and cultural documents, as César Merchán-Hamann, Hebrew and Judaica Curator at the Bodleian Library explains: 'It's a window that lets you look in fantastic detail at centuries of Jewish life, not just in Egypt but the world in which they lived. There are letters and documents from traders in Yemen, Syria, Palestine, Spain, Italy, France,

*c.*1250–1550 Rabbinic Period. Jewish Law interpreted by scholars for respective communities

1258 Mongolian Siege of Baghdad. End of Islamic Golden Age

1274 Posthumous publication of Thomas Aquinas's *Summa Theologica*

1276 Rudolph von Habsburg rules Austria. Dynasty uninterrupted until 1918

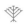

North Africa, Constantinople. We don't have anything else like this, in terms of the extent of areas it covers, the range of documents.'[71]

More than 400,000 documents were recovered in all, an astonishing record of Fustat's vibrant Jewish community. They include hastily scribbled notes, lengthy philosophical tracts, love letters, poems, children's doodles, shopping lists, recipes, magic spells, astrological treatises, ingredients for medicines, school writing exercises, orders for goods, business accounts, tax records, details of dowries and trousseaus, invitations to parties, marriage negotiations, promises of payments to suppliers, disputes over property, arguments over wills, and requests to physicians. The letter requesting the Fustat dinner service was also found in the Geniza. Written in Hebrew, Arabic, Judeo-Arabic and Aramaic, this precious 'rubbish' gives voice across the centuries to the vitality and diversity of Jewish life in Islamic Egypt.

1290 Expulsion of the Jews from England

1291 Acre captured from Crusaders. Mamluks rule Palestine until 1516

1296 First War of Scottish Independence

1299 Osman I establishes Ottoman empire

14 BODLEIAN BOWL T'

COLCHESTER, ENGLAND, *c.1260*

'And steadfastly do we endure
While waiting for the Light.'
Meir of Norwich, *Ode to Light*

JEWISH COMMUNITIES SPREAD rapidly throughout the Mediterranean world from the first century CE, but it was not until the eleventh century CE that Jewish people in any significant number began to cross the Channel and settle in England. This magnificent bronze cauldron, known as the Bodleian Bowl, is intimately bound up with the story of how the Jews first came to England in 1070 and what happened to them during the next two hundred years before they were abruptly expelled from the country in 1290.

The Bodleian Bowl was discovered at the end of the seventeenth century in a disused moat in Norfolk, almost three hundred years after the expulsion of the Jews, and for a long time to come remained shrouded in mystery. Who first discovered it is unknown, but it was said that he instantly became rich, so the bowl

may have been buried with a stash of money inside it. After its discovery Dr John Covel, the Master of Christ's College, Cambridge, acquired the bowl. He refused to let anyone else see it, but did not have the skills to translate the inscription himself. In March 1742 it was bought for £1.5s.0d by Dr Richard Rawlinson, who called it 'my metal Jewish vessel' and bequeathed it to the Bodleian Library in Oxford on his death in 1755.

Standing almost 25 cm high and weighing in at a hefty 5 kg, it has a long Hebrew inscription encircling the rim and is impressively decorated with hoof-shaped feet, birds, flowers, stags and fleur-de-lys. The bowl's value and importance were beyond doubt, but who owned it, what it was for and how it ended up in a Norfolk moat for a long time resisted answers. The Marquis of Northampton, writing in 1696, thought the bowl 'a great

c.1300–1700 Renaissance Era. Cultural bridge between Middle Ages and Modern Era

1303 Knights Templar withdraw from Arwad, the last Crusader stronghold in the Middle East

1306 Expulsion of the Jews from France

Robert the Bruce crowned King of Scots

mystery' and described it as a 'rabbinical porridge pot', intended by its users to symbolise the biblical pot of manna. Other theories were that it might have been used by rabbis to wash their hands during ritual observance, or to hold water during the preparation of the dead before burial. The purpose and provenance of the bowl was still unclear as late as 1887, when it went on display in the Anglo-Jewish Historical Exhibition at the Royal Albert Hall. However, it is now generally agreed that it was in all likelihood used to collect charitable donations.

The Hebrew inscription puzzled scholars, too, with its tantalising mixture of abbreviations, missing letters and words without clear meaning. According to a translation proposed by Dr Israel Abrahams, the inscription reads:

This is the gift of Joseph, son of the Holy Rabbi Yechiel, may the memory of the righteous holy one be for a blessing, who answered and asked the congregation as he desired, in order to behold the face of Ariel as it is written in the Law of Jekuthiel, 'And righteousness delivers from death'.[72]

The phrase 'face of Ariel' ('l'chazot pnei Ariel' in Hebrew) can indicate either Jerusalem or the Temple or both,[73] while *Jekuthiel* is one of the names given in the Bible for Moses (I Chronicles 4:18).[74]

Property deeds and other documents have revealed that Joseph was a leading member of the Jewish community in Colchester in the thirteenth century[75] and the eldest of the three sons of Rabbi Yechiel of Paris, a leading Talmudic scholar in thirteenth-century France and head of the renowned Paris *yeshiva*. Joseph's brother-in-law, Rabbi Isaac ben Joseph of Corbeil, was also a distinguished Talmudicist and author of the *Sefer Mitzvot Katan (Small Book of Mitzvot)*, an important thirteenth-century legal code also known by its acronym *Semak*. Joseph had spent time in prison (it is not known exactly for what) and on his release made a vow to emigrate to Palestine, an intention he began to realise in around 1257. Before his departure Joseph put his affairs in order, transferred his property in Stockwell Street, Colchester to his brother Samuel and presented the bowl as a gift to the local Jewish community, which had possibly raised money to help fund his journey. An alternative theory is that the bowl was made in France, taken from there to Akko in Palestine, where Rabbi Yechiel had founded a *yeshiva*, and was later brought to England as Crusader plunder.[76]

Joseph left England in 1260, either with his father or possibly after his father's death,[77] travelling first to France and Greece, then on to Palestine, where he subsequently died. He was buried not far from Haifa in a graveyard at the foot of Mount Carmel, alongside many other eminent rabbis. Rabbi Yechiel may also have died there, although other accounts indicate he only got as far as Greece, where he fell ill, and then returned to France and died there.[78] A tombstone for Rabbi Yechiel, found on the site of the Jewish cemetery in Paris

1307 Knights Templar murdered by Philip the Fair of France

Edward II becomes King of England

1314 Battle of Bannockburn. Scots reclaim independence from England

1315 Islam supplants Christianity in Dongola (present-day Sudan)

and now in the Musée d'Art et d'Histoire du Judaïsme, appears to confirm these accounts.

The bowl's decorative features, its owners and their connections with France reflect the origins of the Jewish community in medieval England, which came originally from Rouen in Normandy. Actively encouraged by William the Conqueror, who was keen to foster trade between the two countries, French Jews began arriving in England soon after the Norman Conquest. They spoke a form of medieval French in their daily life and studied Torah with the help of French translations. They also frequently had French names, such as Bonami, Bonafoy, Deulecresse and Joiette. Rabbi Joseph of Colchester, for example, was also known by the rather splendid name of Messire Delicieux.

For the next century the Jews flourished in England, forming settled communities in many towns and cities, including Norwich, Oxford, Hull, Lincoln and York. Highly literate and numerate, especially compared to the general population of medieval England, their opportunities for employment were nevertheless very restricted, but they played a vital part in the economic life of the country as financiers and moneylenders, the main occupations they were permitted to practise and which were forbidden to Christians. While Jews in other European countries were allowed to work in medicine and agriculture, and to trade in wine and other commodities, such as wool and wheat, in England they were confined more stringently to moneylending, which would prove both beneficial and problematic in the years to come.

In Oxford the Jewish community seems to have been involved in both the procurement of bullion for the Royal Mint and the actual production of coins. Archaeological finds in 2015 from the old Jewish quarter around Great Jewry Street (now called St Aldate's) included vessels that had been used for smelting metals. Earlier excavations revealed that the houses in the Oxford Jewish quarter were connected by underground passageways, quite possibly designed for the safe traffic of money to and from the castle mint.

As long as the Jews had money they were a valuable source of income and could rely on royal protection

One of the oldest Jewish communities in England, Jews had begun to settle in Oxford as early as 1075 and over the next two centuries they grew steadily in number, wealth and influence, owning some impressive stone properties in and around Great Jewry Street. At its peak, between 1170 and 1220, the medieval Jewish population of Oxford consisted of around 100 people in a city of about 2000, and owned perhaps as many as 100 to 150 properties. The graceful vaulted stone ceilings of one of these medieval Jewish homes has survived to this day and can be viewed in the basement of the modern Town Hall.

Jewish landlords and property owners played a significant part in the establishment of the University. Merton College, one of the

1320 Dante completes
The Divine Comedy

1327 Edward II dies
(probably murdered)
in Berkeley Castle

1337 Beginning of 'Hundred
Years War' between
England and France

1347 Black Plague. Up to
40 per cent of Europe's
population die in first
year alone

earliest colleges in Oxford, was established in the 1260s with the help of a wealthy local Jew named Jacob of Oxford (also known as Jacob fils. Magister Moses), who was instrumental in the purchase, and even the purpose-built designs, of some of the buildings. Balliol College and Christ Church were also endowed with properties that were originally owned by the city's medieval Jews.

As private tutors, local Jews further assisted the university's students and scholars in their study of Hebrew texts. The Franciscan philosopher Roger Bacon (c.1220–92), who spent many years of his life in Oxford, not only wrote with genuine respect and admiration about Jews, but was an excellent Hebraist. He was in all likelihood personally acquainted with members of the Jewish community, and quite possibly worked with respected Jewish scholars such as Jacob of Oxford. One unnamed Christian deacon who was taking Hebrew lessons with an Oxford Jew in the early thirteenth century fell so deeply in love with his tutor's daughter that he had himself circumcised and converted to Judaism in order to marry her – for which, on 17 April 1222, he was found guilty of apostasy and burnt at the stake at Osney Abbey.[79]

Cash-strapped Oxford students would often pawn their books to local Jewish moneylenders in order to fund their drinking sprees and other expenses. In 1244 so many books were held in pawn by the Jews that a riot broke out. The Chancellor of Oxford, Robert Grosseteste, from that point on banned all contact between Jewish pawnbrokers and the students, and set up a university-run loan chest, called St Frideswide Chest, where students could borrow money without jeopardising their studies.[80]

The relationship between Christian Hebraists and Jewish scholars appears in several cases to have been a close one in the twelfth and thirteenth centuries, with evidence of English Christians, such as Herbert of Bosham (c.1120–94) and Ralph Niger (1140s–c.1199), studying Hebrew texts and working with Jewish scholars for assistance with their study of the Hebrew Bible, the Septuagint (the Greek translation of the Bible) and the Vulgate (Latin Bible). A number of medieval manuscripts have survived in which the Hebrew text of the Bible has been painstakingly translated with the Latin written word for word above the Hebrew in places to create a bilingual edition, enabling the two versions to be directly compared.[81]

The medieval period was a boom time for Jewish book production, and there is likewise evidence of Jews employing Christian artists to illustrate their Hebrew books. These were mostly made by individuals for their own use, unlike Christian books which were produced in dedicated writing workshops attached to institutions such as monasteries and universities. From the mid-thirteenth century, however, it seems medieval Jews began making books for communal use. The collections of Hebrew and Jewish books and manuscripts at the Bodleian Library in Oxford is one of the greatest in the world, and includes three superb *mahzorim* (prayer books for festivals)

1348 Jews massacred in France due to rumours that they caused the Plague by poisoning wells

c.1350 Establishment of Kingdom of Siam

Water power begins to be used in England

1350 on Jews invited to parts of Italy for financial purposes

commissioned by wealthy Jewish patrons for communal use in synagogue as a way of making their mark and establishing their prestige in their communities.[82] All three were elaborately illustrated with pen drawings or coloured and gilded illuminations, produced by skilled Christian artists who appear to have been working under the supervision of Jewish scribes.[83] The *Laud Mahzor* includes illustrations for the festival of Purim, showing Queen Esther and King Ahasuerus, and the hanging of Haman and his sons as punishment for their plot to kill the Jews of Persia (see Chapter 12). A panel for the Passover festival illustrates the Egyptians in pursuit of the escaping Israelites (see Chapter 7). Instructions for the illuminator are still visible in places, written in Latin, an indication that the artist was Christian. In the *Tripartite Mahzor* a full page is dedicated to the first letter of the *Kol nidrei* prayer, one of the most solemn moments of *Yom Kippur*, the Day of Atonement. The illustration, however, is anything but solemn, with its depiction of two wrestling dragons at the foot of the page and, at the top, a man emerging out of the head of a fantastical monster while blowing a reed pipe. The earliest of these three prayer books, the *Michael Mahzor*, gets things even more wrong: an illuminated panel at the start of the first volume is upside down, again strongly suggesting that the artist was a Christian who could not read Hebrew. The error was clearly picked up by someone who did because the illustrations in the rest of the *mahzor* are the right way up. Most of the pictures are of

animals, dragons, hunters and fighters, and decorate the text rather than illustrating it directly. The only feature that singles them out as being for Jewish use is that no human faces are shown. Instead they are either covered or replaced with animal faces. Later copies left out the human figures completely.[84]

Jewish medieval manuscripts used different scripts according to where they were commissioned and made, with manuscripts from Italy showing the influence of Latin scripts, for example, and those made in Spain and North Africa influenced by Arabic script. Illustrations, too, reflect the manuscript's place of origin, as do variations in methods of production and the types of materials used, providing further indication of frequent interaction, collaboration and intellectual exchange between Jews and their non-Jewish neighbours.[85] The boundaries between countries and cultures was also porous, with books and manuscripts travelling with their owners from one place to another. Evidence of this is a remarkable *siddur* (a prayer book for daily use and Shabbat) from the late twelfth century, now in the collection of Corpus Christi College, Oxford.[86] Made in northern Europe and written in Ashkenazic Hebrew script, it came into the possession of an Arabic-speaking Sephardic Jew who settled in England. He used the blank pages of the prayer book to jot down some of his business transactions in Judaeo-Arabic (Arabic written in Hebrew letters), the only known example of a document from medieval England written in this language and a reminder of the extent to which

Jewish life at this time was frequently trans-national, with trade, religion and language forging connections that easily cut across national borders.

Jews living in medieval England, as elsewhere in Europe, were legally the personal property of the king, and as such they came under royal protection. To begin with at least, this meant they enjoyed a number of special privileges. As wards of the Crown they had the freedom of the king's highways, and as royally protected financiers they participated to some degree in court affairs. The downside to this special status was heavy taxation. At the end of the twelfth century, although the Jews made up less than 0.25 per cent of the English population, they were providing 8 per cent of the total income of the royal treasury. During the twelfth and thirteenth centuries extra taxes levied on the Jewish community, as well as assets confiscated from wealthy individual Jews, helped to fund the Christian Crusades and the construction and expansion of many of England's finest churches and cathedrals, among them Norwich Cathedral and Westminster Abbey in London.

As long as the Jews had money and no competition from other moneylenders, they were a valuable source of income and could rely on royal protection. But the medieval Jewish community was exceptionally vulnerable to the caprices of individual monarchs. Under

Cash-strapped Oxford students would often pawn their books to local Jewish moneylenders in order to fund their drinking sprees

William the Conqueror (1066–87), William Rufus (1087–1100) and Henry I (1100–35) the community prospered. Under subsequent rulers their situation was more precarious. The battling royal cousins Matilda and Stephen repeatedly imposed exorbitant additional taxes called tallages on the Jews, in part to fund their internecine civil war. Under Henry II (1154–89) the country enjoyed a period of economic stability, and during his reign a number of Jews made substantial fortunes. Henry II also allowed provincial Jews to have their own cemeteries for the first time. Before that the only Jewish cemetery in England, serving the whole of the country's Jews, was in London.

The next hundred years, however, saw a drastic reversal in the fortunes of England's Jews. Richard I (1189–99) not only used the Jews to finance his 1189 Crusade, but also forced them to pay the enormous sum needed for his ransom when he blundered into captivity on his way home. In Richard's absence his brother John had taxed the Jews relentlessly, and took this practice to a new level when he in turn became king. Having bankrupted the country with his disastrous campaign against the French in 1210, John imposed crushing taxes on his only remaining source of funds – his Jewish wards. Punishments for non-payment of these taxes included confiscation of goods and property, severe fines and collective imprisonment.

1381 Peasants' Revolt in England

1382 *Cambridge Yiddish Codex* written. Oldest surviving document in Yiddish

1386 Heidelberg University founded

Lithuania becomes last part of Europe to convert to Christianity

Entire communities of men, women and children, young and old, were locked up on numerous occasions. Desperate to keep his rebellious barons on side, the king allowed them to plunder whatever Jewish assets they pleased. Under John's son Henry III (1216–72) and grandson Edward I (1272–1307), their situation deteriorated still further.

Fuelled by zeal for the Crusades and resentment of the Jews' special status and presumed wealth, physical assaults on Jews escalated from the middle of the twelfth century on. As moneylenders Jews were despised and hated by the very people who relied upon their services. In 1190 a violent riot erupted against the Jews of York. The entire Jewish community took refuge in the castle, where they eventually committed suicide *en masse* rather than fall into the hands of the murderous townsmen. Other attacks took place in London, Norwich and King's Lynn. It was around this time that Jews across Europe were forced by papal decree to wear an identifying badge to distinguish them from other citizens. In England it was ordained that:

> Every Jew shall wear on the front of his dress tablets or patches of cloth four inches long by two inches wide, of some colour other than that of the rest of his garment.[87]

This usually took the form of a white or yellow badge signifying the two tablets of Moses.

Perhaps the most pernicious form of anti-Jewish hostility was the accusation that Jews were murdering Christian children as part of their Passover rituals. This allegation, known as the blood libel, was made for the first time in 1144 in Norwich, then home to one of the oldest and richest Jewish communities in England, after the mutilated body of a young man called William was found in woodland near the city. No evidence was ever found to connect Jews to William's death, nor were any Jews in Norwich found guilty of the crime, but six years later, in 1149, the allegation was resurrected – this time in the trial of a Christian knight called Sir Simon de Novers. Newly returned from the Second Crusade and deeply in debt, de Novers was accused of murdering a local Jewish banker to whom he owed money. In itself the murder of a Jew in medieval England was hardly ground-breaking news, since physical attacks on Jews were fairly commonplace. As Jews were chattels of the king, however, the murder had to be prosecuted.

Given the clear evidence that de Novers had arranged the murder, the outcome of the trial was generally assumed to be a done deal. What turned the case into a high-profile spectacle was the defence mounted at the trial by Bishop William Turbe on the knight's behalf. The bishop's audacious line of argument was that:

> We Christians should not have to answer in this manner to the accusation of the Jews, unless they are first cleared of the death of our Christian boy, of which they are themselves are known to

*c.*1387 Chaucer begins
The Canterbury Tales

1394 Final expulsion of
Jews from France

1399 Richard II abdicates to
Henry IV of England. End of
Plantagenet dynasty

1405 Beginning of Ming
Dynasty-sponsored Chinese
naval expeditions to Indian
Ocean and Southeast Asia

have been previously accused and have not yet been purged.[88]

In other words, Simon de Novers should not be punished for killing a Jew until the Jews had been collectively punished for killing William. The knight's legal team even went so far as to claim that the murdered Jewish banker had been the original ringleader of William's alleged abduction and death, portraying 'the Jews as killers of Christ and William as … a type of Christ based on his physical sufferings'.[89] No ruling was reached, the case was adjourned *sine die* and the guilty knight walked free. A year later, in 1150, a young monk at Norwich Cathedral called Thomas of Monmouth decided to make a martyr of William in a work entitled *The Life and Passion of William of Norwich*, presenting the Jews not just as William's killers (despite not a shred of evidence to support this assertion), but as insatiable for Christian blood in general.[90]

From then on, the myth of the blood libel rapidly took hold in Christian imagination. Whenever a Christian child died accidentally or in some unexplained manner, the Jews were likely to find themselves accused. This resulted in massacres in Bury St Edmunds in 1181, Bristol in 1183, Winchester in 1192, London in 1244 and Lincoln in 1255. In the French town of Blois in 1170 it was the excuse for executing 30 entirely innocent Jews, seventeen of them women, some pregnant, others holding young children in their arms, all burnt to death in the building in which they had been locked.

Despite its entirely fictitious beginnings, the myth of the blood libel stuck and would bring great misery to the Jews, as Professor Emily Rose, author of *The Murder of William of Norwich*, explains: 'The accusation of ritual murder led to instances of the torture, death and expulsion of thousands of Jews throughout Europe and to the extermination of hundreds of communities. In the wake of the accusation, a large number of Jews were exiled, executed, burned at the stake, or died in prison. Accusations of ritual murder – at times mere rumours of it – provoked riots in every century well into the twentieth, some eight centuries after the death of William of Norwich … [T]he purported victims of ritual murder were honoured, and their stories became foundational legends of churches the length and breadth of Europe. Jews murdering such victims were portrayed in manuscripts, sculpture, paintings, and stained glass. In the modern era, such depictions appeared in prints, posters, and postcards, and even on magazine covers prominently displayed at bus stops, company cafeterias, and public parks.'[91]

By the time Rabbi Joseph left Colchester in 1260, the Jewish community in England was sunk in poverty and despair. The ban on Christian usury had recently been lifted, Jews now faced stiff competition from non-Jewish moneylenders, and the beleaguered Crown had less reason to stick its neck out to defend its Jewish citizens. Stripped of their assets, the Jews were now deprived of the means to earn a livelihood and increasingly afraid for their

1415 England defeats France at battle of Agincourt

1412–51 Pressure on Jews in Spain and Portugal to convert. Measures introduced to discriminate against *Conversos*

1420s Expansion of Aztec empire in Mexico

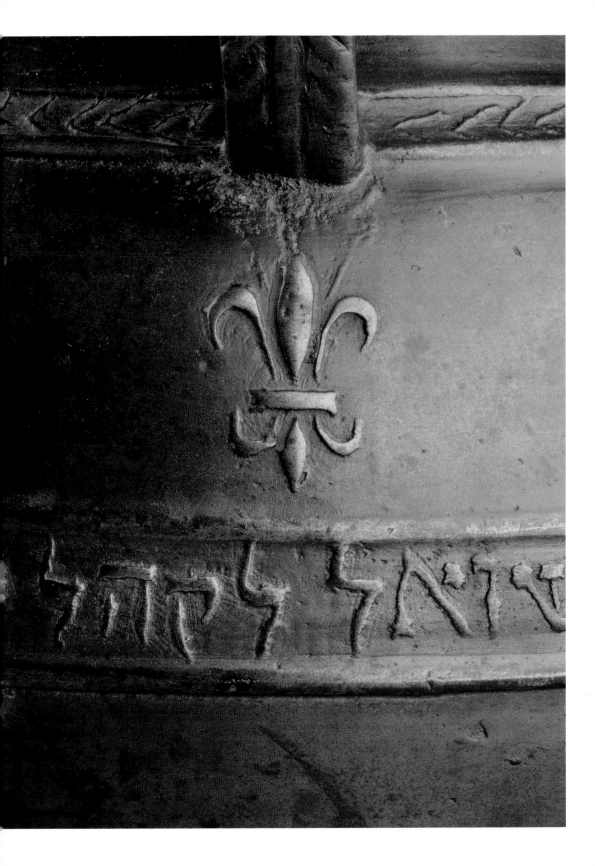

personal safety. Between 1263 and 1267 the combined forces of England's barons and gentry (the two groups most indebted to money-lenders) attacked one English Jewish community after another, murdering many of their inhabitants under the guise of waging war on the Crown. In addition, they put huge pressure on the king to introduce increasingly oppressive restrictions on the Jews, to reduce their sources of income. In 1269 new laws were passed, forbidding Jews from owning land or property other than their own homes or those rented to other Jews, and confiscating all their assets when they died. Jewish children were also no longer allowed to inherit from their parents, and from 1275 on Jews were banned from lending money.

The end was now in sight for England's Jews. With almost no way to earn a living, some resorted in desperation to illegal options. In 1278, 293 Jews were found guilty of coin-clipping and hanged at the Tower of London. Among them was an Oxford Jew, Vives Le Long, whose house stood on the corner of present-day Brewer Street. A heart-rending poem by the thirteenth-century Rabbi Meir of Norwich expresses the dreadful plight of the Jews at this time. Described as 'the poet of a community at the edge of oblivion', almost nothing is known about Meir beyond his poems, twenty in total, which were unearthed in the nineteenth century in the archives of the Vatican Library and finally translated into English seven centuries after they were first written. But Meir's words speak for themselves:

Forced away from where we dwelt
We go like cattle to the slaughter
A slayer stands above us all.
We burn and die.[92]

On 18 July 1290, just 30 years after Joseph had left for Palestine, Edward I issued an edict expelling the entire Jewish population from the country in return for a huge grant of 150,000 marks to support his war against the Scots.[93] Any Jew remaining in the country after All Saints Day (1 November) of that year did so on pain of death. Between 4000 and 16,000 Jews fled to the continent. Many returned to northern France or moved to countries such as Poland, where Jews were still legally protected. A small number remained, either by converting to Christianity or concealing their identity and religion. England was the first European country to expel its Jewish population, but in the following centuries France, Spain, Portugal and others would follow suit.

In the space of just two centuries the Jewish community in medieval England arrived, thrived and was systematically demolished. Encouraged to come to the country, they were then despicably abused, exploited as cash cows by the Crown, mercilessly stripped of everything they had worked so hard to create, despised first for their financial acumen, then for the poverty to which they had been reduced. Forced from the towns and cities they had come to regard as home, they were obliged to continue their journey, as so often before, taking with them

no more than the belongings they could carry. For the next 350 years Jews were officially banned from England.

The frantic exodus that must have followed the king's edict in July 1290 may explain how the Bodleian Bowl found its way to the bottom of a moat in Norfolk. Perhaps it was dropped by accident during the fear-fuelled dash for the coast. Or perhaps it was intentionally hidden in the moat, in the hope it might be retrieved at some point in the future. For all its well-kept secrets, the Bodleian Bowl is a poignant relic of England's medieval Jewish community, a reminder of their technical skill, commercial savvy, religious piety, and enormous financial contribution to the country. It stands as a symbol of the fluctuating fortunes of Jews, not only in England but in the medieval Diaspora as a whole, and tells a multi-stranded story of Jews who travelled around the world and of Jews who did their best to set down roots, a story not just of suffering and despair, but also of extraordinary resourcefulness and resilience.

1444 First printing presses

1449 'Purity of Blood' statute passed in Toledo, Spain, forbidding *Conversos* and their children from holding public office

1450–1520 Explusion of Jews from many towns in Germany

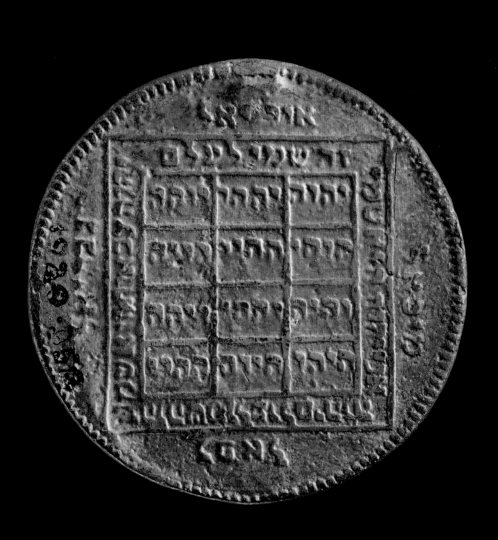

15 MAGIC AMULET ו ט

PROVENANCE UNKNOWN (POSSIBLY FRANCE), 1450–1600

'This is a mystery, deep and wondrous.'
Sa'adiah Ben Amram, *The Poet, the Dove and the Beloved*

THE MIDDLE AGES and Renaissance in Europe were a period of mass migrations for the Jewish people as persecution and expulsions repeatedly forced them to move from one country to another. Increasingly segregated in ghettos and Jewish quarters, Jews were generally regarded by Christians at this time as strange and different, socially inferior, and followers of a perverse and dangerous religion. Yet at the same time the Jews were recognised as useful for trade and business, and knowledgeable in science and medicine. Many Christians also believed that the Jews possessed a unique magical resource: the Hebrew language.

Jews had long been associated with magic in the minds of Christians, and by the time this amulet was made magic was an entrenched part of life throughout Europe for Jews and non-Jews alike. Hebrew was widely regarded by Jews and Christians as a language with mystical superpowers. For Jews, the special power of Hebrew was believed to come from three sources: the names for God, the words and phrases spoken by God, and the letters of the Hebrew alphabet itself. Magic amulets featuring Hebrew writing, such as this one, often combined all these elements and were therefore believed to have especially effective supernatural powers.[94]

The front of this little copper amulet, just 4 mm in diameter, is decorated with a magic square divided into twelve boxes. Each box contains a different combination of four Hebrew letters y, h, v and h, which together form the word *yahweh*, also known as the Tetragrammaton, the Jewish way of writing the sacred name for God. Hebrew letters also correspond to numbers, which both individually

and combined held an additional mystical significance. The number 15, for example, could not be written with the letters indicating 10 and 5 because these are two of the four letters in the Tetragrammaton. Instead, it had to be written with the letters/numbers for 9 and 6, as is still the case in Hebrew today.[95]

Each side of the square bears the name of one of the four Archangels: Uriel, Gabriel, Raphael and Michael, alongside which are quotations from the Hebrew Bible relating to God's name. The four lines of inscription read:

Ze shmi leolam
[This is my name forever]
Hashem tzva'ot hu shemo
[The Lord of Hosts this is his name]
Hashem shemo leolam hashem
[This is God's name forever]
Ani hashem hu shemi
[I am God, this is my name]

Jewish amulets and other magic objects have been found in many parts of the world, dating back as far as the First Temple period. The earliest amulets were made of thin sheets of metal, usually silver, bronze or copper but sometimes gold or lead, and were inscribed with a short incantation to protect or heal their owner. In some places spells were also written on bowls (see Chapter 10) and on potsherds.

The Hebrew Bible strictly forbids anything to do with witchcraft (black magic), clearly stating that 'There must not be found among you anyone that ... uses divination, a soothsayer, or an enchanter; or a witch, or a charmer; or a medium, or a wizard, or a necromancer' (Deuteronomy 18:10–11). But practice of what we might describe as 'white magic' (protection from the forces of evil) was widespread and sanctioned by at least some of the early Jewish sages. The Babylonian Talmud contains numerous references to demons and angels, and offers instructions for a wide variety of spells and incantations for healing purposes and to aid the learning of Torah. One Talmudic recommendation for deterring evil spirts at night is to recite a verse with the phrase 'Voice of the Lord' seven times before retiring to bed. Repeating certain words or phrases a set number of times (usually three or seven) was believed to increase the power of the spell, while incantations to undo unwanted events often advised reciting key words or phrases backwards, or reducing the letters of a word or phrase until it had no meaning and therefore no power.[96] Nonsense words were also common in magical lore, a custom dating back to the Babylonians, as were foreign words from languages associated with the ancient world and no longer in use, such as Sumerian and Aramaic. Rashi, the great French medieval rabbi, considered the use of incomprehensible words to be an essential part of the art of casting spells.[97] Other rabbis in the Middle Ages, most notably Maimonides (see Chapter 13) were highly critical of the belief in and practice of magic, but it remained popular in all forms, and certainly by the twelfth century magic was probably a routine part of life for many people, both

1460–7 Trials against
Spanish *Conversos*
in Valencia

1469 Marriage of Isabella I
and Ferdinand II, unifying
Spain

1473 Cordoba approves
edict banning *Conversos*
from holding public office

1475 Ritual murder libel
of Simon of Trent

Jews and gentiles. Indeed, many Jewish amulet makers appear to have been rabbis or their disciples.

In the early twelfth century the mystical branch of Judaism known as Kabbalah emerged out of France and flourished in Spain in the thirteenth century, before spreading to North Africa, Palestine and other parts of Europe in later centuries. Although Kabbalah developed in very different ways in these different places, it retained as its central tenet a conviction that the mysteries of the universe were contained in sacred biblical texts and could be discovered through an understanding of the secret symbolism of the 22 letters of the Hebrew alphabet and the ten primordial numbers, known as 'sefirot'. As already mentioned, Hebrew letters each correspond to a number, so words could also be interpreted as a sequence of numbers, which added together, acquired (or revealed) further meaning.

The earliest known treatise on Jewish esoteric wisdom was the *Sefer Yetzirah* (Book of Creation), which was possibly created as early as the second century CE, and viewed the letters of the Hebrew alphabet as the secret code to understanding the creation of the universe, linking them to specific parts of the body. It also gives detailed instructions for making a *golem*, a human-like creature made of clay or mud, which could be animated by inscribing the word *emet* (truth) on its forehead. The *Sefer Raziel* (Book of Raziel), another hugely influential mystical text, attributed to Eleazer of Worms and written around 1230, asserted that the secrets of creation had

originally been revealed to Adam by Archangel Raziel, the angel of mysteries, to help him survive life outside the Garden of Eden. The *Sefer Raziel* explains in great detail the secret meanings contained in the 72 Hebrew letters of the names of God and also sets out the hierarchy of angels and spirits, and their specific areas of influence. An indispensable guide for medieval amulet makers, it provides the necessary incantations for instructing these heavenly spirits, as well as giving practical instructions for making amulets and talismans. It was not strictly necessary to read the *Sefer Raziel* to benefit from its wisdom; simply owning it was believed to give protection from fire, robbery and an array of evil spirits.

The foremost kabbalistic text, however, was the *Zohar* (meaning 'radiance' or 'splendour'), which first appeared in around 1275 and was probably written by the Spanish mystic Moses de Leon, although he vehemently denied it until his dying day. The *Zohar* set out the mystical aspects of Torah to explain the secret origin and structure of the universe, and was a huge influence on kabbalistic thought in Spain for the next two hundred years, and later in Safed in Palestine, where many Spanish mystics fled after Jews were expelled from Spain in 1492. The Safed mystics ensured these ideas spread throughout the European and oriental Jewish Diaspora, and this in turn would in turn play a major role in the development of Hasidism in Germany and Eastern Europe.[98] All three of these texts are still in print today.

By the time this amulet was made many

aspects of kabbalistic Judaism had found their way into mainstream Jewish beliefs about magic, and beyond. The Renaissance was a period of burgeoning interest in Hebrew texts among Christians, a number of whom became interested in Kabbalah, but gave it their own gloss, interpreting kabbalistic texts as proofs for Christianity.

Contrary to appearances this particular amulet would never have been used by a Jew. Despite being covered front and back in Hebrew letters and symbols, its owner was almost certainly a Christian. The evidence for this can be found on the reverse side of the amulet itself. The pentagon, a symbol strongly associated with magic rituals by Jews and non-Jews, is surrounded on all five sides by Hebrew names for Jesus, including *Yesho*, *Yeshua* and *Yehoshua*, alongside which are quotations from the Prophets and the Psalms. Inside the pentagon a circle contains an image of a bearded head with a halo and biblical quotations related to the Messiah. One, from the Jewish prophet Isaiah, reads 'wondrous advisor, mighty hero, eternal father, ruler of peace', a phrase believed by Christians to refer to the birth of Jesus.

Amulets such as this one were made by Jews for Christians and were in great demand in the Middle Ages. They were particularly common in Provence, frequently carried by Christian pilgrims and Crusaders setting sail from the ports of southern France for the Holy Land of Palestine.[99] The owner of this amulet may have been English, but the amulet is unlikely to have been made there,

as Jews were still officially banned from the country in the fifteenth and sixteenth centuries. It is far more likely to have been made in France and bought by an English pilgrim before boarding ship, perhaps in the hope that the amulet's Hebrew words and symbols would bring divine protection against the perilous journey ahead. It has been pointed out as somewhat ironic 'that the same crusaders who acted so brutally to the Rhineland Jews should have sought protection on the hazardous part of their journey by using amulets originating from the very same people they had so cruelly maltreated on the earlier part of the same travels'.[100] Hebrew inscriptions on non-Jewish magic objects were common enough, but the repeated references to Jesus on this amulet raise the possibility that it might have belonged to a Christian kabbalist.

Connection with the occult was by no means beneficial at this time for Jews, who were frequently accused of involvement in witchcraft and satanic practices, including the infamous myth of the blood libel (see Chapter 14). While Christians may have been happy to make use of the alleged magical powers of Hebrew texts and the Hebrew alphabet, this did not preclude treating Jews themselves with contempt and baseless cruelty. In France, where this amulet most probably came from, the twelfth to sixteenth centuries were a particularly bad time for the Jews, who suffered repeated attacks on their communities, religious persecution, confiscation of property, collective imprisonment and no fewer than three *en masse* expulsions from the country. In

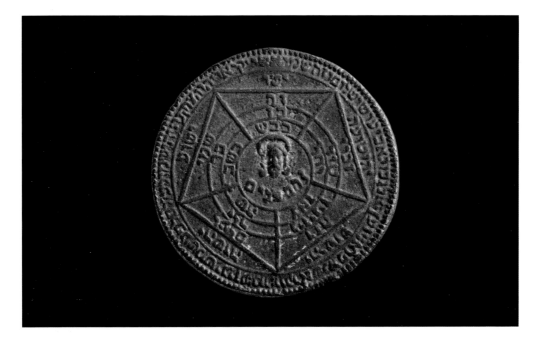

1240 the Talmud itself had been put on trial on the grounds that it was morally and spiritually corrupt. The charges were brought by a Jewish convert to Christianity and former disciple of the Paris *yeshiva*, called Nicholas Donin of La Rochelle, who argued it was a blasphemous text. The chief Jewish spokesman at the trial, held in Paris before Louis IX, was none other than Rabbi Yechiel, the great Talmudic scholar whose name appears on the Bodleian Bowl (see Chapter 14). But to no avail. On 17 June 1244 the Talmud was banned and 24 carriage loads of priceless manuscripts, many with marginal notes by leading Jewish scholars of the day, were publicly burned.[101] Thousands of volumes of other Jewish religious books were similarly confiscated and burned in France, an occurrence that would become woefully common in other countries in Europe in the following centuries.

This particular amulet, most probably made by a French Jew and sold to a Christian, possibly en route to the Holy Land, is a reminder of the complex interaction of Jews and non-Jews in medieval and Renaissance Europe. The perceived distinctiveness of the Jews was a source sometimes of curiosity and interest, sometimes of fear and loathing. As with the attitude to the Hebrew language and texts, Jewish customs and beliefs were respected by some and simultaneously reviled by others. As the amulet attests, continuous and often contradictory cross-currents of influence and engagement were as much a part of this double-edged

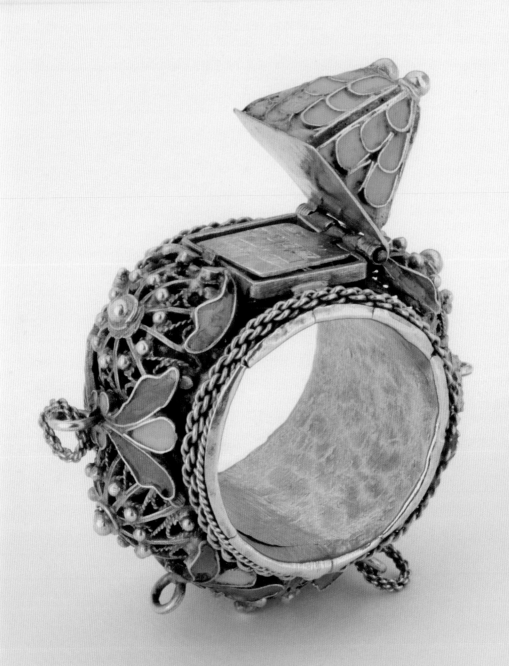

16 WEDDING RINGS טו

VENICE, ITALY, 1500–1600

*'My beloved is mine, and I am his,
that feedeth among the lilies.'*
Song of Songs 2.16

JEWISH WEDDINGS HAVE for centuries included the gift of a ring, as in many other cultures and religions. Rabbinic law makes it clear this is not an option but obligatory: 'The groom should give to the bride a plain ring, with a value not less than one perutah'. The perutah was the lowest value of coin, which has been taken to mean that the giving of a ring was a symbolic act rather than a financial transaction, although of course marriages were that too. This exquisite sixteenth-century wedding ring, one of six such rings in the Ashmolean, is anything but plain, suggesting it was a ceremonial object rather than intended for daily use. It may have been given during the *silvonot*, which celebrates the making of the match, or during the betrothal period, which generally spanned the year leading up to a marriage. This kind of ring was worn on

the middle finger during the actual wedding ceremony. Afterwards it would be strung on a chain and worn round the neck, or kept by the family or community. Similar rings were in use from as early as the seventh and eighth centuries, and continued to be made in this style into the seventeenth and eighteenth centuries. An engraving of Glückel of Hameln, a seventeenth century German Jewish housewife, businesswoman and memoirist, shows her wearing an elaborate ring of this kind round around her neck, presumably after her second marriage in 1700, at the age of 54, to Cerf Levy, then the richest banker in Lorraine.

The Ashmolean's wedding rings are thought to come from Italy or Transylvania. Like earlier and later ones, they are inscribed with Hebrew words and decorated with Jewish motifs. One is decorated with a *chuppah*, the canopy beneath which the bride and

1504 Moghul empire founded in India by Babur the Great

1516–7 Ottomans conquer Palestine, allowing Jews freedom of religion

1516 Creation of first ghetto in Venice

1520 Magellan sails round the world

1520–3 First complete Talmud printed in Italy

groom stand during the wedding ceremony, an integral part of Jewish weddings to this day. Others are decorated with a little building, mounted on top of the ring, symbolising both the Temple in Jerusalem and the new home the couple will make together. The words *mazal tov* ('good luck' in Hebrew, as well as 'congratulations') appear on five of the six rings; sometimes the words are clearly visible, sometimes they are concealed inside the little house. Another typical inscription on Jewish wedding rings of this kind was a verse from the biblical love poem, the *Song of Songs* (*Shir Hashirim* in Hebrew).

House rings, as such rings are also known, are rare. A twelfth-century house ring was found in the cellar of the Old Synagogue in Erfurt, Germany, the oldest synagogue in Europe, where it had been hidden along with other treasures, probably by a Jewish merchant, during a pogrom in 1349. An extremely beautiful fourteenth-century house ring was found in 1863 in the wall of a house in the medieval rue des Juifs in Colmar, Alsace (now on display in the Musée de Cluny in Paris). It was in all likelihood concealed there for safekeeping shortly before 1349, during the Black Death, when the cantor of the synagogue in Strasbourg was accused of poisoning the wells of Colmar and the entire Jewish community was burned at the stake.

The use of gemstones on Jewish wedding rings was forbidden, so instead they were decorated with filigree or granulated gold. By the sixteenth century enamel was also used and the designs became ever more intricate. The

workmanship on these rings is exceptionally fine. Delicate gold vine leaves, grapes and tendrils weave around flowers enamelled with tiny green leaves and sky-blue petals; a gold roof, smaller than a postage stamp, is decorated with miniature dark blue tiles; five-petalled flowers of cornflower blue and quatrefoils of rich green nestle in cradles of corded gold. Then, as now, they were tokens of love and commitment, as well as symbols of wealth and status.

A Jewish ring features in Shakespeare's play *The Merchant of Venice*, written in 1596, around the time these wedding rings were made and set in the city they are thought to have come from. The play also features one of the most famous fictional Jews in English literature: Shylock the moneylender. In Act III of the play Shylock discovers that a precious ring, given to him by his late wife before they were married, has been stolen. The thief is his own daughter Jessica, who has eloped with her Christian lover, taking the ring with her. Shylock's anguish and fury at his daughter's betrayal is matched by his sorrow for his lost ring. 'It was my turquoise, I had it of Leah when I was a bachelor,' he laments. 'I would not have given it for a wilderness of monkeys.'[102] It is the first moment in the play when we glimpse a softer side to Shylock, and are invited to see a man who once loved and was loved, a man who is not merely a Jew, as his enemies see him, but a human being as they are. Only a few moments earlier Shylock has railed at his tormentors with the famous lines:

Hath not a Jew eyes? Hath not a Jew hands, organs, dimensions, senses, affections, passions? Fed with the same food, hurt with the same weapons, subject to the same diseases, healed by the same means, warmed and cooled by the same winter and summer, as a Christian is? If you prick us, do we not bleed? If you tickle us, do we not laugh? If you poison us, do we not die?[103]

The Merchant of Venice deals explicitly with issues of religious intolerance and forced conversion, which at the time Shakespeare was writing were highly topical for Catholics and Protestants as well as Jews. The Spanish Inquisition had begun just over a hundred years earlier, in 1481, and was still active. In the first twelve years of the Inquisition around 31,000 *conversos* (secret Jews) and New Christians had been burned at the stake, more than 700 in Seville alone. In 1492 the entire Jewish population of Spain was expelled, ending centuries of flourishing Spanish Jewry. The year 1536 saw the start of the Portuguese Inquisition. As in Spain, thousands of people suspected of being Jews were put on trial, executed or forced to convert. The last *auto de fe* in Portugal took place on 27 October 1765, while the Spanish Inquisition was only finally abolished in 1808.

Throughout the sixteenth century Jewish refugees from Spain and Portugal fled to other countries in Europe, the Near East, North Africa and South America, often joining existing communities or forming new ones. Many Portuguese Jews went to France, Poland and Holland. A great number emigrated to Italy. Expulsions from Sicily and persecution in France and Germany also drove Jews from those countries into northern Italy. By the sixteenth century Venice had a significant and diverse Jewish community, made up of immigrants from several different countries. Venice was also the first city in the world where Jews were forced to live in a designated area. The word 'ghetto' comes from the Italian *geto* meaning 'foundry', because the first Jewish quarter in Venice, instituted in 1516, was on the site of an old foundry.

Just as cultural and commercial life thrived in Elizabethan England despite religious conflict and persecution between Christians, so Jewish cultural and commercial life thrived in many parts of Europe despite anti-Jewish measures and outbreaks of violence. The elaborate decoration of these wedding rings reflects the vibrancy of Jewish craftsmanship in Italy during the middle to late Renaissance. Northern Italy, in particular, was a concentrated hub of Jewish innovation and productivity. As bankers and moneylenders, Jewish enterprise played an important role in the economic wealth and expansion of the region. Jews were also actively involved and highly valued as goldsmiths, silversmiths, glassmakers, clothmakers, silk weavers, leather workers and much more besides.

The art of printing, too, was from its beginnings largely a Jewish undertaking. In the fifteenth century Jews were at the vanguard of printing and book production; they founded

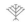

presses in more than a dozen cities and towns in northern Italy, including Mantua, Sabbioneta and Cremona. One of the earliest and most renowned Italian presses was in Soncino, founded in 1480 by a Jewish family who had settled there after fleeing persecution in Germany. Jewish printers were already active in Avignon by 1444, six years before Gutenberg's 'invention' of the printing press. One of Italy's first papermaking factories was founded by a Jewish family in the town of Salo, and supplied Jewish printing presses in the region. Three-quarters of all Hebrew books printed in the fifteenth century came from Italian Jewish presses, vital to the spread of ideas across the continent and throughout the Jewish European Diaspora.

Northern Italy also produced many eminent Jewish physicians in the fifteenth and sixteenth centuries. The universities of Padua and Perugia allowed Jews to study medicine, among the few medical schools in Europe to admit Jews at that time. Renowned for their abilities, Italian Jewish physicians acted as personal physicians to popes, cardinals, bishops and dukes. The Portaleone family of Jewish doctors treated the nobility of Padua and Mantua for over 300 years. Mantua was so hospitable to the Jews that they dubbed it *kiriah ha-alizah*, the 'happy city'. The *Zohar*, the preeminent book of Jewish mysticism (see Chapter 15), was printed for the first time in Mantua in 1558, at a time when Hebrew books elsewhere in Europe were being burned. One of the 1558 printed versions of the Zohar can be seen today in the library of Lincoln College, Oxford.

Besides medicine and printing, sixteenth-century Mantua was a flourishing centre for music, theatre and literature. Jewish musicians, actors and dancers were welcomed at the Mantuan court of the Gonzaga family. Judah Leone de Sommi Portaleone (1525–90), a Jewish theatre producer, director and general impresario, staged lavish performances for the Duke of Gonzaga, with casts of actors and dancers sometimes running into the hundreds. But then de Sommi liked to do things on a grand scale: the first theatrical producer in Italy, he was also a prolific poet and playwright who penned hundreds of pastoral comedies in Italian and in Hebrew, amounting to no fewer than sixteen published volumes. As well as founding the synagogue in Portaleone, de Sommi also wrote the first European guide to acting, the *Dialogues on the Dramatic Art*, published in 1556.

Important and innovative Jewish music also emerged out of sixteenth-century northern Italy. Salamone Rossi (born c.1570), the greatest Jewish musician of the period and a resident of Mantua, revolutionised Jewish music by setting sacred Hebrew texts to polyphonic choral music, a ground-breaking synthesis of Jewish and Christian cultural traditions. Described as the 'Beethoven of his times', Rossi brought Renaissance music into the synagogue for the first time, with his settings of psalms, hymns and prayers. Dating from 1589 to 1623, many of his compositions were written to be performed in the synagogue, including his most famous work, *Hashirim asher l'Shlomo* ('The Song of Solomon', also known as the 'Song

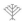

of Songs', referred to earlier in this chapter). Rossi also composed numerous pieces for the Mantuan court and became the first person ever to publish Jewish music, a turning point in European Jewish history.

Rossi seems to have enjoyed special status in Mantua, and was exempted from some of the restrictions imposed on other Jews. A document in the Mantuan archives records that Rossi was granted 'unrestricted freedom to move about the town', and was permitted to do so 'without the customary orange mark on his hat' that would have identified him as a Jew.[104] However, he was no apologist for the Christian authorities. In 1602 seven young Jewish men were executed and strung up on the public gallows for making fun of a local priest. From then on, conditions deteriorated for Mantuan Jewry, and a decade later all two thousand of Mantua's Jews were confined in a ghetto. Salomone Rossi expressed his feelings about this through his music. One of his compositions, a setting of Psalm 137, draws on the Babylonian exile of the Jews in the sixth century BCE to articulate his anger about the mistreatment of Jews in his own day, and the pain of a people living in exile from their own land. 'Our captors demand that we sing and amuse them, saying "Sing us the songs of Zion!"', one verse laments. 'How can we sing the songs of the Lord in a foreign land?'

The Jews of northern Italy were never immune from persecution, but they also enjoyed periods of relative tolerance and fruitful interaction with their Christian neighbours. They may have lived in ghettos, but they did not live in cultural isolation and, where conditions allowed, they contributed directly and indirectly to the cultural and artistic flowering of the Italian Renaissance.

Throughout Piedmont, Lombardy and the Veneto, jewel-like synagogues from the sixteenth century on are testament to the sophistication, material success and confidence of northern Italian Jewish communities during this period. Although these synagogues seldom draw attention to themselves on the outside, the interiors are often enchantingly lovely. The Norsa Torrazza Synagogue, first built in 1513 and the last surviving synagogue in Mantua, is quietly elegant with ornately stuccoed white walls and cool pink-and-white stone. The synagogue at Casale Montferrato, which dates back to 1599, is more baroque. Decorated in stunning gold-and-white Carrara marble, it features stately arches and a gold-lacquered screen to conceal the women's gallery on the second floor. Men and women would sit separately in synagogues at this time, a custom dating back at least to the early first century CE and still observed today by Orthodox Jews. Venice had no fewer than five different synagogues, the largest of which was built by refugees from Spain and Portugal. Although these synagogues and others like them were tucked away in the streets of the Jewish ghettos, often behind drably inconspicuous facades, the refinement and quality of the craftsmanship that created such interiors are, like the beauty of these Jewish wedding rings, evidence for the stability and dynamic creativity of Jewish life in northern Italy at this time.

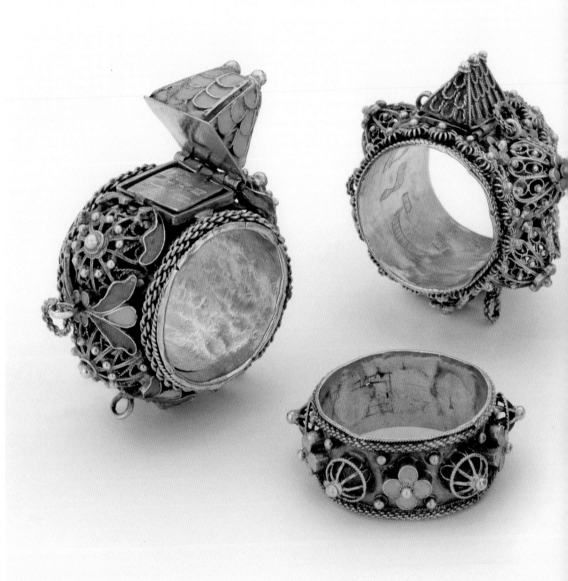

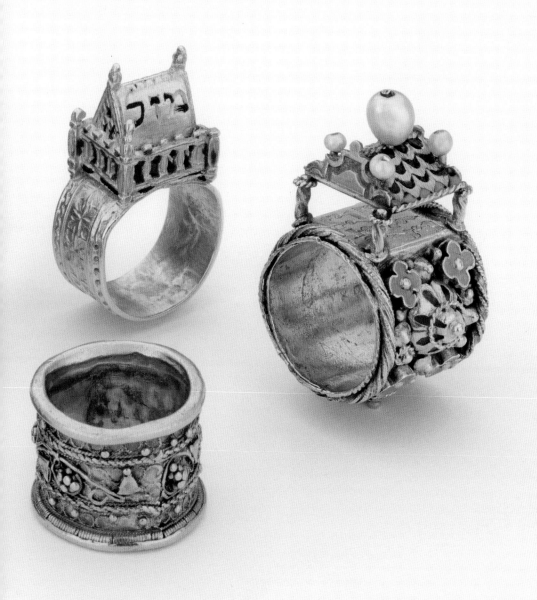

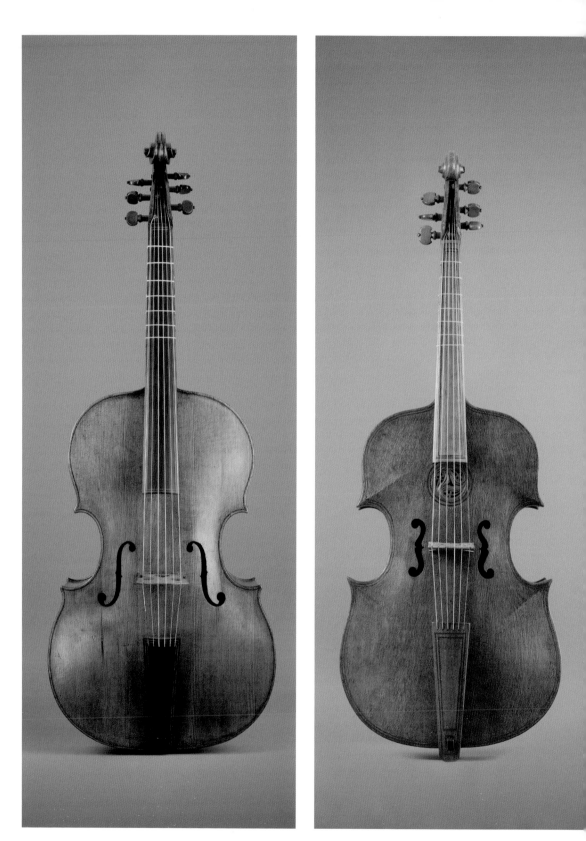

17 ITALIAN VIOLS 17

CREMONA AND BRESCIA, ITALY, 1570–1620

'Then we shall sing new songs and rejoice'

Raphael da Faenza, *Song with Galantina*

EWISH IMMIGRANTS FREQUENTLY took their skills and occupations with them from one country to another. Among the substantial numbers of Jews who settled in northern Italy after fleeing persecution in Spain and Portugal were many musicians and makers of musical instruments. They brought with them centuries of musical experience and technical accomplishment, helping to secure northern Italy's reputation during the Renaissance as home to some of the greatest musical instrument makers in the world. These late sixteenth-century Italian viols (*viola da gamba* in Italian*)* were made by two maestros of the profession, Girolamo Amati and Gasparo da Salo.

Although shaped broadly like modern cellos, viols have six strings rather than four, and usually a rose for sound production. They also have characteristics of lutes in the purfling around the edge of the instrument. On the back of the Amati viol, the letter 'M' indicates that this particular instrument was made for the rich and powerful Medici family. The da Salo viol has the unusual feature of subtle diagonal ridges where the upper and middle bouts meet. The body of the viol is made of an unusual type of spruce, used only by da Salo. Both of these exceptional musical craftsmen made their mark in cities that were already renowned for music, Brescia and Cremona. Less well-known is the fact that both Amati and da Salo had close personal connections with the local Jewish populations in the cities where they lived and worked.

Girolamo Amati (c.1551–1630) was born in Cremona. He was part of a family of brilliant instrument makers that included his father Andrea (c.1505–78), brother Antonio (c.1537–1607) and son Nicolo (1596–1684).

| 1609 Tea introduced in Europe from China | 1619 First African slaves exported to Virginia, North America | 1620 *Mayflower* sails from Plymouth to New World | 1625 New Amsterdam (Manhattan) founded by Dutch West India Company | 1626 Completion of St Peter's Basilica in Vatican City |

Andrea Amati is credited with the design of the modern violin as well as the creation of some of its finest examples. Nicolo Amati is reputed to have taught Stradavari. The surname Amati is traditionally Jewish, suggesting the family may originally have been Jews who converted to Catholicism. Andrea Amati appears to have begun his professional life as assistant to a local businessman named Leonardo da Martinengo, who was also the son of a Jewish convert. In Catholic Italy, conversion would have been an essential step for any Jew who wished to join the required guild for instrument makers.

Gasparo da Salo (1542–1609) lived in Brescia, another flourishing musical city, in the province of Venice. He also came from a family of distinguished musicians and instrument makers. By the second half of the sixteenth century his workshop was one of the most important in Europe, producing every type of stringed instrument. Da Salo introduced important innovations to the design of his violins which were particularly known for their rich tone and powerful sound, important for performances in large open air venues such as Piazza di San Marco in Venice. According to Francisco Bontempi, who has discovered much previously unknown information about the ancient and thriving Jewish presence in Cremona and Brescia, Gasparo da Salo enjoyed a long-standing association with a Jewish family called Bachi, who supplied the special type of spruce da Salo used for his famous instruments. The Bachis later moved to Cremona, after plague killed many Brescian instrument makers. Brescian Jews were also behind the invention of a secret recipe for the varnish used in da Salo's instruments, claimed to contribute to the rich tonal qualities of the stringed instruments for which the region was renowned.[105]

In Brescia and Cremona music brought Jews and non-Jews together for both work and pleasure. The results were not always to everyone's liking. The Archbishop of Milan, Carlo Borromeo, complained of Cremona in 1575 that 'During Lent the Jews celebrate their Purim and grill meat with Christians and sing, play instruments, dance, and have a tournament with them'. He also objected to 'A certain Moses [who] maintains a school where he teaches the playing of musical instruments and dancing. The school is also attended by Christians during Lent and other holidays'.[106]

Whether or not such complaints had an immediate impact on people's behaviour, they nevertheless sound a warning note. After more than a thousand years of successful co-existence and fruitful interaction between Jews and Christians, Brescia expelled its Jewish population in 1572 and Cremona followed suit in 1597. For the next five centuries the role played by Jews in creating the musical instruments for which these two cities were so famed was almost entirely expunged from the official record.

Brescian Jews were also behind the invention of a secret recipe for the varnish

1632–52 Building of the Taj Mahal in India

1636 Harvard University founded in Cambridge, Massachusetts

1642–49 English Civil War

1648 Peace of Westphalia forms basis of modern nation-state system

1649 Charles I of England beheaded. England becomes a Commonwealth

But it was not only the instruments of northern Italy that were highly prized. The musicians too were in great demand. Henry VIII, a passionate lover of music and great enthusiast for dancing, singing and composing, swelled the number of English court musicians tenfold during his reign. In the 1530s the king decided he wanted some of these brilliant Italian musicians for his court in London. Jews were still banned from England at this time by royal edict, but Henry was never one to let existing rules stand in his way. In 1540 he hired a six-member violin/viol consort, known as the *newe vialles*, or the Venetian Brethren, led by Ambrose Lupo. All six musicians were Jews from northern Italian Sephardic communities. Places at court were passed from father to son, and the family of Ambrose Lupo formed a musical dynasty in the court of Henry VIII and beyond, making a major contribution as performers and composers for several generations.[107] As Roger Prior has pointed out: 'Under Henry, the 'English' viol consort at court was entirely the province of not just imported foreign musicians, but mostly Jewish ones.'[108]

Nor were the Lupos the only Jewish musicians in Henry VIII's court. A few months earlier, in October 1539, Henry had dispatched his agent Edmond Harvel to Venice to procure a top-notch recorder consort. Four brothers by the name of Bassano were found, described in a letter from Harvel to Thomas Cromwell as 'all excellent and esteemed above all other in this city'.[109] Before the year was out not four, but five Bassano brothers

and their families had travelled to England at the king's expense and were installed at court in London. They and their descendants would serve as musicians in the royal court for the next hundred years, where they played not only the recorder, but the cornett, crumhorn, flute, lute and shawn. They also composed music for the court and were highly regarded instrument makers.

Although they did not advertise the fact, Bassano was a common name among northern Italian Jews in the sixteenth century. The family probably came from a town called Bassano del Grappa, which had expelled its Jewish population in 1516. This may explain why the Bassanos had moved to nearby Venice and, in public at least, now chose to pass as Catholics. Venice cannot have felt entirely safe, however, or it is unlikely the brothers would have seized the opportunity, at some personal risk, to leave everything behind in 1539 and chance their luck in England. Another clue to the family's identity is the Bassano coat of arms, which consisted of three silkworm moths and a mulberry tree, indicating a link to silk-farming. The art of sericulture (silk-making) had been introduced to Italy by the Jews and for a long time was an exclusively Jewish occupation.

Once in England the Bassanos settled to begin with close to the Portuguese Jewish community in London. Although outwardly Catholic in Venice, they soon began attending the Protestant Church in London, dropping their previous Catholic appearances 'with suspicious ease'. At the same time, however, they

seemed to retain some attachment to their Jewish roots. Several of the Bassano brothers and their children went on to marry Jews, including members of the Lupo family.[110]

The social status of musicians rose sharply from the mid-sixteenth century on and, as court musicians, the Bassanos and Lupos were already a cut above all other musicians in Tudor and Elizabethan England. Both these musical dynasties continued to flourish under Henry VIII's daughter, Elizabeth I. The second generation of Lupos and Bassanos were part of the circle of court entertainers that included William Shakespeare, whom they would certainly have known. Musicians and actors often worked together when they performed for the queen, and also met socially outside of court.

Emilia Bassano (1569–1645), the younger daughter of Baptista Bassano, has been proposed as a possible candidate for the enigmatic 'dark lady' of Shakespeare's sonnets, and it is entirely plausible that Shakespeare knew Emilia, who was for many years the mistress of his patron, Lord Hunsdon.[111] Sonnets 127–54 make frequent reference to his tormented passion for a black-haired, black-eyed woman, which fits with Emilia's dark Sephardic complexion. They also contain numerous veiled allusions to Jews, and possible references to the Bassano coat of arms. Like the Lady of the Sonnets, Emilia was illegitimate, married, sexually promiscuous and musical. The sonnets are filled with puns and word-plays connected to music and musical instruments, for example Sonnet 128, which

opens with the line, 'How oft, when thou, my music, music play'st', and continues through the next thirteen lines to express the poet's regret that he is not the instrument she is playing with such pleasure.[112] Emilia Bassano was almost certainly musically accomplished, as Roger Prior reminds us: 'Emilia's father, husband, son, four uncles and many of her cousins were royal musicians and as a family the Bassanos made some of the best instruments in Europe. The name Bassano was synonymous with music, and their knowledge was passed on from one generation to the next. Fathers taught sons, and had good reason to teach their daughters too, as was the custom among Italian Jews.'[113]

Besides the intriguing possibilities presented by the 'Dark Lady' sonnets, Shakespeare set two of his plays in Venice: *Othello* and *The Merchant of Venice*. One has a character called Bassanio, the other an Emilia.

Three generations of Bassanos worked as royal musicians, serving Henry VIII, Elizabeth I, James I and Charles I. Emilia Bassano's son, Nicholas Lanier, would become the first musician to hold the title of Master of the King's Music. As servants of the Court they were well paid, enjoying a certain social standing and an array of financial privileges and rewards including clothing, food and travel expenses. From being poor, low-status musicians in Venice in the early sixteenth century, the Bassano family steadily integrated into English society. They attended the Anglican Church, gave their children Christian names, acquired the title of gentleman and property

| 1664 Official charter of protection granted for Jews of England | 1665 Great Plague of London | 1666 Shabbetai Zevi declares he is the Messiah | 1670 Hudson's Bay Trading Company founded. Jews expelled from Vienna | 1683 Isaac Newton publishes Theory of Gravity |

and, in some cases, married into the English gentry. Like the Amatis and the Lupos, music and musicianship were their passport to a better life, free from the problems that came with being Jewish at a time when anti-Semitism in Europe was rife.

Although Jews were still officially banned from England in the sixteenth century, in reality small communities of Spanish and Portuguese *conversos* in London and Bristol were tolerated by both Henry VIII and Edward VI. In 1588 the *converso* Dr Hector Nunes was lauded as a hero for being the first to warn of the sailing of the Spanish Armada. Elizabeth I's physician, Roderigo Lopez, was another *converso*. In 1594 Lopez was accused of treason, tortured and executed, after which many Jews in England fled to Holland and Belgium. In 1609 Portuguese merchants were expelled from London on suspicion of being Jewish, yet within a few decades a new community of *conversos* was living in London, made up partly of refugees from Rouen and the Canary Islands.

From the sixteenth century on there is evidence for a number of individual Jews making their life in England. The first English coffee house was opened in Oxford in 1650 by Jacob the Jew, a Lebanese, who imported his coffee from Turkey. Four years later, another coffee house opened its doors on the opposite side of the street, this one owned by Cirques Jobson, a Jew from Syria. A dramatic rise in coffee-drinking in Oxford was matched by an increasing interest in the Hebrew language and theology, which made Jewish scholarship a valuable source of information for Protestant theologians. Men such as John Claymond (1517–37), the first President of Corpus Christi College, Oxford, and Edward Pococke (1604–91), Regius Professor of Hebrew at Oxford, were passionate collectors of Hebrew manuscripts and early printed books, ensuring the preservation of a great many priceless Jewish texts. Thomas Bodley (1545–1613), founder of the Bodleian Library in Oxford, was another keen Hebraist, who actively sought Hebrew manuscripts for his new library. He also seems to have known a number of local Jews, unofficially tolerated at that time in Oxford as Hebrew teachers.

Other Jewish scholars secured prestigious academic posts in English universities by converting to Christianity. Immanuel Tremellius (*c.*1510–80) was Professor of Hebrew at Cambridge University from 1548 until 1554. Born and raised in a Jewish family in Ferrara, Italy, he converted in the 1530s while studying in Padua. Tremellius published numerous important and influential translations of the Old and New Testament, including a Hebrew translation of Calvin's Geneva Catechism. His Latin translation of the Hebrew Bible was reprinted 34 times in 150 years. Tremellius's relationship with his Jewish roots was not entirely

In the space of just over a century, Jews were now allowed to live openly in England once more

| 1685 Births of composers Bach, Handel and Scarlatti | 1687 Newton publishes Laws of Motion | 1694 Bank of England established | 1699 First steam engine | 1700–60 Life of the Baal Shem Tov |

straightforward. Despite his conversion, his work was suffused with the influence of his Jewish upbringing and he was often accused of 'judaising'. His scholarship made Protestant theologians far more aware of rabbinic thought and the Hebraic origins of the Bible, and while Tremellius rarely cited Jewish authors in his published works, he referred extensively to rabbinic authorities and other Jewish sources in his lectures.

Jacob Barnet, another Hebrew teacher in England, was less effective in walking this fine religious tightrope. A Venetian Jew, Barnet moved to England in the early seventeenth century on the promise that he would convert to Christianity. He taught Hebrew to the French scholar Isaac Casaubon, who took a keen interest in Jewish texts, and whose own family had experienced religious persecution as Huguenots. By 1614 Barnet was living in Oxford, but was still Jewish. The day before he was due to be baptised, Barnet absconded. The Warden of New College ordered a hunt for Barnet, who was soon found, arrested and brought back to Oxford, where he was imprisoned. When he allegedly confessed that he had no intention of converting, there were calls for his execution. Barnet languished for some time in the university prison, before somehow managing to escape and slip out of the country, possibly with Casaubon's help. Not long after this, in 1641, the German botanist, Jacob Bobart the Elder, arrived to take up post as the first Head Gardener of the recently established Oxford Botanic Gardens. An eccentric character who kept a

goat for a pet, Bobart was almost certainly a crypto-Jew.

The position of Jews in England was transformed in 1655 when Rabbi Menasseh ben Israel of Amsterdam submitted a seven-point petition to the Council of State, requesting the return of Jews to England:

> [T]he Jewish Nation, though scattered through the whole World, are not therefore a despicable people, but as a Plant worthy to be planted in the whole world, and received into Populous Cities: who ought to plant them in those places, which are most secure from danger; being trees of most savoury fruit and profit[.]

Oliver Cromwell supported Menasseh's petition, and called a conference at Whitehall to discuss the matter, although his motivation for supporting readmission may have had less to do with the principle of religious tolerance than the potential benefits to the English economy.

Although no official verdict was reached and no formal decree passed, it was established by Cromwell at the Whitehall Conference that no actual law forbade readmission. By skilfully avoiding a political collision with opponents on the issue, Cromwell succeeded in removing any legal obstacle to readmission and, after 350 years of official absence, Jewish life in England gradually revived.

Two centuries later, the English-born Jewish artist Solomon Hart would depict

1701 Kingdom of Prussia declared under Frederick I

1703 Peter the Great founds St Petersburg

1715 Louis XIV dies. Beginning of Age of Enlightenment

1729–86 Life of Moses Mendelssohn, father of the Jewish Enlightenment

1740 Frederick the Great assumes power in Prussia

this momentous occasion in Jewish history with his marvellously evocative painting, *The Conference of Menasseh ben Israel and Oliver Cromwell* (1878). The son of an engraver, Hart was born in 1806 and went on to become the most successful Jewish artist working in Britain in the nineteenth century, a life path and career trajectory that owed a good deal to Menasseh's petition to Cromwell. His grandfather, Henry Hart, had arrived in England from Prussia in around 1750 and settled in Plymouth, where there was an established Jewish community. An observant Jew for his whole life, Solomon Hart painted a number of joyous Jewish religious scenes, including *The Feast of the Rejoicing of the Law at the Synagogue in Leghorn, Italy* (1850) and *Interior of a Polish Synagogue at the Moment when the Manuscript of the Law is Elevated* (1830). He also painted Jewish characters from English literature, including Shylock from *The Merchant of Venice*. The first Jew elected to the Royal Academy (see chapter 18), he was Professor of Painting at the Royal Academy from 1854 to 1863 and its Librarian from 1864 to 1881, a year which saw the death of another great English-born Sephardi Jew,

Benjamin Disraeli, the country's first Jewish-born Prime Minister.

In the space of just over a century, from the time when the Bassanos arrived in London and were obliged to keep quiet about their Jewish identity and origins, Jews were now allowed to live openly in England once more. In December 1656 a lease for the first London synagogue was signed, and in 1698 the Act for Suppressing Blasphemy made it legal to practise Judaism. By 1690 around 400 Jews were living in England; by 1734, this number had increased to 6000. For the following two hundred years Sephardi and Ashkenazi Jews continued to move to England, often in flight from persecution elsewhere in Europe, in the hope of building more settled and prosperous lives in a country known for its religious tolerance and economic vitality. They no longer had to exist under the guise of Christianity, as the Bassanos and Lupos had initially done, or convert, as the Amatis had in Italy. Geographical mobility was crucial to the success of these great musical families, as it would continue to be essential for countless others, a feature of Jewish life that, time and again, would prove vital to the survival of the Jewish people.

DIASPORA

Fig.27 Interior view of the Jewish catacombs of Vigna Randanini in Rome.
©LEONARD RUTGERS

Fig.28 Part of a decorative panel from a sarcophagus lid, depicting the funeral feast for the deceased. Rome, *c.* fourth century. 30 cm x 68 cm.
© ASHMOLEAN MUSEUM, UNIVERSITY OF OXFORD, AN2007.46

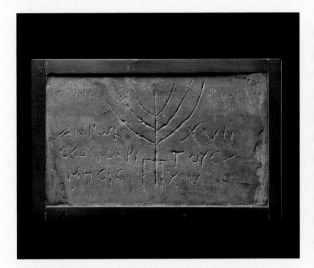

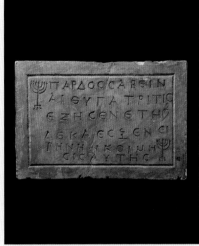

Fig.29a Marble epitaph of Venerosa, from Jewish catacombs at Vigna Randanini, Rome, fourth century CE. The inscription reads 'Venerosa aged 17, and (she lived) with her husband 15 months'. 33.3 cm x 36.8 cm.

© ASHMOLEAN MUSEUM, UNIVERSITY OF OXFORD, AN2007.59

Fig.29b Marble epitaph of Sabeina, from Jewish catacombs at Vigna Randanini, Rome, fourth century CE. The inscription reads 'Pardos to Sabeina his daughter, who lived 16 years. In peace is her sleep'. 28.5 cm x 43.5 cm.

© ASHMOLEAN MUSEUM, UNIVERSITY OF OXFORD, AN2007.53

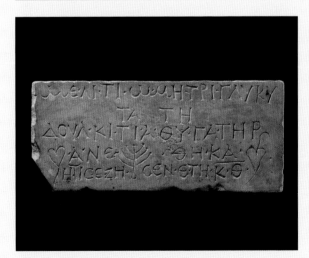

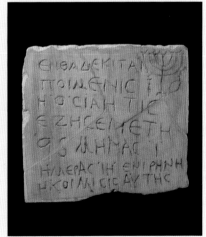

Fig.29c Marble epitaph of Melition, from Jewish catacombs at Vigna Randanini, Rome, fourth century CE. The inscription reads 'For her dearest mother Melition, Dulcitia her daughter set (this) up. She lived 29 years'. 20.2 cm x 46.7 cm.

© ASHMOLEAN MUSEUM, UNIVERSITY OF OXFORD, AN2007.57

Fig.29d Marble epitaph of Poimenis, from Jewish catacombs at Vigna Randanini, Rome, fourth century CE. The inscription reads 'Here lies Poimenis, the pious woman, she who lived 96 years 10 months 8 days. In peace her sleep'. 17.2 cm x 29.5 cm.

© ASHMOLEAN MUSEUM, UNIVERSITY OF OXFORD, AN2007.57

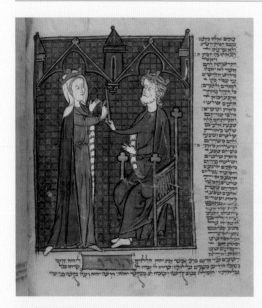

Fig.30 Full-page miniature of King Ahasuerus holding out the golden sceptre to Queen Esther, from *The Northern French Miscellany*, The scene illustrates the Book of Esther, 8:4.

© THE BRITISH LIBRARY BOARD BL MS ADD 11639 F.260V

Fig.31 Aert de Gelder (1645–1727), *Esther and Mordecai*.
Oil on canvas, 75.5 x 96 cm.

PRIVATE COLLECTION

Fig.32 Manuscript from the Cairo Geniza, now in the Bodleian Library, Oxford. An autograph copy of Moses Maimonides's draft of part of the *Mishneh Torah* (Repetition of the Law) in Maimonides' own hand. Fustat, Egypt, twelfth century.

© THE BODLEIAN LIBRARIES, UNIVERSITY OF OXFORD, MS. HEB. D. 32, FOLS. 53B-54A

Fig.33 Solomon Shechter in his rooms at Trinity College, Cambridge, at work on the Geniza fragments.

CAMBRIDGE UNIVERSITY LIBRARY

Fig.34 Medieval Jewish money changers. Illustration from a fifteenth-century French manuscript.

WWW.BIBLELANDPICTURES.COM / ALAMY STOCK PHOTO

Fig.35 The expulsion of the Jews from medieval France in 1182.

ART COLLECTION 3 / ALAMY STOCK PHOTO

Fig.36 Festival prayer book for Shavu'ot (Festival of Weeks)
and Sukkot (Festival of the Tabernacles), Ashkenaz, 1300–29.
Moses receiving the Ten Commandments at Mount Sinai.
Some of the human faces have been replaced with the faces
of animals, in accordance with the Biblical prohibition on
depictions of people.
© THE BRITISH LIBRARY BOARD BL ADD MS 22413 F.3R

Fig.37 *Tripartite Mahzor*, Ashkenaz, fourteenth century. Initial
word of the opening prayer for the Day of Atonement (*Kol nidrei*),
one of the most solemn days in the Jewish calendar. The scenes
of noisy fighting beasts above and below the Hebrew letters
suggest the illustrators may not have been Jewish.

© THE BODLEIAN LIBRARIES, UNIVERSITY OF OXFORD, MS. MICH. 619, FOL. 100V

Fig.38 *Michael Mahzor*, Germany, 1257–8. Opening hymn for the 'Sabbath of the Shekel'. The illumination is upside down, revealing the hand of a Christian illustrator who did not know Hebrew.

© THE BODLEIAN LIBRARIES, UNIVERSITY OF OXFORD, MS.MICH. 617, FOL. 4V

Fig.39 *Book of Ezekiel* (chapter 30), England, early thirteenth century. The main text is in Hebrew with Latin *superscriptio* and the Vulgate.

© THE BODLEIAN LIBRARIES, UNIVERSITY OF OXFORD, MS CAN. OR.62, FOL. 59R

Fig.40 *Oppenheimer Siddur*, fifteenth century, Germany. This tiny and exquisite prayer book was made by and for the personal use of its Jewish owner, who clearly loved music. Medieval musicians here play a variety of instruments, including the lute, shawn and bagpipes.

© THE BODLEIAN LIBRARIES, UNIVERSITY OF OXFORD, MS. OPP. 776, FOL. 79V

Fig.41 Pentateuch with Haftarot and Megillot, northern Italy, (Ferrara?), 1472. The opening of the Book of Exodus. The floral decoration and animals indicate the manuscript was illuminated by a Christian artist.

Rothschild Mahzor, prayer book for the Days of Repentance, Italy, 1492. The lavish depictions of birds and animals decorate the text but do not refer to it in any way. This and the human faces suggest the illuminators were not Jewish.

Fig.43 Opening page of the *Sefer ha-Zohar*, one of the most important Kabbalistic texts. Cremona, 1558.

Fig.44 Full-page miniature of the Tree of Life guarded by four angels. *From The Northern French Miscellany*.

Fig.45 *Un mariage juif* (*A Jewish Wedding*), *c.*1780 by Marco Marcuola (1740–93).
The bride and groom stand under a *chuppah*, the traditional Jewish wedding canopy,
while a servant tries to drive away a dog that has wandered into the room.
PHOTO © MAHJ / MARIO GOLDMAN

Fig.46a & b Pair of *Ketubot* (sing. *Ketubah*) Jewish
marriage contracts, from Italy, *c.* eighteenth century.
THE NATIONAL LIBRARY OF ISRAEL

Fig.47 *Portrait of a Musician.* Anonymous Cremonese Artist (*c.*1570–90). The identity of the young man in the painting is not known but has been suggested to be the Italian master instrument maker Gasparo da Salo.
© ASHMOLEAN MUSEUM, UNIVERSITY OF OXFORD, WA1952.123

Fig.48 View of the back of a *viola da gamba* made by Girolomo Amati. The 'M' carved on the button suggests that this instrument was once the property of the Medici family.
© ASHMOLEAN MUSEUM, UNIVERSITY OF OXFORD, WA1939.24

Fig.49 Title page of Salamone Rossi's musical setting of *The Songs of Solomon*, (*Ha-shirim asher li-Shlomo* in Hebrew), Mantua, northern Italy, 1622.
PUBLIC DOMAIN

EMANCIPATION

1770 ON

During the eighteenth and nineteenth centuries, the Jewish Enlightenment, *Haskalah*, advocated religious reform and social integration. Led by German-Jewish philosopher Moses Mendelssohn, *Haskalah* was a European-wide intellectual and cultural movement based on the ideal of reason. Its proponents, the *maskilim*, encouraged Jews to study secular subjects, including the sciences and modern languages. *Haskalah* coincided with a period of political and social freedom for European Jews, including the abolition of ghettos and the granting of full civil rights. As a result, many new professions and occupations became accessible to Jews for the first time.

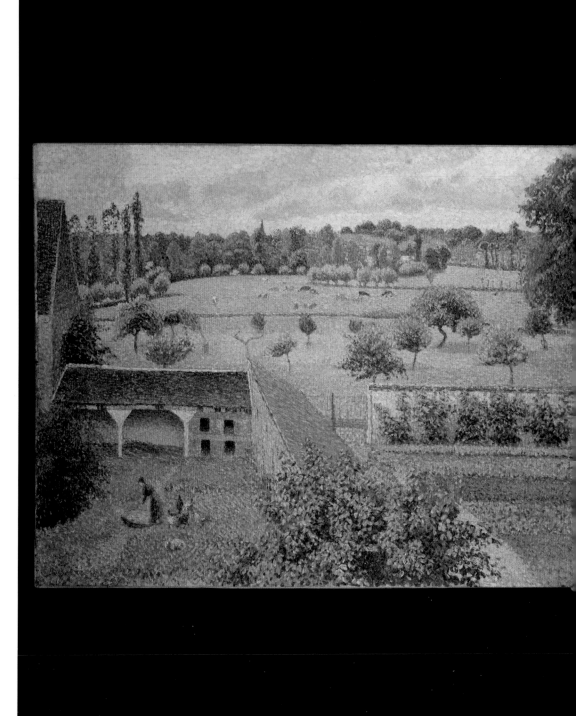

18

VUE DE MA FENÊTRE, ERAGNY

BY CAMILLE PISSARRO

NORMANDY, FRANCE, 1886–8

'If you will it … it is no dream.'
Theodor Herzl, *Altneuland*

'BLESSED ARE THEY who see beautiful things in humble places where other people see nothing.' This was the opinion of the artist Camille Pissarro, who painted urban and rural landscapes alike with a meticulous eye for the humble and beautiful. Despite the fact that he was born outside of France and was of Jewish descent during a period of marked French anti-Semitism, Pissarro was a central figure in the French Impressionist art movement in the second half of the nineteenth century. His restless creative energy ensured his own work never became routine or predictable, and he was a generous and influential mentor to many younger artists, including Seurat, Cézanne, Van Gogh and Gauguin. Cézanne became a close friend and described Pissarro as 'a father to me…a little like the good Lord'.

Pissarro exhibited in all eight of the Impressionist exhibitions in Paris, the only artist to do so. It was at the last of these, in 1886, that this painting, *Vue de ma fenêtre*, was first exhibited, appearing in the same room as Seurat's *La Grande Jatte*. Two years earlier he had moved with his wife and six children (and with another child on the way) to Eragny-sur-Epte, a small village in Normandy, where he lived for the last twenty years of his life and where he painted this view from his studio window. For Pissarro the countryside was never merely scenic or a place of leisure, 'but the only viable alternative to the social ills poisoning life in the towns and cities'.[114] He wanted to translate onto the canvas the sensations made in an instant by nature, 'the beautiful harmonies which immediately hit the eye',[115] and the emotions and spiritual response they evoked. His love for the countryside was also an important

influence on Cézanne, and the two artists often painted alongside one another 'en plein air'.

In keeping with so much of his work, the serene atmosphere of *Vue de ma fenêtre* is underpinned by compositional and technical complexity. The striking red roof at the centre of the painting, in Pissarro's own opinion, gave the painting 'its whole character', although it initially failed to please his Paris art dealer. 'What they do not like are the brick-yard houses, precisely what I had so worked on!' he complained.[116] He was exploring the point technique of neoimpressionism at this stage, but was finding it 'more monotonous than simple' and resistant to 'the liberty, the spontaneity, the freshness of sensation' that he wanted.[117] He was particularly frustrated by his slow progress. 'You will not believe that

I take three or four times as long to finish a canvas or gouache...I despair of it,' he wrote in November 1886,[118] a year in which he finished seventeen oil paintings, a steep reduction on the 34 oils of the year before. Even in the final years of his life, Pissarro's artistic output was impressive. He completed 46 oil paintings in 1900, 49 oil paintings in 1901, 64 oils in 1902 and 42 oils in 1903, the year that he died. 'I cannot live without working hard,' he said, only a few months before his death. 'It has become second nature to me.'[119]

Born in 1830 on the island of St Thomas in the Danish West Indies, Jacob Abraham Camille Pissarro was the third child in a family of Sephardi Jews. There were a number of Jewish communities in the Caribbean by the early nineteenth century, the majority of which

Jewish artists in nineteenth and early twentieth century

Before the nineteenth century, Jewish painters were a rare phenomenon. In previous centuries highly skilled Jewish artisans had found artistic expression in ceramics, manuscripts, books, instruments, jewellery, glass, gold and silverware, but professional Jewish painters and sculptors were virtually unheard of. This dearth of Jewish artists is often attributed to the biblical prohibition against idolatry

and representation of human figures, but the real explanation had more to do with social and economic pressures. Materials and training were expensive, and most Jewish artists, in addition, could secure neither apprenticeships nor admission to art schools and colleges.

From the early nineteenth century on, Jewish emancipation and assimilation throughout Europe, combined with the *Haskalah* movement, the Jewish Enlightenment, at last opened the door to many fields

previously closed to Jews, including the visual arts. This led to the emergence of many outstanding Jewish artists in continental Europe in the nineteenth and early twentieth century, including Moritz Oppenheim, Camille Pissarro, Jozef Israels, Mark Antokolsky, Amadeo Modigliani, Marc Chagall and Chaim Soutine.

This was likewise a time of unprecedented opportunity for Jewish artists in Britain. Solomon Alexander Hart, born in Plymouth in 1811, the son of

were made up of Sephardis. Camille's father, Frederic, had moved to St Thomas from Bordeaux in the south of France. His ancestors, however, were not French, but Portuguese. Camille's great-grandfather, Pierre Rodrigues Alvares Pizzarro, was from Braganza in Portugal, and came from a long line of *conversos* who had secretly maintained their Jewish faith for over ten generations. It was Pierre's son, Joseph Gabriel, who emigrated to France at the end of the eighteenth century.

In Bordeaux, where Joseph settled, there had been a well-established community of Portuguese Jewish merchants since the fifteenth century. Known as 'nouveaux Chrétiens', they were welcomed for their business acumen and trade networks in this important trading port, so long as they officially lived as

Catholics. Over the centuries the need to conceal their Jewish identity slowly fell away, and in 1791 they became the first Jews in Europe to be emancipated and given full citizenship.[120] By the time that Frederic Pissarro was born, the Jews of Bordeaux were a prosperous, close-knit and openly Jewish community, with Jewish schools, kosher butchers and synagogues. Influenced by the *Haskalah* movement, the community was also highly acculturated. As a schoolchild Frederic studied French and arithmetic, as well as Hebrew and the Bible. Study of the Talmud and Midrash was expressly excluded, as was corporal punishment. Compared with the strictly religious *cheders* (Jewish schools) in Eastern Europe at this time, the curriculum in Bordeaux was astonishingly enlightened and secular.

an engraver, became one of the most important artists in nineteenth-century England, and the first Jew to be elected to the Royal Academy in 1840. Simeon Solomon, another prominent Victorian artist, was influential in the Pre-Raphaelite and Aesthetic movements, while Solomon J. Solomon, born in 1860 to a long-established Anglo-Jewish family, was a successful and innovative portrait painter in the late nineteenth century. His subjects included George V, Queen Mary and the Prince of Wales (later Edward VIII). He also painted large-scale scenes from mythology and the Bible, and during the First World War played a key role in developing military camouflage. His sister, Lily Delissa Joseph, was also a professional artist. Bradford-born William Rothenstein, the son of German-Jewish immigrants, was another key figure in the British art world at the turn of the century, founder of the Carfax Gallery, Principal of the Royal College of Art from 1920–35 and a tireless champion of many younger Jewish artists, including Mark Gertler (see Chapter 20). Works by a number of important Jewish artists, including Camille Pissarro, Lucien Pissarro, Simeon Solomon, Ossip Zadkine, Jacob Epstein and Lucien Freud, are on display in the Ashmolean, and the museum also holds works by Orovida Pissarro, William Rothenstein, Leon Bakst, Leonid Pasternak, Feliks Topolski, Max Liebermann, Barnett Freedman, Alfred Wolmark and Leon Kossoff.

1820 Antarctica discovered

1845 Oxford University Picture Galleries opens on the site of the current Ashmolean

1848 Marx-Engels publish *The Communist Manifesto*

*c.*1850 Levi Strauss starts selling 'jeans' to Californian Gold Rush miners

Religious worship of any kind would prove anathema to his son Camille, who from early adulthood was a self-proclaimed atheist and anarchist. Nor did he have much time for the bourgeois, mercantile world of his upbringing, determined instead to become an artist. In 1852, at the age of 22, after five years reluctantly working for the family business in St Thomas, Camille absconded to Venezuela with his friend, the Danish artist Fritz Melbye. 'I left everything and fled to Caracas in order to break the chain which tied me to bourgeouis life,' as he later recalled.[121] In 1855 he moved permanently to France, intent on pursuing his artistic vocation.

Pissarro made few references to his Jewish identity in his voluminous correspondence, nor are there any references to explicitly Jewish subject matter in his work. 'For the Hebrew that I am,' he once said, 'there is very little of that in me.' Yet this does not mean his Jewishness was either forgotten or irrelevant. Throughout his life Pissarro would frequently be forced to confront his Jewish origins, whether he wished to or not. Artist friends would sometimes greet him with the words 'Hail to Moses', and frequently referred to his Semitic appearance. The writer George Moore, a regular at the same Paris café as Camille, thought he looked 'like Abraham' with his long white beard. A less affectionate description by the French novelist Félicien Champsaur compared him to 'Abraham in an opera-bouffe'.[122]

At the time of his birth in 1830, Camille's parents were mired in an ongoing and very public controversy about their marriage. Frederic had been sent to St Thomas as a young man to help his uncle's widow, Rachel Petit, manage the family business. The couple fell in love and in 1826 they were married 'according to the Israelitish ritual'. The marriage was duly announced in the *St Thomas Times*, but the very next day the synagogue published a counter announcement declaring that marriage to an aunt was prohibited under Jewish law. It took Frederick and Rachel seven years of long and fierce argument before their marriage was formally sanctioned by the Jewish authorities. Their three children born in the meantime, who included Camille, were considered illegitimate and forced to attend the local primary school, where they were the only white children. The stigma of illegitmacy and the scandal of his parents' marriage were no small matter in the tiny Jewish community on St Thomas, and the distress it caused the whole family may well have informed Camille's own ingrained atheism and anarchism.[123]

At the age of eleven, Camille was sent to boarding school outside Paris and, apart from a brief spell back in St Thomas between 1827 and 1854, he would spend the rest of his adult life in France. One indication of just how uninterested he was in his Jewish heritage as a young man comes from a letter from his father, written in early October 1859, by which time the family had moved back to France. Camille was then working as an artist in Paris, and his father was writing to remind him that the next day was Yom Kippur, one of the most important days in the Jewish calendar, and to ask Camille, on his mother's

1851 First world fair in London. Crystal Palace constructed in Hyde Park

1855 Sir David Salomons becomes first Jewish Lord Mayor of London

Alexander II becomes Tsar of Russia. Instigates progressive reforms

1858 Emancipation of the Jews Act passed in Britain

1861–5 American Civil War

behalf, to stop work for a moment and spend the High Holiday at home with his family.[124] No reply from Camille has survived.

One year later, in 1860, the issue of Jewish identity flared up more seriously, and once again in relation to marriage, when Camille became involved with Julie Velay, a kitchen maid in his parents' household. When Julie fell pregnant the couple wanted to marry, but Camille's parents refused: Julie was neither educated nor Jewish. She was no match for their Camille and crucially, because she was not Jewish, their children would not be recognised as Jewish either since Jewish identity is passed down through the mother. (Judaism was originally patrilineal, shifting gradually to matrilineality between the fourth century BCE and second century CE.) Regardless of these objections, Camille and Julie went their own way and were eventually married in a registry office in England in 1871, by which time they had two children and Julie was pregnant with their third. Despite their social differences and frequent financial hardship, it was a close and happy union, but Camille's mother's bitter and enduring objections to Julie were a source of painful tension in the family for many years to come.

Of Camille and Julie's seven children, two died in childhood. The remaining five all became artists in their own right. Lucien (b.1863), the eldest, was in many ways the closest to his father, despite moving to England in 1890. Camille wrote to Lucien every week that they were apart and the Ashmolean holds over 700 of their letters, as well as a huge archive of artwork by Camille and his descendants. Lucien's only child, Orovida (1893–1968), was born in Epping, Essex and raised in London. She also became a successful painter and printmaker. Her first catalogued etchings were made in 1914 at her grandfather's studio at Eragny in France. Carel Weight's striking portrait of Orovida is on display in the Ashmolean.

The issue of Jewishness was not yet behind Pissarro. In 1892 it reared its head once more when Lucien decided to marry. His intended wife, Esther Bensusan, was everything Lucien's mother was not: Jewish, educated and solidly middle class. This time it was her father who objected. In the eyes of Jacob Bensusan, and those of his Orthodox Jewish community in London, Lucien was not Jewish because his mother was not Jewish, just as Lucien's grandparents had feared. Jacob Bensusan would only agree to the marriage of his daughter to Lucien on condition that the couple consented to be married in a synagogue, that Lucien embrace Judaism, and that any sons must be circumcised. He threatened to disown his daughter if she continued with the marriage without these conditions. Camille Pissarro was brought in to try and defuse the 'Jewish problem', without any success. Lucien and Esther ignored her father and married in a registry office, just as Camille and Julie had done 21 years earlier.

It was politics, however, rather than family and marriage that obliged Camille Pissarro to examine his feelings about his Jewish identity most deeply. The trigger for this

1862 Moses Hess publishes *Rome and Jerusalem*

1863 Emancipation Proclamation issued, freeing all American slaves

1865 US President Abraham Lincoln assassinated

1867 Karl Marx publishes *Das Kapital*

Full emancipation of Jews in Austro-Hungarian empire

was the notorious Dreyfus Affair. In 1894 a French military officer called Captain Alfred Dreyfus was accused of treason for allegedly passing French military secrets to the German Embassy in Paris. Evidence soon began to emerge that Dreyfus was entirely innocent of the charges and the real culprit was a French nobleman, Major Ferdinand Estherhazy, who had been receiving a monthly pension from the German attaché in exchange for information. But the French military authorities, hoping to avoid a scandal, hushed up the evidence in favour of Dreyfus, who was put on trial, found guilty and sentenced to imprisonment on Devil's Island. Appeals to overturn the conviction were refused. Dreyfus was a Jew, and for a great many people in French society at the time this was proof enough of his guilt.

The Dreyfus Affair bitterly divided France as a nation and brought deep-seated anti-Semitism into the open. The Affair also divided the French artistic community. Many sided with Dreyfus, among them Pissarro, Monet and Signac, but others, including some of Pissarro's closest friends such as Cézanne, Renoir and Degas, did not. Renoir expressed the opinion that Pissarro and his family belonged

to 'that Jewish race of tenacious cosmopolitans and draft-dodgers who come to France only to make money', while Degas, who had worked alongside Pissarro and corresponded with him closely for many years, and whom Pissarro greatly admired, emerged as a rabid anti-Semite, refusing to have anything more to do with his former friend and colleague. A painting by Degas exhibited in Paris in 1879, *Portraits à la Bourse*, depicts Jewish financiers with caricatural loathing as sinister, hook-nosed figures. After Camille's death Degas wrote to the artist Henri Rouart:

> So he has died, the poor old wandering Jew ... What has he been thinking since the nasty affair, what did he think of the embarrassment one felt, in spite of oneself, in his company? ... What went on inside that old Israelite head of his? Did he think only of going back to the times when we were pretty nearly unaware of his terrible race?[125]

What went on in Pissarro's head even before the Dreyfus Affair is revealed in some of his letters. In May 1889 he wrote to his niece about his lack of acceptance as an artist, which he believed was:

> ... A matter of race, probably. Until now, no Jew has made his art here [in France], or rather no Jew has searched to make a disinterested and truly felt art. I believe that this could be one of the causes of my bad luck.[126]

Strangely, in the same year, he produced a series of 28 pen and ink drawings, *Les Turpitudes Sociales*, satirising capitalist society. As Degas had done ten years earlier, Camille in these drawings depicted rich Jewish financiers with hook noses and pot bellies, a series of images that to modern eyes look shockingly anti-Semitic. These drawings explicitly expressed his loathing for capitalism, but perhaps they also answered a less-conscious desire to distance himself from what he also disliked in some of his fellow Jews. At this point, however, it seems that he did not identify himself directly with these stock images, nor feel implicated in the broader anti-Semitism they expressed.

Between 1889 and 1898, however, the subject of anti-Semitism and the Dreyfus Affair crop up repeatedly in his correspondence, showing Pissarro's growing recognition that he, too, as a Jew, was vulnerable to the widespread and indiscriminate hatred poisoning his country. He sent a passionate letter of support to the novelist Emile Zola, who had publicly denounced the French government for its treatment of Dreyfus in his famous article *J'accuse*. 'Accept the expression of my admiration for your great courage and the nobility of your character,' Pissarro wrote in his letter to Zola, who in 1898 was forced into exile in England (accompanied by his wife and his mistress) to evade imprisonment for libel for his outspoken criticism of the French authorities. Other correspondence sent by Pissarro at this time shows how deeply sickened he was by the anti-Semitic opinions being expressed

in the French press and reveal a close interest in the progression of the Dreyfus case.[127] At one point his wife Julie even wrote to him, angrily complaining that 'Doubtless the affaire Zola takes all your time, so you can't write to me …That interests you much more than your family'.[128] Pissarro's response to the Dreyfus Affair shows that 'he took [it] very much to heart [and] had become sensitised to the various manifestations of anti-Semitism and to their dangerous consequences'.[129]

Until his death, Pissarro continued to produce paintings that seemed unaffected by his evolving consciousness of what it meant to be Jewish. Yet his life and letters tell a different story, giving us a better understanding of a Jewish artist's dilemma in late nineteenth-century France.[130]

Camille Pissarro died in 1903, three years before Dreyfus was finally officially fully exonerated and pardoned. For many Jews and non-Jews, in France and other countries, the answer to the seemingly ineradicable evil of anti-Semitism was Zionism and the creation of a Jewish national state, where the Jews could live their lives free at last from fear of persecution. The Dreyfus Affair played a significant part in the formation and pursuit of the Zionist goal, a movement spearheaded by the Hungarian Jewish journalist Theodor Herzl, who covered the Dreyfus trial for the Viennese newspaper, *Neue Freie Presse*, and spent the rest of his life lobbying tirelessly for the creation of a Jewish national homeland. Herzl set out his political manifesto in 1896 in his hugely influential work *Der Judenstaat* (The Jewish State). He

followed this up with a novel, *Altneuland* (Old New Land), published in 1902, depicting his utopian vision of an egalitarian society free of anti-Semitism in which women had equal voting rights, property was shared and Jews and Arabs lived peacefully alongside one another. 'It goes without saying,' Herzl wrote in his diary around this time, 'that we shall respectfully tolerate persons of other faiths and protect their property, their honour, and their freedom with the harshest means of coercion. This is another area in which we shall set the entire world a wonderful example.' *Altneuland* was translated into Hebrew with the title *Tel Aviv*, meaning 'hill of Spring', which gave its name to the city founded soon after by Zionist Jews in 1909. Herzl died in 1904, too soon to see either the building of Tel Aviv or the realisation of his dream of a Jewish homeland, but in 1949, in accordance with his will, Herzl's body was moved from Vienna to Jerusalem and buried on Mount Herzl, named in his honour.

At the time of Camille Pissarro's death in 1903 and Herzl's a year later, Jewish political nationalism was still in its infancy. For many European Jews, especially those living in the Austro-Hungarian and Russian empires, where conditions for Jews were becoming increasingly difficult, Zionism gave new voice to an ancient and deeply-felt longing for a return to Eretz Israel, the land of their forefathers. Unexpected support for the Zionist cause came from a number of influential evangelical Christians, who concurred with the view that Palestine was the ancient homeland of the Jewish people and welcomed the

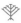

return of the Jews to the Holy Land as a necessary precursor for the return of the Christian Messiah. By no means all Jews, however, supported the nationalist goals of the Zionists. Claude Montefiore, for one, argued that it would undermine the stability of Jews settled in the diaspora and be exploited by anti-Semites wanting to rid their countries of Jews. While Montefiore would be proved correct in some respects, for a great many Jews the coming decades only intensified this longing, which rapidly hardened into a practical resolve as it became ever more apparent that secularism, assimilation and acculturation (or even just keeping your head down and digging your cabbage patch) had done little to diminish deep-seated prejudice against Jews.

This was the dawn of a century that would see a phenomenal outpouring of Jewish talent in every conceivable branch of professional life, from architecture to art, science, mathematics, economics, music, law, literature and psychology. But it was also the century that saw anti-Semitism unleashed in its most terrible form yet, with the rise of German fascism under the Nazis. In the space of just 50 years Nazism would engulf the whole of Europe and lead to the murder of more than six million Jewish men, women and children, and many millions of others. Among them were not only Herzl's youngest daughter, Trude, who died at the hands of the Nazis in Theresienstadt, but also Alfred Dreyfus's granddaughter, who was murdered in Auschwitz.

Pissarro's life and art have their place in this complex, wider Jewish story. His family were, for generations, part of the European Jewish diaspora, striving to integrate their existence with those around them, whether overtly or covertly, to live as ordinary citizens and to be treated as individuals, regardless of faith or ethnic identity. Pissarro himself eschewed all outward forms of Jewishness, but he could not entirely escape his Jewish roots, nor, in the last decade of his life especially, the dark and far-reaching shadow of anti-Semitism.

The Ashmolean holds one of the world's largest archives of artworks by Camille Pissarro, his son Lucien Pissarro and his granddaughter Orovida Pissarro. The collection includes twelve oil paintings by Camille, over 500 of his drawings and a virtually complete set of his etchings and lithographs. It also contains many of Lucien's watercolours, oils, sketches, woodblocks and engravings, together with the 34 books he produced for his publishing venture, The Eragny Press, which printed works by Flaubert, Ronsard, Villon, Keats, Coleridge and the Belgian poet Verhaeren. In addition to the extensive correspondence between Camille and Lucien, the Pissarro Collection in the Ashmolean contains more than 500 letters from Lucien to his family and friends, among whom were many leading artists including Gauguin, Sickert, Signac and Monet, as well as close to 400 letters written by Julie Pissarro, and several hundred more to and from Orovida.

19 PROCESSION
BY DAVID BOMBERG

LONDON, ENGLAND, c.1914

> 'Floating, sailing in a sea of blue, alert to the song
> of delight in the heart of the heavens – of the sky,
> circling mutely in searing light.'
>
> Shaul Tchernichovsky, *Eagle! Eagle Over Your Mountain*

FROM 1881 ONWARDS, anti-Semitism erupted across the Russian empire in waves of violent pogroms that would continue on and off for 30 years, resulting in the deaths of many thousands of Jews and leaving hundreds of thousands more homeless and destitute. Economic conditions in parts of Russia and elsewhere in Eastern Europe also deteriorated markedly during this period. These severe and combined pressures on Jewish life led to mass emigration. Between 1881 and 1914 over 2 million Jewish people left Russia, Poland and the Austro-Hungarian empire in search of better, safer lives elsewhere. The majority made their way to America; many others emigrated to Palestine, South Africa and elsewhere in Western and Northern Europe. Around 150,000 Jewish immigrants came to Britain. Their children included a generation of brilliant young Jewish artists, among whom was the outstanding modernist painter David Bomberg.

This powerful early work by Bomberg was created at some point between 1912 and 1914, possibly in response to the unexpected and devastating death in 1912 of his mother, to whom he was exceptionally close. A watercolour from 1913, entitled *Family Bereavement*, depicts a mourning family, almost certainly Bomberg's own. At the centre of the picture two people cling to one another, their partially abstracted forms anticipating the way Bomberg renders human figures in *Procession*. Here, geometric blocks of colour are carefully juxtaposed to evoke the ponderous forward movement of what appears to be a funeral procession, while also conveying the heavy weight of the mourners' sorrow, of individuals bowed down with grief.

1899–1900 Famine in India. Over one million deaths	**1899–1902** Second Boer War. 26,000 Boers die in British concentration camps	**1900** Sigmund Freud, *The Interpretation of Dreams*	**1901** Nobel Prizes awarded for first time	US President William McKinley assassinated by Leon Czolgosz

An atmosphere of intense personal loss is here mediated by Bomberg through contrasting elements of rigidity and fluidity and his skilled deployment of semi-abstract techniques. A work by Jakob Kramer, *The Day of Atonement*, painted a few years later in 1919, although very different in style, bears interesting similarities to *Procession*. Kramer, who knew Bomberg personally and professionally, portrays a group of Jewish worshippers gathering to pray on Yom Kippur, a day of mourning in Judaism, wearing their *tallit* (prayer shawls) draped over their heads, their bodies forming very similar shapes to those Bomberg alludes to in his boldly innovative earlier work.

Procession was painted on paper in thickly applied oils, and was afterwards cut out and attached to a panel of plywood, then lightly varnished, possibly at a later date. The brushstrokes within each section of the painting are in the same direction, but change from one section to the next, helping to give the complete work its palpable sense of movement. The frame has been made simply by attaching four wooden battens onto the front of the panel. Just visible in the lower right-hand corner of the painting is Bomberg's signature. On the back of the panel there are signs of an unfinished picture of a standing figure, possibly a self-portrait, painted directly onto the wood without any primer or ground. There are also traces of words left by labels which were subsequently removed, one of which

> *'Pugnacious wasn't strong enough. He wanted to dynamite the modern art world'*

seems to refer to Lambs Conduit Street in London, where the sculptor Jacob Epstein, a friend and sometime patron of Bomberg's, then had a studio.[131]

While David Bomberg's adult life was marred by an exceptional and wholly unwarranted degree of neglect by the London art world, his early years were in many ways entirely typical of the experience of children of British Jewish immigrants from Eastern Europe. The seventh of eleven children, he was born in 1890 in the slums of Birmingham. His father, Abraham, was a leather worker from Poland. The family had fled to England a short time before Bomberg's birth to escape anti-Jewish pogroms in Eastern Europe, and in 1895 the family moved from Birmingham to the East End of London. Bomberg showed an artistic gift from an early age and his mother, Rebecca, nurtured and encouraged his talent and ambition. In 1907, while drawing in the Victoria & Albert Museum in London, he was befriended by John Singer Sargent, who in turn introduced him to the influential Jewish artist Solomon J. Solomon. In 1911, with financial help from the Jewish Educational Aid Society, Bomberg was able to take up a place at the Slade School of Art.

This was an exciting and radical time in the visual arts. The advent of Post-Impressionism and the European avant-garde were shattering traditional approaches and overturning ingrained expectation about how art

should look and what it could do, and in his early work Bomberg was quick to embrace the possibilities of Cubism and Futurism. Seeing paintings by Cézanne for the first time at an exhibition of Post-Impressionist art in 1910 was a pivotal moment for the twenty-year-old Bomberg, and the French artist would prove to be a lifelong inspiration. Three years later, in 1913, Bomberg and Jacob Epstein were sent to Paris by the Whitechapel Gallery to select work by Jewish artists for its forthcoming exhibition of Modernist art. Bomberg was able to meet many of the leading artists then working in Paris, including Picasso and Modigliani, who gave him a roll of his own drawings 'to commemorate our meeting and my [Bomberg's] appreciation of his approach'.

A daring and adventurous artist from the start, Bomberg was quickly recognised as a significant figure in the emerging British avant-garde and his work elicited strong reactions. In his personality, too, he was a forceful, stubborn and outspoken presence. According to his childhood friend Joseph Leftwich, 'Pugnacious wasn't strong enough. He wanted to dynamite the modern art world'.[132] A large solo exhibition at the Chenil Gallery, London in 1914, when Bomberg was just 23 years old, led the poet and philosopher T. E. Hulme to proclaim him 'an artist of remarkable ability'.

In his early work David Bomberg frequently drew on the Jewish world of his upbringing. *Ju-Jitsu* was inspired by the East End wrestling school attended by his older brother Mo, a keen boxer, and *Jewish Theatre* and *Ghetto Theatre* by the East End's vibrant Yiddish theatre. *In*

the Hold paid homage to workers in the East End docklands, and alludes to another scene he would have known well: the chaotic disembarkation of exhausted Jewish immigrants from the holds of the ships that had brought them to England. In all these works Bomberg employed stridently Modernist art forms to express his interest in form and colour.

During the First World War Bomberg signed up for the Royal Engineers, spending two harrowing years fighting on the Western Front in France, where one of his brothers was killed in action. The entire experience left him with a deep hatred of war. Forty-one thousand British Jews (of a total population of 280,000) fought in the British Army during the war, and many died in its service, although this did little to quell anti-Jewish sentiment in England. Accusations of lack of patriotism were frequently levelled against Jewish soldiers, despite incontrovertible evidence of their bravery and loyalty. Anti-German sentiment simultaneously led to a surge of attacks on Jews and Jewish properties in England, targeted for their German-sounding names and language, which were in fact Yiddish.

In 1922 Bomberg was appointed by the Zionist Organisation to be the official artist in Palestine, which had been under British rule since 1917 following the collapse of the Ottoman empire. His official brief was to record the 'Zionist reconstruction work' with a series of depictions of 'heroic' pioneers hard at work draining swamps, quarrying and building settlements. But Bomberg was no fan of Zionism and proved a distinctly unobliging chronicler

of Zionist achievements, reluctant to compromise his artistic integrity for the sake of Zionist propaganda, as he saw it. Apart from a handful of half-hearted pictures of Jewish labourers, it was the physical, not the political, landscape in Palestine that appealed to him. The majority – and the best – of his paintings from this time are notable for their total absence of people, focusing instead on the shapes and forms of architectural structures and the natural surroundings. He was particularly mesmerised by the blazing heat and intense light. 'I was a poor boy from the East End,' he later said, 'and I'd never seen the sunlight before.'

One of his favourite places to paint was the garden of Austen St Barbe Harrison, chief government architect in Palestine from 1922 to 1937, himself a gifted artist who shared Bomberg's appreciation for the landscape and climate of the southern Mediterranean. 'How can I be happy,' Harrison once observed, 'in a place where the sun does not always shine?' Harrison designed buildings throughout Palestine, including the Central Post Office on Jaffa Road in Jerusalem. He was also responsible for the design of the new coinage for British-ruled Palestine. Back in England in the late 30s, he designed the buildings for

The Whitechapel Boys

It was Bomberg's friend Joseph Leftwich who coined the phrase 'the Whitechapel Boys' to describe the group of talented young Jewish artists who emerged onto the London art scene in the years immediately before the First World War and whose leading members were David Bomberg and Mark Gertler (see Chapter 20). The majority of the so-called 'Whitechapel Boys' – one of whom, Clara Birnberg (later known as Clare Winsten), was incontrovertibly a woman – had grown up in the Jewish East End and studied at the Slade School of Art between 1909 and 1914.[133]

Raised in tight-knit Jewish communities, in homes where English was barely spoken, these young artists were keenly aware of their status as outsiders, and acutely sensitive to the stigma of being Jewish in England at a time when casual anti-Semitism was commonplace. Many knew each other personally, having shared childhoods in the materially poor but culturally rich Jewish community in London's East End – an area so densely populated with immigrants from Eastern Europe that it was described by Leftwich as 'the shtetl transplanted to London'. In reality, poverty apart, this was a vibrantly diverse community

made up of immigrants from many different countries, whose wildly disparate religious and political views encompassed radical anarchism, Zionism, anti-Zionism, vehement atheism and intensely religious conservatism, and whose occupations ranged from peddlers and tailors to lawyers and bankers.

It was in this extraordinary, cramped, dynamic, multilingual melting pot that these ambitious young artists supported and encouraged one another in their creative ambitions. They shared studios, sat for one another's paintings and spent their evenings walking and talking together in the streets

1905–7	1906 Alfred Dreyfus	1907 Picasso begins	1908 Ford Model T	1909 Tel Aviv
State-sanctioned anti-Semitic pogroms in Russia	finally acquitted of treason charges	Cubist period	introduced	founded in Palestine

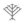

Nuffield College, Oxford. His initial plans were deemed too 'un-English' and he was obliged to adapt them, as he sniffily put it, along 'the lines of Cotswold domestic architecture'.[135] Bomberg and his first wife, Alice Mayes, had rented part of a house directly below Harrison's on the slopes of the Silwan Valley. The two men met one night when Bomberg was out painting the moonlit landscape and they quickly became fast friends.[136] By night and day the location enjoyed a stunning view across the valley and the ancient village of Silwan (Siloam in the Bible) towards Mount Zion and the Old City walls of

Jerusalem. One of Bomberg's paintings from this period, *View of Silwan*, on display in the same gallery as *Procession*, was painted from here and captures the sculptural shapes of the city in the stark, early morning light.[137]

Bomberg's time in Palestine marked the start of his lifelong engagement with the natural world, although ironically, it was a convulsion in the natural world, in the form of a severe earthquake in July 1927, that brought Bomberg's time in Palestine to an abrupt conclusion. He was painting on a rooftop near the Western Wall in Jerusalem when the quake started and, although he was unhurt,

of Whitechapel. Soon after, as students at the Slade School of Fine Art, many of them were actively involved in the emerging Modernist movement.

A defining moment for these artists came in 1914 when the Whitechapel Art Gallery opened a new exhibition entitled *Twentieth Century Art: A Review of Modern Movements*. Tucked halfway through the exhibition was a gallery labelled in the catalogue as the 'Jewish Section', which featured 54 works by fifteen different Jewish artists. They included David Bomberg, Mark Gertler, Clara Birnberg, Isaac Rosenberg, Joseph Kramer and Bernard Meninksy. Grouping

these artists together on the grounds of their Jewishness drew fierce criticism from some quarters, but the artists themselves for the most part welcomed the chance to exhibit their work, grateful for any help that came their way and eager to embrace the Whitechapel's explicit challenge to the tradition-bound world of the Royal Academy.[134] Although these artists never exhibited as a group again, they all shared a passionate interest in exploring the new forms of artistic expression spreading to England from the continent. There was never a self-styled Jewish 'group' or 'school' of painting, nor did

they share a particular set of aims or beliefs, or anything that could be called a specifically Jewish 'style' of work. But together and individually, they played a decisive and enduring role in helping to shape the English art world from 1909 onwards.

In addition to works by three of the Whitechapel Boys, David Bomberg, Mark Gertler and Bernard Meninsky, the Ashmolean's art collection includes drawings, paintings and sculpture by several other important twentieth-century Jewish artists, including William Rothenstein, Alfred Wolmark, Jacob Epstein, Lucien Freud and Leon Kossoff.

he was deeply disturbed by the physical devastation and loss of life, reminded perhaps of his traumatic time fighting in the First World War. Convinced he could not paint amidst the ruins, he hurriedly cobbled together a boat fare to France and soon after left Palestine for good.[138] Back in England, his work now increasingly turned from urban to rural landscapes, from the mechanistic to the organic. His unwavering commitment to form was no longer expressed in man-made structures, but in exuberant encounters with nature. By contrast, his few paintings of human figures from this time convey an increasing sense of isolation and alienation from British society, in part caused by his growing disquiet about unfavourable reactions to his work.

In 1929 Bomberg visited Toledo in Spain, which prompted a period of renewed artistic vitality. He returned in 1934, with his second wife, the painter Lilian Holt, and her daughter Dinora, spending time first in Ronda and then in the Asturian Mountains. 'Art endeavours to reveal what is true and needs to be free,' he once said,[139] and it was here in the Spanish countryside that he at last found the freedom to express a deep and intensely creative accord with nature in paintings that were expansive and expressive, sensual and deeply spiritual. Forced back to England once more by the outbreak of the Spanish Civil War, he was confronted with the grim realisation that while his artistic vision had been thriving abroad, his reputation back home had collapsed. From galleries to critics to collectors, London's art world turned its back on Bomberg. The

problem was not only the innate conservatism of the art establishment, but also anti-Semitism, from which his friend, the sculptor Jacob Epstein, also suffered. Between 1939 and 1944 Bomberg applied for over 300 posts and was rejected for all of them. In 1945 he finally found work as a teacher at Borough Polytechnic, where he stubbornly refused to teach to the prescribed syllabus. Fiercely criticised by other art schools, he was greatly admired by his own students and an inspirational teacher to a young generation of postwar Jewish artists, including Leon Kossoff and Frank Auerbach.

For the rest of his life Bomberg struggled for public recognition, suffering wholly undeserved neglect by the British art world. Major galleries and art critics persistently and perversely passed over his work in favour of far less significant artists. A survey of Modern British Art in 1944 entirely omitted Bomberg from its list of leading artists and sculptors, and in 1950 he was similarly excluded from a selection of artists asked to provide work for the Festival of Britain celebrations. The artist Wyndham Lewis was a lone voice in protesting, in 1949, that Bomberg 'ought to be one of the half-dozen most prominent artists in England'.[140] When Bomberg, in baffled desperation, offered four of his best works directly to the Tate Gallery, he met with a humiliating rejection. Much of his work, including many of his finest paintings, was never exhibited in his lifetime and instead sat for years in storerooms, unsold and unseen.[141] 'The world of Art,' he wrote, with understandable

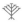
bitterness, 'is as much a jungle as the Hyena inhabited swamps of Burma Africa and the Amazon. Hunters and Hunted acquire Fame as Killers. With indifference they rip out one another's guts. The Vultures who bare the Kill, and those who submerge and drown to kill, are still our Professional Colleagues.'

Yet despite continual rebuffs and rejections, and the bouts of depression Bomberg suffered as a result, he continued to produce honest, vital and passionate work, displaying, in the words of critic and art historian Richard Cork, 'a defiant will to survive in the teeth of the most overwhelming adversity'.[142] Bideford Bay, in North Devon, inspired a number of powerful, melancholic landscapes in 1946, and a six-week stay in Cornwall in 1947, followed by a painting trip to Cyprus later the same year, produced paintings surging with physical energy and emotional intensity, reflecting Bomberg's deeply empathic response to his natural surroundings. Works such as these and his Spanish paintings are suffused with the spiritual quality that was so central to Bomberg's artistic philosophy. The physical, natural world was infinitely more than an appealing visual scene for Bomberg; it was a means to encounter the sublime, 'the magnitude contained in the Billions of tons of living rock', as he described it. A passionate belief in the ability of great art to express 'a spiritual consciousness' informed all of his mature work, enabling him 'to draw together the strands of vision, of perception, of structure and of form, in a unifying and transcendent embrace with the natural world'.[143] Although Bomberg himself attributed his artistic approach to the twin influences of Cézanne and the eighteenth-century philosopher George Berkeley, his passionate spiritual sensibility and the ecstatic quality of his engagement with the physical world resonates also with his family's Jewish roots in the world of Eastern European Hasidism.

In 1954 Bomberg and his wife returned to Spain, where he would remain until his death in 1957 at the age of 68. Working out of a semi-derelict house near Ronda, physically and artistically marginalised and in failing health, he produced his last great works. One of these is the profoundly moving self-portrait, *Hear, O Israel*. The title of the painting comes from the first words of one of the most important of all Jewish prayers, the *Shema*, recited twice daily in many synagogue services, sealed inside the *mezzuzot* nailed to the doors of Jewish homes, and the last words a Jew is meant to utter before death. Like *Procession*, painted over 30 years earlier, *Hear, O Israel* is a work full of pathos and poignancy, personal despair and spiritual nobility. It expresses Bomberg's own sense of mortality as well as his deeply felt connection to his Jewish roots. It is a painting raw with his pain and awareness of injustice, both as a Jew and as an artist. By the time of his death in 1957 Bomberg was utterly impoverished and virtually forgotten, but it is works such as *Hear, O Israel* that capture what makes him so truly and lastingly great: his unextinguished and unshakeable faith in the transfiguring and redemptive capacity of art.

20 GILBERT CANNAN AND HIS MILL

BY MARK GERTLER

ENGLAND, 1916

'Perhaps only migrating birds know –
Suspended between earth and sky –
The heartache of two homelands.'
Leah Goldberg

THE SPINDLY FIGURE at the centre of this painting by the Jewish artist Mark Gertler is the writer Gilbert Cannan, a well-known figure in early twentieth-century London society. A close friend and something of a father figure to Gertler, he is shown standing in front of his mill in Cholesbury in rural Buckinghamshire. The two men would lock themselves away in the mill to talk for hours at a time, much to the annoyance of Cannan's wife Mary, who behind his back referred to Gertler as 'a back-street Jew'.[144] The painting's bold colours and shapes have an almost child-like quality, and the work as a whole gives an initial impression of a pleasant English country scene, but this air of innocence quickly gives way to a brooding atmosphere, the sense that something is askew. Cannan himself is a curiously insubstantial figure, his features blurred and

his expression more anxious than assured. He is dwarfed by the two large dogs on either side of him and the cone-shaped mill looming behind. The recurring triangles in the picture create an uneasy sensation of entrapment, while the dark trees, the spear-like fencing and the mill all lean at odd angles, as if on the brink of collapse.

The sense of instability that pervades the painting could be an allusion to the First World War. The conflict raging on the other side of the English Channel was daily claiming the lives of thousands of young men in what Gertler, a fervent pacifist, called 'wretched, sordid butchery'. His childhood friend, the poet and artist Isaac Rosenberg, would die fighting in France two years after this painting was made. Equally, the painting's atmosphere of unease may refer to more private issues in the life of the artist and his subject. Soon after this

| 1916 Battles of the Somme and Verdun | Easter Rising in Ireland | First birth control clinic opened by Margaret Sanger in New York | 1917 Russian Revolution and creation of the Soviet Union | America enters First World War |

painting was finished, Gilbert Cannan had a serious breakdown from which he never fully recovered. The repeated triangles in the paintings may also allude to Cannan's complicated emotional entanglements. His wife Mary was still married to her first husband, J. M. Barrie, the author of *Peter Pan*, when she met Cannan. The dog on the right of Cannan in Gertler's painting originally belonged to Barrie and was the inspiration for Nana, nurse of the Darling children in *Peter Pan*. Mary and Cannan married in 1914, but by 1916, when Gertler was working on this painting, the marriage was failing and both were involved with other people. Gertler was himself locked in a hopeless love triangle with the artist Dora Carrington, who was besotted in turn and just as hopelessly with the homosexual author and historian Lytton Strachey.

Gilbert Cannan and his Mill is not only one of Mark Gertler's most enigmatic works, it is a painting with a hidden life. Beneath the overt complexities of the surface image, invisible to the naked eye, is an altogether different painting: an unfinished work that in many ways goes to the heart of Gertler's life and art. The concealed image was first discovered in 2014, when *Gilbert Cannan and His Mill* was X-rayed as part of ongoing investigations into the making and meaning of Gertler's early work by Aviva Burnstock, Head of Conservation at the Courtauld Institute, and Sarah MacDougall, Head of Collections and

To begin with the entire family lived in a single room in a tenement building in Shoreditch

co-curator at Ben Uri Gallery and Museum. They were hoping to find preliminary sketches for Gertler's famous anti-war painting, *Merry-Go-Round* (1916, Tate). Instead they found something entirely unexpected: an unfinished oil painting of a Jewish couple.

This incomplete image revealed by the X-ray bore strong similarities to a small watercolour Gertler had painted two years before, in 1914, entitled *Rabbi and Rabbitzin*. It is a stark and powerful work, which could not be more different from *Gilbert Cannan and his Mill*. Embued with a sense of weighty permanence, it depicts with great directness the poverty, stoicism and resilience of the East End Jewish community of Gertler's childhood. The couple sit side by side in their humble kitchen, their arms linked and hands clasped. There are touches of humour in the painting – the woman's bun echoing the loaf of bread, the man's hat echoing the shape of the teapot – but the overall impression is one of humility and pathos. The couple's over-large hands express the physical hardship of their lives and the ceaseless manual chores required for their daily existence, while the double circles of their interlocking arms suggest the links in a chain, conveying both the unbreakable bond between them and their deep connection to their ancient religious and cultural roots. Their strong physical postures and sombre, almost impassive facial expressions speak of the centuries of suffering of Jewish

1917 Britain conquers Ottoman army in Palestine. Collapse of Ottoman empire

The Balfour Declaration pledges support for Jewish homeland in Palestine

1918 Tsar Nicholas II and family murdered by Bolsheviks

1918–21 Russian civil war leads to widespread anti-Semitic violence

1918 11 November Armistice with Germany brings fighting to an end

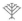

people, and allude also to the more recent troubles in Eastern Europe endured by Ashkenazi Jews such as Gertler's own parents and their contemporaries. With its fused elements of wry humour, spartan domesticity and inescapable hardship, *Rabbi and Rabbitzin* is a stylised yet honest depiction of the Jewish world that shaped Gertler's own earliest experiences and with which he was deeply familiar. It is a work that both captures the conditions of new Jewish immigrants in London and at the same time evokes the Old Country they had left behind. It is in many ways a visual counterpart to the world conjured by Sholem Aleichem's literary masterpiece, *Tevye the Dairyman*, first published in Yiddish in 1894 and later turned into the Broadway musical *Fiddler on the Roof*.

Gridlines visible on the original watercolour indicate that Gertler intended to transfer the image to a larger canvas and work it up as an oil painting. No such painting has ever come to light, but the image revealed by the X-ray indicates that he had certainly made a start on this project. Why Gertler abandoned the painting we will never know. Like many cash-strapped artists he frequently reused existing canvases, so he may well have painted over the underlying image for entirely pragmatic reasons of cost. Yet given the known facts of Gertler's personal life, the painting of a thoroughly English scene and subject over one that it is explicitly Jewish in its subject matter only adds to the final painting's complexity and sense of instability and uneasy enclosure. As Sarah MacDougall of the Ben Uri Gallery

explains, 'We know Gertler did more works on Jewish subjects than have survived, and although he stopped painting explicitly Jewish subjects, his Jewish background and culture – which at the Slade were regarded as his specialist milieu – remained very important to him. Combining this knowledge of community with elements of modernism and drawing on the wider history of the Jewish diaspora, *Rabbi and Rabbitzin* can be seen as a microcosm of his work as a whole.'[145]

Born in Spitalfields, London in 1891, Gertler was a complex individual, with what one friend described as an appealing 'gypsy gaudiness and vehemence'. Extremely charming when he wanted to be, he had 'a boundless and entirely irreverent' sense of humour and was a wonderful raconteur, with a tremendous gift for mimicry.[146] Acutely sensitive to noise, he was also emotionally volatile, given to spectacular tantrums as a child and in adulthood prone to periods of profound despair and fits of extreme behaviour. When he heard that Dora Carrington had married Ralph Partridge, for example, he tried to buy a gun and threatened to shoot himself.

Like his contemporary David Bomberg, he was the youngest child of impoverished Jewish immigrants from Eastern Europe. His mother came from Przemysl, a small village in Austria-Hungary, now in Poland, and when Gertler was still a baby his parents returned to Przemysl for several years, eking out a living as innkeepers. When the inn failed, his father, Louis, decided to try his luck in America. Faring no better there, Louis returned to

1919–23 Third *Aliyah* to Palestine. Around 35,000 Jews emigrate

1919 Treaty of Versailles formally ends the First World War

1920 First commercial radio broadcast

1920–1 Arab riots in Palestine

Women given the vote in the USA

England, and in 1896, when Mark Gertler was six years old, the rest of the family joined him. During the long voyage by ship, Gertler danced for the other passengers in exchange for food. His mother always insisted it was only thanks to her youngest son's charms that he and his four older siblings survived the journey. Later in life he frequently delighted his family and friends with his skills as an entertainer. On one occasion, when Gertler and Charlie Chaplin met in the 1930s, the pair did an impromptu double act that involved dancing on the table.[147]

Like the vast majority of Jewish immigrants at this time, the Gertler family lived in grinding poverty in the East End of London. To begin with the entire family lived in a single rented room in a tenement building in Shoreditch before eventually moving to a small flat in Whitechapel. They spoke mostly Yiddish at home, and even after 40 years in England Gertler's mother Golda, to whom he was devoted, spoke almost no English. Artistically talented from an early age, Gertler used to cover the pavements with chalk drawings. In 1908, when he was seventeen years old, he secured a place at the Slade School of Fine Art, the first working-class Jewish boy of his generation to do so. As with Bomberg, this was only possible with financial help from the Jewish Educational Aid Society, which also paid at one point for Gertler to have dental treatment, and similarly covered the cost of false teeth and clothing for Jakob Kramer and eye and lung treatment for Isaac Rosenberg, which gives some idea of just how impoverished these young artists were.[148]

Gertler began to attract serious critical attention even before he had left the Slade. His early work drew directly on the Jewish community of his youth and included powerful depictions of people and places he knew

well. He described his childhood experiences in great detail to his friend Gilbert Cannan, who drew heavily on their conversations in his 1916 novel *Mendel*. This thinly disguised depiction of Gertler's early life vividly conveys the chaotic, poverty-stricken environment he had grown up in and the enormous obstacles Gertler had faced as a poor Jewish boy intent on becoming an artist. Gertler himself loathed Cannan's book, describing it in a letter to William Rothenstein as 'an agglomeration of cheap trash' from which he had 'suffered a great deal' and 'never...ceased to blush over'.[149] His Jewish roots were nevertheless a source of pride. He was very close to his family, loved to tell stories about the Jewish East End and took both Dora Carrington and Gilbert Cannan there to see the Yiddish theatre, which he regarded as infinitely superior to English theatre.

As Gertler's artistic career took off, helped by the patronage of Lady Ottoline Morrell, he became increasingly involved with the English artistic milieu of the Bloomsbury set and the Garsington circle near Oxford, forming genuine friendships with many of the leading artists and writers of the day. Gertler's Jewishness was undeniably a part of his exotic interest. D. H. Lawrence, Aldous Huxley and Katherine Mansfield all based characters in their novels on Gertler, and his dark good looks earned him the sobriquet 'the Jewish Botticelli'. Lawrence regarded Gertler's talent as an artist as inextricably linked to his Jewish identity, writing to him in 1917 about his new work, *Merry-Go-Round*:

Your terrible and dreadful picture has just come...it is the best modern picture I have seen: it is great, and true...you have made a real and ultimate revelation – I tell you, it takes 3000 years to get where this picture is, and we Christians haven't got 2000 years behind us yet.'[150]

Virginia Woolf was less admiring of Gertler. On one occasion, after he had been for tea with the Woolfs in Sussex in 1918, she wrote in her diary:

We have been talking about Gertler to Gertler for some 30 hours; it is like putting a microscope to your eye. One molehill is wonderfully clear; the surrounding world ceases to exist. But he is a forcible young man; if limited, able & respectable without those limits; as hard as a cricket ball; & as tightly rounded and stuffed in at the edges. We discussed – well, it always came back to Gertler....And if you do slip a little away, he watches very jealously, from his own point of view, & somehow tricks you back again. He hoards an insatiable vanity. I suspect the truth to be that he is very anxious for the good opinion of people like ourselves, & would immensely like to be thought well of by Duncan [Grant], Vanessa [Bell] & Roger [Fry].[151]

Virginia Woolf's feelings about Gertler were doubtless influenced not only by her high

The Balfour Declaration

Violent pogroms in the Russian Empire between 1880 and 1921 affected over 530 Jewish communities, resulting in an estimated 60,000 deaths and the exodus of around 2.5 million Jews from Eastern Europe. Their desperate plight provoked an international outcry and fuelled the Zionist dream of a Jewish national homeland. The realisation of this goal would take the next five decades, but a decisive turning point was the Balfour Declaration of 1917.

In November of that year, the Ottoman Empire finally collapsed and Palestine fell to the British. Back in London, a group of British Zionists, headed by Chaim Weizmann, had already been working for months to secure the support of the British government for a Jewish national homeland in Palestine. A key negotiator was the brilliant Polish-born journalist and linguist Nahum Sokolow, who deployed his considerable diplomatic skills to gain British, French and Vatican support for Zionism. It was Sokolov who came up with the phrase 'Jewish national home', a formulation which would fire people's imaginations and resonate with their deepest yearnings in the years to come.

On 2 November 1917, a brief but life-changing letter arrived for Lord Rothschild from the Foreign Secretary, Lord Arthur Balfour, informing him that 'His Majesty's government view with favour the establishment in Palestine of a national home for the Jewish people, and will use their best endeavours to facilitate the achievement of this object, it being clearly understood that nothing shall be done which may prejudice the civil and religious rights of existing non-Jewish communities in Palestine, or the rights and political status enjoyed by Jews in any other country.' On the same day, Chaim Weizmann wrote to Lord Rothschild to thank him for helping to bring about 'the granting of the Magna Carta of Jewish liberties.'

The Balfour Declaration was rubber-stamped in April 1920 at the San Remo Conference, and formally agreed by the League of Nations in July 1922 when it granted Britain the Mandate of Palestine, but the Zionists still had a steep climb ahead of them. While some hailed Lord Balfour as the new Cyrus and rejoiced that centuries of exile were now at an end, the Declaration was deeply controversial both within and beyond the Jewish community. The Arab world would strenuously resist its implementation every step of the way.

During the 1920s and 1930s, persecution in Eastern Europe and Nazi Germany lent acute urgency to the practical need for a Jewish homeland, and emigration to Palestine (*Eretz Israel* in Hebrew) rose sharply. In the aftermath of the Holocaust, on 29 November 1947, almost thirty years to the day since Balfour sent his historic letter, the UN General Assembly voted for the creation of a Jewish state. Six months later, the British pulled out of Palestine, and on 17 May 1948, the State of Israel was declared. Chaim Weizmann was sworn in as the first President in February 1949. 'Few men of our time,' he said, 'have dreamed a dream so long and lived to see it fulfilled.'

opinion of herself, but also by her complicated feelings about Jews more generally. Her husband Leonard was Jewish, and this had been a considerable problem for her when she was trying to decide whether or not to marry him. Her Jewish mother-in-law was a perennial source of embarrassment, disdainfully portrayed in Woolf's diaries as vulgar and emotionally cloying, qualities Woolf explicitly associated with Jewishness. While these responses were informed by the complexities of Woolf's own psychology, they also reflected attitudes towards Jews that were by no means uncommon in England in the interwar years, a fact of which Gertler was highly aware. Pulled in such irreconcilable directions, Gertler increasingly felt himself to be an outsider, at home nowhere in English society. In an anguished letter to Dora Carrington in December 1912, he wrote:

By my ambitions I am cut off from my own family and class and by them I have been raised to be equal to a class I hate! They do not understand me, nor I them. I am an outcast.[152]

Fiercely proud as he was of his Jewish background at one level, he also felt constrained by his Jewish identity, recognising it to be a serious barrier to acceptance and success in English society. By 1915 he was expressing a desire to be free of 'the sordidness of my family, their aimlessness, their poverty and their general wretchedness'. He longed, he said, to belong to 'no class'. When his father died

in February 1917, however, he did not hesitate to cancel his plans and return home to observe the traditional Jewish mourning rites, explaining to Carrington:

It is the custom among Jews for the family of deceased to sit 'shiva' in the home where the person died. This means that the family sit on low stools for a week, say special prayers, and also the men are not allowed to shave for a month. I shall have to keep this up to some extent for the sake of my mother, and also because I somehow want to. I shall not shave probably for a week and shall be going down to my people every day for that time to mourn with them.[153]

He was deeply pained by his mother's grief, 'a sight that nearly broke my spirits for ever', and in a letter to his friend S. Koteliansky, written the following day, he describes his father's funeral as 'the worst day I've had in my life. I never wish to see another day like it'. Yet only a few lines later he is expressing an intense desire to escape his grieving family and return to his life beyond the East End: 'Apparently one does not "sit" on Saturdays, so tonight when I leave them, I shall shave... After sunset I am free so will meet as usual at the Campbells.'[154]

If Gertler was ambivalent about his Jewish identity, he was similarly suspicious of belonging to any of the 'schools of painting' of his day. Strongly influenced by the Post-impressionists, in particular Cézanne, Gertler

| 1929 New York Stock Market crash and beginning of Great Depression | Arab riots in Palestine. Massacre of Jewish population in Hebron | 1931 Construction completed on the Empire State Building | 1932 Franklin D. Roosevelt becomes 32nd President of the United States | 1933 Nazi Party takes power in Germany |

was also interested in Modernist techniques, and a great admirer of the works of artists such as André Derain and Juan Gris. While he showed an awareness of these techniques in many of his works, including *Rabbi and Rabbitzin* and *Gilbert Cannan and his Mill,* he was dismissive of both Cubism and Futurism as aesthetic movements, referring in 1913 in a letter to Dora Carrington to what he called, 'all this abstract intellectual nonsense'. He enjoyed five successful one-man shows in the 1920s and his work sold well, but thereafter his fortunes began to falter. The death of his beloved mother from tuberculosis in 1932 and Dora Carrington's suicide in the same year, the collapse of his marriage in 1936, the loss of patronage and the debilitating effects of his own tuberculosis, which he probably contracted as a child, together with his despair about the impending war, all took a terrible toll on his mental health. On 23 June 1939, at the age of 48, impoverished, deeply depressed and, by his own account, an artistic failure, Gertler committed suicide.

The Times described his death as 'a serious loss to British art', and he is now acknowledged as one of the most influential artists of the interwar period.

In the light of Gertler's troubled personal history, *Gilbert Cannan and his Mill* and the unfinished painting hidden beneath its surface together provide a palimpsest work that is emblematic of the artist's lifelong struggle to reconcile his drive to become a successful English artist with his deep attachment to his Jewish roots and identity. Albeit in very different ways, both Mark Gertler and David Bomberg reflect the many challenges faced by Jewish immigrants and Jewish artists in the early twentieth century as they sought to find a place in British society while retaining their cultural identity as Jews. Whereas Bomberg stood resolutely apart from the British art world and society, Gertler tried, unsuccessfully, to integrate the two. While neither received the acclaim in their lifetime that they fully deserved, each is now recognised as an artist of enduring importance.

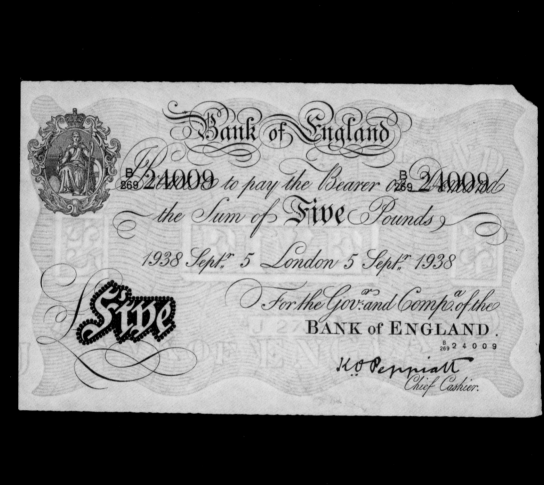

21 ENGLISH BANKNOTE

נא

SACHSENHAUSEN, GERMANY, 1943

*'I would watch the buds swell in spring, the mica glint
in the granite, my own hands, and I would say to myself:
I will understand this, too, I will understand everything.'*
Primo Levi

FROM THE MOMENT Hitler came to power in Germany in April 1933, it became apparent that the Nazis' anti-Semitic rhetoric was the expression of entirely serious intent. Anti-Jewish laws were rapidly enacted throughout the country, and German Jews watched helplessly as their bank accounts were frozen, their property and businesses were confiscated, and from one day to the next they found themselves debarred from their trades and professions. Physical attacks on Jewish civilians and looting of Jewish shops became increasingly commonplace, encouraged, sanctioned and in many instances organised by the state. Arrests and disappearances occurred with mounting frequency. On 10 May 1933, as part of the so-called 'purification' of German intellectual life, 34 university towns held mass burnings of books by newly blacklisted authors, among them a great many Jewish writers, including Karl Marx, Sigmund Freud, Stefan Zweig and the great nineteenth-century poet Heinrich Heine. Among the estimated 25,000 works consigned to the flames was Heine's play, *Almansor* (1820–21), which contained the prophetic warning: 'Where they burn books, they will also ultimately burn people.'

The first Nazi concentration camp opened at Dachau, near Munich, in early 1933, a truckload of inmates arriving on 22 March, imprisoned without trial and immediately put to hard labour under the most appalling conditions, 'whipped until their skin broke, beaten until they suffered brain damage'.[155] One volunteer guard at Dachau was Rudolf Höss, the future commandant of Auschwitz. By the summer of 1933 nine more camps were up and running in the Brandenburg province. Sachsenhausen concentration camp, situated 35 km north of Berlin, opened in 1936, and it was here, during the Second World War,

1936 Leon Blum elected first Jewish prime minister in France

1936–9 Spanish Civil War. Around 7000 Jews join the International Brigade

Arab Revolt in Palestine in protest to increasing Jewish immigration

1937 Peel Commission Report. British proposal rejected by Arabs

1938 Hitler annexes Austria

that this English banknote was made. Both the camp and the banknote were products of German fascism under Hitler, and as such are inextricably connected to history's darkest and most depraved anti-Semitic regime, unparalleled before or since in its scale and lethal impact. But the banknote also tells another story, revealing how a group of men who seemed doomed to become the victims of Hitler, instead, through a combination of guile and good luck, managed to survive.

The banknote is an exceptionally high-quality forgery of an English five-pound note, also known colloquially as a 'white fiver', and it was made as part of an audacious Nazi plot to destabilise the British economy. Devised and rubber-stamped under the highest level of secrecy on 18 September 1939, just days after the outbreak of the Second World War, the plan was to undermine the British economy by printing millions of fake English banknotes. These would then be dropped from planes all over Britain, thus flooding the country with bogus currency, devaluing the pound, and critically damaging Britain's economic relationship with its allies and other neutral countries. If the plan succeeded, it would deal a catastrophic blow to the war against fascism, since the stability and integrity of the pound were essential to the Allied war effort. Codenamed Operation Bernhard, after Major Bernhard Krüger, the SS officer in charge of the plan's implementation from 1942 until the end of the war, this would become the largest counterfeiting scheme in the history of economic warfare. The forgeries, when they were finally ready,

were so difficult to distinguish from the originals that the Bank of England reluctantly acknowledged them to be 'the most dangerous ever seen'.[156]

The first attempts at forging the notes were not a success and the project stalled until 1942 when the Reich Finance Ministry decided to have another go and brought in Bernhard Krüger to manage the operation. Krüger was a trained textile engineer and before the war had been a factory manager. Beyond the formidable technical demands of the financial forgery with which he was now tasked, he also faced the immediate challenge of how to motivate his new 'work force', who were neither Nazis nor Nazi sympathisers, but Jewish prisoners drawn from the death camps, chosen for their relevant skills as printers and graphic artists, and forcibly conscripted into the plot as slave-labourers. Krüger was fully aware that his team had ample reason for wanting the operation to fail, and neither he nor they were under any illusions as to how their skills would be rewarded: they all knew the forgers would be buried along with their secret the moment the operation was completed. Indeed, Himmler had ordered Krüger to use only Jewish prisoners for precisely this reason. In the event, the prisoners briefly considered sabotage before deciding their best chance of survival lay in full co-operation.

One hundred and forty Jewish prisoners of different nationalities were eventually chosen for the highly specialised work of producing the fake banknotes. A vivid picture of the tight secrecy surrounding the operation emerges from testimonies and interviews

| 1938 Kristallnacht. Synagogues destroyed in Nazi Germany | 1939 Britain imposes severe restrictions on Jewish immigration to Palestine | Hitler invades Poland. Beginning of Second World War | As head of MGM, Louis B. Mayer is the highest-paid man in America | 1940 Charlie Chaplin's *The Great Dictator* parodies Hitler and Nazism |

given by the prisoners after the war. Brought to Sachsenhausen from other camps, including Ravensbrück and Buchenwald, the counterfeiters were locked in a barracks on the outer edge of the camp, encircled by barbed wire and sealed off from the other inmates. As Lawrence Malkin, author of *Krueger's Men: The Secret Nazi Counterfeit Plot and the Prisoners of Block 19*, explains: 'Outside this Golden Cage, as the prisoners called it, no-one in the camp, including the Commandant, knew what was going on inside...The prisoners were rarely if ever allowed out, and only individually to the dentist, where they were denied anesthetic lest they inadvertently spill the secret.'

Yet there were advantages to being a counterfeiter, as the nickname the Golden Cage suggests. Krüger used a carrot-and-stick strategy to ensure the loyalty of his workers: while the omnipresent stick was the threat of death, Krüger's carrot was to treat the men, as far as possible, as he had treated his employees before the war. He addressed them politely as 'Sie', not the informal 'du', let them grow their hair and wear civilian clothing, and gave them Sundays off. They received extra rations, and were only made to work an eight-hour day. In the context of a Nazi concentration camp, these were the most extraordinary privileges. In exchange, Krüger imposed exacting standards on the prisoners' work, demanding the highest level of attention to detail to get the forged bills as near as possible to perfect. This meticulousness had the added benefit of putting care before speed, and by

prolonging the whole process, deliberately or otherwise, Krüger also helped to keep his Jewish prisoners alive.

From a technical perspective, making the forgeries was no mean feat. The design of English notes of high denominations, and the technology applied in their production, had not changed for over a century, both factors which assisted the counterfeiters, but many significant challenges remained, not least of which was cracking the complex identifying codes devised by the Bank of England to make each and every bill traceable. Then there was the task of replicating the intricate designs on the notes, which included tiny flaws, introduced by the Bank as further protection against forgery. These deliberate flaws ranged from near-invisible dots on the right hand of the figure of Britannia, to a miniscule nick in a letter, to a hatching line that stopped fractionally too short. Krüger's forgers had to learn how to identify and duplicate these flaws with the utmost precision. One of the most difficult tasks was finding a precise match for the paper used by the Bank of England. As Malkin explains, 'It was blended from linen and a tough yarn known as ramie, which was extracted from nettles. Depending on soil and climate, the fibres would differ, and so would the water in which they were pulped...Even genuine [banknotes] of different issues emitted infinitesimally different fluorescent tones when examined under the ultraviolet light of a quartz lamp, which was the principal tool for detecting counterfeit bills in those days.' Krüger managed to locate a German

Warsaw Ghetto established

First prisoners arrive at Auschwitz

1941 Battle of Leningrad

Nazis begin extermination of mentally or physically disabled citizens

1942 Wannsee Conference. Implementation of the Final Solution

company, Hahnemuehle, which used a water source that very closely resembled the water in the plant in rural Hampshire used by the Bank of England. Over 100 batches of paper were tested, and Krüger was only satisfied when he was sure that over 95 per cent of the paper for the forgeries passed the ultraviolet test. He nevertheless took the added precaution of testing out the paper on blind prisoners, to ensure that it not only looked right, but even made the same sound as the genuine banknotes.

By 1943 the counterfeit notes were ready for distribution. One of the prisoners, Felix Tragholtz, was sent under armed guard to the Reichsbank in Berlin to test the notes. The teller accepted the money without demur. Krüger arrived at Barracks 19 soon after and, according to Lawrence Malkin, pulled a sterling note out of his pocket and declared with a smile, 'Look at this, gentlemen. This note has been circulating in English banks and accepted as genuine. Congratulations on excellent work. I'm proud of you, gentlemen.' Albeit this was an illegal operation, Krüger and his team had every right to be proud. They had succeeded in producing some of the most perfect forgeries ever made, virtually indistinguishable from genuine notes. From late 1943 and all through 1944, the counterfeit notes rolled off the printing presses at the rate of 650,000 a month. By the end of the war, the Germans

From late 1943 and all through 1944, the counterfeit notes rolled off the printing presses at the rate of 650,000 a month

'had forged more pound notes than all the reserves of the bank vaults of the Bank of England...equal to about 15 per cent of all genuine notes in circulation.'[157] Nearly nine million forged notes had been produced, with a face value of £134 million, equivalent to £4.2 billion today.

Sachsenhausen was just one of thousands of prison and labour camps set up by the Nazis between 1933 and 1945, not only in Germany but in almost every country they occupied. Used initially for political prisoners, Sachsenhausen later took anyone the Nazis wanted to eliminate from society, which included Jews, Gypsies, Jehovah's Witnesses, homosexuals, alcoholics, prostitutes, and petty criminals. Although the numbers of Jewish prisoners in pre-war concentration camps in Germany were small in absolute terms, they were very high in relation to the number of Jews in Germany as a whole, and Jewish inmates were subjected to particularly barbaric treatment.[158]

As a central training facility for SS officers, who were then transferred on to other camps, Sachsenhausen was intended as a blueprint for other camps, and was run by some of the Nazis' most infamous and vicious commandants. There were daily executions by hanging and shooting, as well as many casual acts of violence which caused many other deaths. One camp punishment was the 'Sachsenhausen salute' in which the prisoner had to

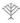

squat for hours with his arms stretched out in front of him. Prisoners were used as forced labour and physical conditions were brutal, resulting in the deaths of tens of thousands of inmates from exhaustion, disease, malnutrition and pneumonia. Thousands more were executed or died as the result of sadistic medical experimentation and other forms of torture. In January 1942 inmates were set to work building a dedicated extermination block, Station Z, which opened five months later with the inaugural execution of 96 Jewish prisoners. Station Z also had its own gas chamber, in operation from March 1943 until the end of the war. More than 200,000 people were imprisoned in Sachsenhausen between 1936 and 1945, and an estimated 100,000 died there.

From late 1941 onwards, camps such as Sobibor, Majdanek and Treblinka were established with the specific intention of exterminating the Jewish population of all Nazi-occupied territories. Jewish prisoners from camps such as Sachsenhausen were transferred to these and other extermination camps to be killed. In January 1942 senior Nazi officials gathered for a secret meeting at a villa on the shores of Lake Wannsee, just outside Berlin, where they agreed the Final Solution to the so-called 'Jewish problem'. A document from the Wannsee Conference lists the size of the Jewish population in each country the Germans planned to absorb into their future empire. This was not a list of potential future citizens, but of the people they had decided to eradicate: in short, a death warrant for

the whole of European Jewry. No-one at the Wannsee Conference was in any doubt about what the Final Solution meant and every man present signed his name to it. By the end of the war, in May 1945, at least six million European Jewish men, women and children had been murdered by the Nazis, in many cases with the active co-operation and collaboration of the countries they invaded. In some countries, such as Poland and Lithuania, over 70 per cent of the pre-war Jewish population had been murdered by the end of the war. In total, of the estimated nine million Jewish people living in Europe in 1933, only around three million survived.

Krüger's team of counterfeiters were among the fortunate 30 per cent, kept alive thanks to their technical skills. But in an ironic twist to the tale, despite the brilliance of their forgeries, Operation Bernhard was never realised. By 1943 the German air force no longer had enough planes to supply its troops at Stalingrad never mind fly around England airdropping fake banknotes. Green-lit with insufficient scrutiny in the first place, the whole operation was then conducted with such secrecy that no-one had thought to consult Reichsmarschall Göring, commander-in-chief of the Luftwaffe, about its practical feasibility. An additional irony of this oversight was that Sachsenhausen was a major source of forced labour for the German aircraft industry. Heinkel, one of the leading aircraft manufacturers during the war, used 6–8000 prisoners at the camp to work on its HE 177 bombers.

As it became apparent that Operation Bernhard could not be put into action, the interests of Krüger and his counterfeiters aligned. Krüger was no longer in favour with the SS high command and, with in-depth knowledge of and responsibility for an illegal state secret, was himself a potential liability. He and his prisoners all now shared the same goal: to survive the war. As Malkin recounts, the prisoners by this time saw Krüger as their protector, calling him 'The Old Man' and 'Uncle Krüger'. 'Together, they appear to have conspired to stretch out the operation by switching [from sterling] to hundred-dollar bills – probably meant to be getaway money for the SS.' A pre-war master counterfeiter named Salomon Smolianoff, a Russian-born Jew, was brought to Sachsenhuasen in 1944 from Mauthausen concentration camp and put in charge of forging the fake dollar bills. As prisoners Georg Kohn and Jack Plapler later testified, the team were also expected to forge an array of other documents, including transit papers, passports, marriage certificates, diplomatic and military papers. Perhaps their most bizarre assignment was a series of English postage stamps: the English king had to be given 'a Jewish nose' and hidden in the corners were the Communist symbols of the hammer and sickle.[159] Everyone involved with the operation by this stage, including Smolianoff, was working to an unofficial slowdown, fervently hoping that the war would come to an end before they did.

In April 1945, with the Red Army closing in on Berlin and Germany's defeat imminent,

Sachsenhausen was evacuated. The counterfeiters along with their machinery were transferred to a new secret location in Nordhausen with the aim of restarting the operation there, but this plan was quickly dropped. Not long after, Krüger abandoned his team to their fate and headed off in the direction of Switzerland. The prisoners were transported to a subsidiary camp, Redl-Zipf in Austria, and from there to Ebensee concentration camp (also in Austria) where they were scheduled to be murdered. But luck was once again on the counterfeiters' side. The SS guards had only one truck for the prisoners, so the transfer had to be made in three trips. On the third trip the truck broke down and the last batch of prisoners had to be marched the rest of the way on foot. They finally reached Ebensee on 4 May 1945. The order was for all the counterfeiters to be killed together, but when the third group arrived at Ebensee the guards discovered that the rest of the counterfeiters had intermingled with the camp's other prisoners. The men from Sachsenhausen were now as impossible to distinguish as their forgeries, and the liquidation order could not be carried out. Two days later the US army arrived, the remaining Nazi guards fled, and the camp was liberated. While technical success had kept the forgers alive during the war, in the end it was technical failure that saved their lives.

The Nazis were not in fact the only ones in September 1939 to have come up with the idea of forging enemy currency. Across the Channel at almost exactly the same time, Winston Churchill was writing to Sir John Simon,

the Chancellor of the Exchequer, proposing something very similar.[60] Although the Treasury quickly rejected what it off-the-record called 'a silly idea', schemes of this kind continued to be suggested for several more years. In May 1942 the economist John Maynard Keynes was still having to quash counterfeiting proposals, writing tartly to the Treasury, 'The proposal to introduce forged currency has been made at least a hundred times before and always rejected for good and sufficient reasons'.[161] The Americans also dabbled with the idea of counterfeit currency, including the novelist John Steinbeck, who on 13 August 1940 wrote personally to President Franklin D. Roosevelt to request an urgent one-to-one meeting to discuss what he cryptically described as 'an easily available weapon more devastating than many battleships'.[162] Roosevelt agreed to a meeting, thought Steinbeck's idea of airdropping counterfeit German currency seemed a good one, and sent him to explain it to Henry Morgenthau Jr, Secretary of the Treasury, who promptly rejected it on moral grounds, telling Steinbeck that he considered the scheme 'crooked' and 'the kind of thing we might expect Germany to do'.[163]

However brilliantly Krüger's team executed their part of their plan, Operation Bernhard was in reality ill-conceived on many levels from the very start. Moreover the scheme was leaked to the British almost immediately.

The prisoners were also expected to forge transit papers, passports, marriage certificates and military papers

On 22 November 1939, within two months of the September meeting at which the Nazis had decided to approve the operation, the British government was supplied with a detailed account of the plan. The Bank of England was duly informed and immediately imposed an outright (but unpublicised) ban on the import of pound notes. While this fundamentally solved the problem of fake notes entering into circulation within Britain, it did not prevent the counterfeits spreading on the black market throughout mainland Europe and North Africa. By the end of the war the SS had used several million of the fake notes for a range of illegal activities, including skimming them off for their own personal use. Fake notes worth millions of pounds were burned in a frantic, last-ditch attempt to get rid of the evidence, and many more millions were packed into watertight crates and dumped by the Nazis in lakes in the Austrian Alps, with the idea of retrieving them at some point in the future. This particular banknote, now on display in the Ashmolean, was fished out of Lake Toplitz in Austria in the late 1950s, and purchased by the museum in 2009. The note contains one of the only features that distinguishes the forgeries from the genuine notes: a tiny cut in the top left serif of the letter 'N' in the word 'BANK' in the watermark.[164]

An extraordinary coda to this story, recounted by Lawrence Malkin in *Kreuger's*

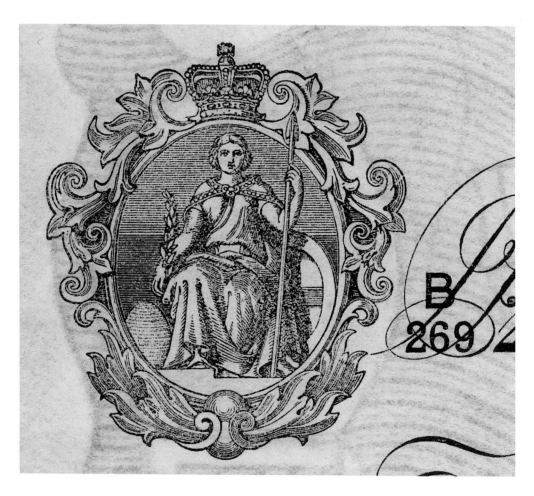

Men, concerns a Nazi money launderer called Jaac van Harten, who masqueraded as an International Red Cross official and fronted his operations with an import–export business in Budapest. In reality van Harten was a Jewish conman named Yaakov Levy. When the *Bricha* (meaning 'escape'), a unit of the Jewish underground, caught up with Yaakov Levy in 1945, they accused him of working with the Nazis. Levy slithered out of trouble by handing over not only a suitcase of jewellery, but thousands of counterfeit English banknotes which he just happened to have in his possession. The banknotes were used to help smuggle Jewish Holocaust survivors out of Europe and into Palestine, and finance the purchase and shipment of equipment for the Jewish underground in their fight against the British.

1951 The Rosenbergs found guilty of espionage and sentenced to death	**1952** Queen Elizabeth II takes throne of England	**1954** Roger Bannister breaks four minute mile in Oxford	**1955** James Dean is killed in a car crash at the age of 24	**1956** Hungarian Revolution

Operation Bernhard was, as Lawrence Malkin succinctly puts it, 'a technical success but a strategic flop and, in the crowning irony, an espionage blowback'. The story of the operation and the Jewish counterfeiters has inspired a number of films and novels, including Frederick Forsyth's novel *The Odessa File* and Leon Uris's novel *Exodus*, in which a Jewish teenager escapes death by showing his counterfeiting skills during selection in Auschwitz. Several of the prisoners-turned-counterfeiters later wrote about their experiences. Adolf Burger, a Jewish Slovak typographer, imprisoned by the Nazis in 1942 for forging baptismal certificates to save Jews from deportation, was brought to Sachsenhausen in 1944 to work on Operation Bernhard, where he became friends with the Russian forger, Salomon Smolianoff. Burger's memoir *The Devil's Workshop*, written many years later in Prague, was published in English in 2009 and formed the basis for the 2007 Oscar-winning film *The Counterfeiters* (*Die Fälscher*).

From August 1945, with the post-war division of Germany, Sachsenhausen fell into the hands of the Russians. They renamed it Soviet Special Camp No. 7 and used it to imprison a range of political enemies, including Nazis, Nazi collaborators and anti-Communists. The camp finally closed in 1950, by which time 60,000 prisoners of the Soviets had been held there, including 6000 German officers. At least 12,000 died of malnutrition and disease. And what of Bernhard Krüger? He survived the war and later worked as a salesman for Hahnemuehle, the company that had produced the special paper for the Operation Bernhard forgeries.

Suez Campaign. Israel gains tacit backing to attack Egypt

1957 Soviets launch 'Sputnik' satellite. Space Age begins

1959 Billie Holiday dies in New York

Fidel Castro takes power in Cuba, ousting President Fulgencio Batista

1960 American U-2 spy plane shot down in Soviet airspace

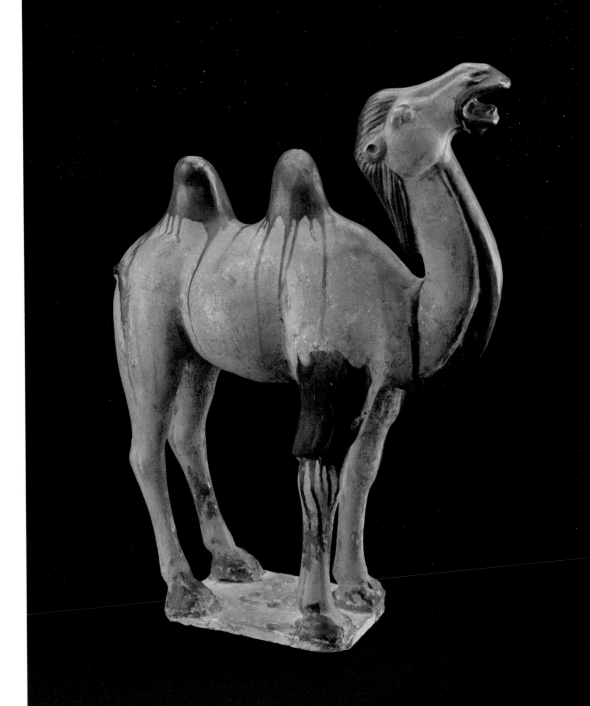

22 TANG DYNASTY CAMEL ‎כב

CHANG'AN, CHINA, TENTH CENTURY CE

'And let your two eyes travel before us
To light the way for me and my friend.'
David Vogel, *When Night Draws Near*

I N THE EARLIEST days of the Jewish journey, as recounted in the Book of Genesis and embellished in midrashic legend, Abraham's servant leaves Canaan with ten camels laden with precious gifts and, accompanied by a convoy of two angels, travels to his master's native land of Haran in Mesopotamia to find a wife for his son, Isaac. There, at the local well, the servant meets Rebecca, the granddaughter of Abraham's brother Nahor. Without knowing the identity of either the servant or his master, Rebecca offers to draw water both for him and for his camels. This is the pre-arranged sign from God, that she is the woman destined to become Isaac's wife. The servant explains who he is and why he has come, then presents the family with costly gifts, clothing and jewellery of gold and silver. To Rebecca he gives a gold nose ring weighing half a shekel and two gold bracelets each weighing ten shekels. According to Jewish legend, the nose ring's half-shekel weight foreshadows the annual half-shekel her descendants will pay to the Temple in Jerusalem, while the two gold bracelets anticipate the two tablets of stone inscribed with the Ten Commandments. Rebecca agrees to marry Isaac and the very next day, ignoring her family's attempts to delay her departure, she and the servant set out from Haran back to Canaan, a journey of seventeen days miraculously accomplished on this occasion in a mere three hours.

Isaac is praying in the fields when they reach Haran at three in the afternoon. His first sight of Rebecca is when he looks up and sees the caravan of camels approaching. For her part, Rebecca 'noticed the unusual beauty of Isaac, and also that an angel accompanied him'. At the same moment, she learns by

divine communication that she is to be the mother of Esau, a prospect that so terrifies her that she begins trembling violently and falls off her camel.[165]

Few objects, then, could provide a more fitting conclusion to *The Jewish Journey* than a camel, or be more emblematic of the physical and spiritual journey of the Jewish people, who in the course of 4000 years have travelled from Mesopotamia in the Ancient Near East to all four corners of the world, sometimes borne along by metaphorical camels, at other times knocked off them by assorted bolts from the blue.

This particular camel has made an exceptionally long journey of its own, travelling over thousands of miles and eleven centuries from Tang Dynasty China to its current home in Oxford. From 1937 to 1964 it stood proudly in the front window of a house on Oxford's Banbury Road, amusing and intriguing passers-by, before being donated to the Ashmolean Museum in 2012. The camel's remarkable connection to the Jewish journey was unknown until very recently, hidden away in the unsorted and forgotten archives of a German professor who had escaped from Nazi Germany in the 1930s.

The camel was originally intended for a journey not in this world, but the next. As a *mingqui*, or spirit object, it was made to be buried in the tomb of a rich and powerful member of Chinese society in the tenth century, to accompany and protect its owner in the afterlife. Funerary objects of this kind were very important in Tang Dynasty China

(618–907 CE). Tombs of the elite were routinely filled with an abundance of ceramic models of people, mythical beasts, horses, camels and even model buildings. Camels commonly featured among these tomb objects because of their association with the Silk Road, the vast network of trading routes that linked China to the Mediterranean and beyond, bringing enormous cultural and material wealth to China at this time. Goods were traded along the Silk Road in both directions, and included carpets, glass, spices, ceramics, paper, ivory, weapons, animals, gold and other precious metals and much else besides. Camels were typically used to transport these goods from one trading post to the next, as the animals were uniquely suited to endure the difficult, often dangerous terrain. Bactrian camels, such as this one, could cover 30 miles a day, carrying huge loads. They could last more than a week without water and withstand both the searing heat of the Arabian deserts and the piercing cold of the Asian mountain passes.

The Silk Road has an ancient association with Jewish merchants, who were active along almost every part of these trade routes. Persian Jews, in particular, travelled and traded extensively throughout Afghanistan, the Caucasus and Central Asia, playing an important role in establishing Bukhara and Samarkand as major trading posts. Settlements of Jewish merchants also extended along the Eastern Silk Road into China. An established Jewish community in China dates back to at least the tenth century, and probably originated with

1967 Six Day War. Israel recaptures Old City of Jerusalem

Leonard Cohen releases his debut album, *Songs of Leonard Cohen*

1968 Martin Luther King assassinated

1969 Apollo 11 successful. Neil Armstrong is first man on moon

Yasser Arafat becomes leader of PLO

merchants from Persia. Some documents suggest there were Jews living in Khanfu as early as 877 CE, while a Chinese poem from the Tang Dynasty era mentions Jewish people living in the city of Xi'ian. The largest Jewish community in medieval China was in Kaifeng and dates from the tenth century CE. During the expansion of China in the Tang Dynasty, the Silk Road and its merchants benefited greatly from the rich exchange of goods, knowledge, information and people. This pottery camel might very possibly have belonged to the tomb of a wealthy Chinese merchant, symbolising his links with the Silk Road, the source of his prosperity and success.

Considerable care has been taken to depict the camel's features, including the chestnut mane on its neck and throat, the woolly coat on its front legs and belly, its upright humps (indicating good health) and richly embroidered saddle cloth. Notoriously temperamental animals, this one appropriately has its head thrown back and its mouth wide open in a loud, eternal bray. It stands 52 cm high and was made from flat sheets of earthenware clay that were pressed into moulds and then decorated with a white clay slip and coloured glazes. Thermoluminiscence dating confirmed that it came from Tang Dynasty China, but beyond that nothing else was known about the camel until research by two Oxford archaeologists, Sally Crawford and Katharina Ulmschneider, revealed its extraordinary story.[166]

Excavated at some point from its Chinese tomb, the camel probably made its way to Europe on the thriving market for Oriental antiques. It was bought at auction in Marburg, Germany in 1924 by the eminent archaeologist Paul Jacobsthal. Born in Berlin in 1880, Jacobsthal came from a solidly middle-class German family. His mother's family were merchants in Hamburg and his father was a doctor. Both his parents were Jewish, although he himself had been baptised as a Protestant. In 1912, at the age of 32, Jacobsthal was appointed Professor of Classical Archaeology at the University of Marburg, where he rapidly established his reputation as a leading art historian and classicist. After the Nazis came to power in 1933, many Jewish academics were dismissed from their jobs simply for being Jews. New racial laws announced at the Nuremberg Rally on 15 September 1935 unilaterally stripped German Jews of their German citizenship and made it illegal for them to marry or have sexual relations with someone who was not Jewish. Anyone with three or more Jewish grandparents was defined as Jewish, even if they or their parents had converted to Christianity. Additional new laws deprived them of most of their political rights. As well as having Jewish grandparents, Jacobsthal came into direct conflict with the Nazi authorities when he refused to tailor historical evidence to fit Nazi ideology. Despite his outstanding academic reputation, he soon found it impossible to publish his work, attend conferences or travel. In 1935 he was forced to resign from his post at Marburg on racial grounds. At the age of 55, Jacobsthal found himself without any means to earn a living in

Germany, or to pursue the career to which he had dedicated his life.

As countries across Europe closed their borders to foreigners, the situation for German Jews became increasingly desperate. Without money or personal contacts, it was extremely difficult for people to find safe haven abroad, even when their lives depended on it. That so many did manage to escape was thanks in part to organisations such as the *Society for the Protection of Science and Learning in Britain*, founded in 1933 by William Beveridge, creator of the National Health Service. This organisation saved thousands of outstanding European scholars by securing funding and jobs for them in Britain and America. Among these refugees from Nazi Germany were no less than sixteen future Nobel Prize winners, including Max Born, Ernst Chain, Hans Krebs, Bernard Katz and Max Perutz. Now called CARA (Council for At-Risk Academics), the organisation continues to support endangered scholars from all over the world.

Paul Jacobsthal was among the more fortunate. In 1935, with the help of his friend and colleague, the eminent Oxford classicist Professor John Beazley, a position was arranged for Jacobsthal as a Visiting Professor at Oxford University. A few months later he and his wife Guste fled to England. Jacobsthal was appointed a Fellow of Christ Church in

At the age of 55, Jacobsthal found himself without any means to earn a living in Germany, or to pursue the career to which he had dedicated his life

1936, and the following year, he took up the post of Reader in Celtic Archaeology there, a position he held for the rest of his working life. In 1944 his book *Early Celtic Art* was published by Oxford University Press, and remains the seminal work on the subject to this day. Oxford University found places for more refugee academics than any other university in Britain. Individually and collectively, in their many areas of expertise, they made an invaluable and incalculable contribution to the University, to the country and to humanity.

When Britain declared war on Germany in 1939, Jacobsthal, along with thousands of other foreigners, was arrested and interned as an 'enemy alien'. As he recorded in his Report on his internment, 'on Friday July 5th 1940 in the morning when I was peacefully writing on Celtic Geometric Ornament a knock came at my door in Christ Church and a plain clothes Police Officer entered producing a warrant of arrest.'[167] Imprisoned first at Warth Mills in Lancashire, and then on the Isle of Man, Jacobsthal wrote two versions of his experience of internment, the Report, first published in 1992 (the original version of which is now lost), and a newly-discovered Diary, found in 2011 by Crawford and Ulmschneider in a box of uncatalogued papers in the Bodleian Library in Oxford. The Diary was clearly not intended for public view and

provides a somewhat different account of his experience of internment than the Report, revealing more clearly 'the psychological blow of being unjustly imprisoned' and offering an unexpurgated glimpse of the distress and discomfort of daily life in the internment camps. The Diary is written in pencil in a lined school exercise book, starting on the last page of the book and working forwards. The entries are mostly short notes, in English but sprinkled with quotations in Hebrew, Greek, Latin and German. Despite his stated intention of recording an objective account of internment, the strain of imprisonment comes through. 'Life gradually becomes timeless the more we are cut off from the outside,' Jacobsthal wrote in one entry in his customary tiny handwriting. 'Living a life with its own law... the world outside far, forgotten, distorted.... People still unknown to each other a fortnight before now living closer to each other than married, sharing beds and rooms.'[168] Elsewhere in the diaries Jacobsthal is highly critical of the conditions in the camps and less than flattering about the British officers and many of his fellow internees. Many of these uncensored observations were left out when he later came to publish his official Report. But as the Diary and Report make clear, 'for Jacobsthal, internment was a difficult but also important experience, and an isolating one in which he found himself facing personal questions about his own identity as an academic refugee in Britain, about loyalty, nationality, and religious identity, and about his past.' Forced into close and uneasy proximity with

other Jewish refugees, with most of whom he had nothing in common socially, spiritually or intellectually, and who in normal circumstances he would rarely if ever have met, 'the internment camps also brought Jacobsthal into contact, for the first time, with the truth about the Holocaust, in which he himself was to lose members of his own family'.[169]

Apart from this period of internment, Jacobsthal spent the remaining 30 years of his life in Oxford, where through his scholarly work he transformed understanding and knowledge of Celtic art. As a sideline to his official activities, it seems that Jacobsthal may also have been involved in the world of espionage; he has been proposed as a model for the archaeologist/spy played by Leslie Morgan in the 1941 thriller *Pimpernel Smith*.

The Tang Dynasty camel was among the possessions that travelled to Oxford with Paul Jacobsthal. It sat on the windowsill beside his desk for the rest of his life, one of his most treasured personal belongings. Far more than just a beautiful object, it expressed his interest in the connections between Greek art and those of other ancient cultures, as Katharina Ulmschneider explains: 'The camel provided a physical manifestation of the way ideas and goods were carried from East to West, a symbol of the way art and culture were shared and transmitted.' The camel also became a code word, used in letters to and from Germany, as a way to refer to himself and to Jewish colleagues still trapped there. As such, the camel itself came to hold a deeper significance for Jacobsthal, as a symbol of the journey that he,

like so many others, had been forced to make against his will and was determined to survive.

The Jewish journey, like that of this pottery camel, is a story both of mobility across physical space, and of continuity and change across time. It is the story of a people who moved from one country to another, taking with them their belongings, their knowledge, their skills, their religion and their ethical codes. Along the way they adopted and adapted the customs of the places where they settled, in turn bringing their own customs to those places. As the 22 objects in this book attest, Jewish people have contributed to the social, commercial and intellectual cultures of the world, as artisans, merchants, financiers, scholars, scientists, musicians, artists and simply as ordinary people going about their ordinary lives. And yes, for sure, they have also numbered among society's supply of criminals, crooks, cheats and con-artists. En route, as these objects remind us, the Jews have interacted closely with other peoples in diverse ways, co-existing peacefully and successfully for long periods of time, sometimes choosing to assimilate, at other times seeking to maintain their distinctive identity. As history and these objects testify, the Jews have rarely been a people apart, unless forced to be so. Through the constant exchange of abstract ideas, material goods, personal and professional relationships, they have for the most part been actively involved in the societies in which they have lived, working, socialising and marrying both within and beyond their own communities.

The story of the Jewish people is not singular or unchanging, but is as diverse as these 22 objects themselves. It is a story of dynamic adjustment and continual re-invention. Yet there is also an exceptional degree of continuity across the journey's vast stretch of time and space. Without a territorial empire or a fixed geographical base for most of Judaism's history (unlike Christianity or Islam, for example), the physical requisites for religious Judaism evolved to become eminently and pragmatically portable: the Torah scroll, prayer books, the mezuzah and the Sabbath candlesticks. Some Jewish festivals and religious practices have survived almost unchanged for thousands of years. Passover is the oldest continually practised religious festival in the world, and the Hebrew language has been in continuous use for over 3000 years. But religious continuity is not the whole story. The resilience of Jewish identity more generally has relied on centuries of transmission of shared ideas, beliefs, ethical codes, customs, stories, sacred texts and, perhaps above all, collective memories. The destruction of Jewish temples, synagogues, books, homes and, all too often, the Jews themselves could not destroy what existed and connected people in their hearts and minds.

The Jewish journey, like that of this little clay camel, is a three-stranded story of mobility, adaptability and continuity, from its beginnings in Mesopotamia and Canaan, when the ancient Israelites first emerged out of the melting pot of different peoples living in the

region, to the international present day, when the Jews once more have their own country and also live among the populations of the world. It is a journey that speaks not only to the Jewish experience, but to the need and right of people everywhere in the world to be able to live in dignity and freedom, respecting and respected by their fellow humans, safe from fear of persecution and prejudice, from one generation to the next.

2001 September 11 attacks. 3000 killed. America responds with War on Terror

Ariel Sharon withdraws Jewish settlements from Gaza

2006 Hamas win Palestinian Legislative Elections

2008 Barak Obama elected first Black President of America

2016 Britain votes in referendum to leave the European Union

EMANCIPATION

Fig.50 The artist Camille Pissarro (1830–1903), photographed in the 1890s. From the Pissarro Archive.
© ASHMOLEAN MUSEUM, UNIVERSITY OF OXFORD, WA.P.ARCH.7

Fig.51 The Proclamation of the Emancipation of the Jews, France, 1790.
PHOTO © MAHJ / MARIO GOLDMAN

Fig.52 Alfred Dreyfus, photographed by Aron Gerschel, Paris, c.1890. The Dreyfus Affair exposed widespread anti-Semitism in France and triggered a national crisis.
PHOTO © MAHJ

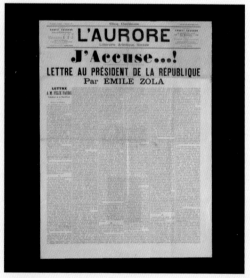

Fig.53 Front page of the *Aurore* newspaper, 1898, carrying novelist Emile Zola's letter to the French President, accusing the French military of a cover-up.
PUBLIC DOMAIN

Fig.54 Camille Pissarro (1830–1903). *Mme Pissarro sewing.* Oil on panel, 16 x 11 cm. This tiny portrait was painted in 1860 when Julie Velay was pregnant with the couple's first child. They were eventually married in London in 1871.
© ASHMOLEAN MUSEUM, UNIVERSITY OF OXFORD, WA1952.6.1

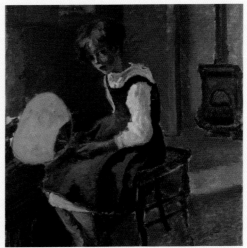

Fig.55 Camille Pissarro (1830–1903) *Bouquet of Pink Peonies*, 1873. Oil on canvas, 73 x 60 cm. This painting was made at a time when Pissarro's eight-year-old daughter was in failing health. The delicacy of the flowers expressed his grief for the fragility of her young life.
© ASHMOLEAN MUSEUM, UNIVERSITY OF OXFORD, WA1951.225.1

Fig.56 Camille Pissarro (1830–1903), *Jeanne Holding A Fan*, c.1873, Oil on canvas, 56 x 46.5 cm. Born in 1865, Jeanne-Rachel Pissarro was always known as Minette in the family. This portrait was painted not long before her death at Pontoise on 6 April 1874.
© ASHMOLEAN MUSEUM, UNIVERSITY OF OXFORD, WA1952.6.2

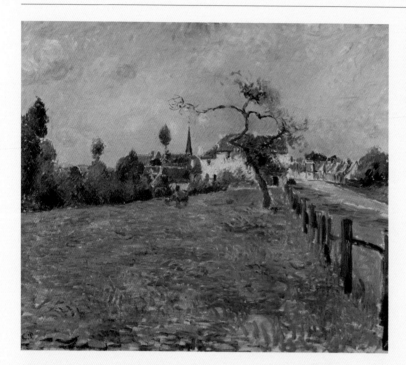

Fig.57 Camille Pissarro (1830–1903) *The Village of Eragny*, 1885 Oil on canvas, 55 x 65 cm. Pissarro and his family moved to the small town of Eragny in Normandy in 1882. He lived there for the rest of his life, painting many scenes of the local places and people.

© ASHMOLEAN MUSEUM, UNIVERSITY OF OXFORD, WA1952.6.3

Fig.58 Lucien Pissarro (1863–1944). Frontispiece to *Jules LaForgue. Moralités légendaires* (1897). One of many works by French and English authors, which Lucien illustrated and printed for his publishing business, The Eragny Press.

© ASHMOLEAN MUSEUM, UNIVERSITY OF OXFORD, WA.PA.77.3894

Fig.59 Carel Victor Morlais Weight (1908–97) *Miss Orovida Pissarro*, 1957. Oil on canvas, 112 x 160 cm. Orovida was the daughter of Lucien and grand-daughter of Camille, and a distinguished artist in her own right. Presented to the Ashmolean by Orovida Pissarro.

© ESTATE OF CAREL WEIGHT. ALL RIGHTS RESERVED, BRIDGEMAN IMAGES, 2017

Fig.60 Orovida Camille Pissarro (1893–1968) *The Tiger Hunt*
Tempera on linen, 99 x 142 cm. Signed and dated: '1932 Orovida'.
© ASHMOLEAN MUSEUM, UNIVERSITY OF OXFORD, WA1968.472

Fig.61 Orovida Camille Pissarro (1893–1968) *The Archer's Return*.
Tempera on linen, 91.8 x 71.5 cm. Signed and dated 'Orovida, 1931'.
© ASHMOLEAN MUSEUM, UNIVERSITY OF OXFORD, WA1968.471

Fig.62 Photograph of David Bomberg by Henry Handler, *c.*1914. Taken around the time of the Whitechapel Art Gallery exhibition of Twentieth Century Art, for which Bomberg curated a section on Jewish artists.

Fig.63 *Mark Gertler*, possibly by Dora Carrington. Pencil, *c.*1909–11.

Fig.64 Photograph of the Slade School picnic, c. 1912. David Bomberg is in the back row, third from left. Dora Carrington is in the front row, first on the left; Mark Gertler is in the front row, fourth from left.

Fig.65 David Bomberg (1890–1957) *Opera 10*. Pen and brush with India ink on paper over indications in graphite, 1920. One of several studies by Bomberg of workers in the London docks.

Fig.66 Fig.66 David Bomberg (1890–1957) *Family Group 7*. Pen and brush with India ink on paper over indications in graphite, 1920. Made at the same time as *Opera 10*, this study is possibly of weary and disorientated Jewish immigrants disembarking in the London docks.

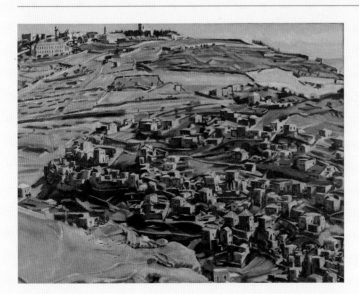

Fig.67 David Bomberg (1890–1957) *View of Silwan*, 1923. Oil on canvas. Painted by Bomberg during his time in Palestine from the garden of his friend, Austen St Barbe Harrison. Jerusalem is visible on the hill on the far side of the Silwan Valley.

Fig.68 David Bomberg (1890–1957). *Ghetto Theatre*, 1920. Oil on canvas.
Painted not long after the First World War, this scene from the Jewish East End
captures Bomberg's increasing sense of alienation and entrapment.

Fig.69 David Bomberg (1890–1957) *Hear, O Israel*. Oil on wood. 1955.
Painted in Ronda, Spain, this powerful self-portrait was one of Bomberg's
last works and conveys his deeply held connection to his Jewish roots.

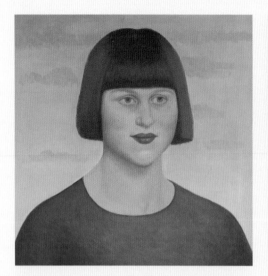

Fig.70 Mark Gertler (1891–1939) *Portrait of Dora Carrington*, 1912. Oil on canvas. Painted while Gertler and Carrington were students at the Slade Schoool of Art. The doomed love affair was a source of deep anguish to Gertler.

THE HUNTINGTON LIBRARY, ART COLLECTIONS, AND BOTANICAL GARDENS. PURCHASED WITH FUNDS FROM THE CALIFORNIA COMMUNITY FOUNDATION

Fig.71 Photograph taken at the Garsington home of Gertler's patron Lady Ottoline Morrell, 1920. From left to right: T. S. Eliot; Mark Gertler; Lady Ottoline Morrell.

© NATIONAL PORTRAIT GALLERY, LONDON

Fig.72 Mark Gertler (1891–1939) *Young Girlhood, No. 2*. Oil on canvas, 13.5 x 64 cm. Signed and dated: 'Mark Gertler 25'.

© ASHMOLEAN MUSEUM, UNIVERSITY OF OXFORD, WA1959.54.2

Fig.73 Mark Gertler (1891–1939) *Apples in a Bag*. Oil on cardboard, 26.7 x 29.9 cm. Signed in monogram and dated: 'M.G. 25'.

© ASHMOLEAN MUSEUM, UNIVERSITY OF OXFORD, WA1968.23

Fig.74 Simeon Solomon (1840–1905) *Venus and Pygmalion*. Detail from a section of The Great Bookcase designed by William Burges.
© ASHMOLEAN MUSEUM, UNIVERSITY OF OXFORD, WA1933.26

Fig.75 Sir Jacob Epstein (1880–1959) *The Death of Moses*. Watercolour on paper, 57.7 x 45 cm.
© THE ESTATE OF SIR JACOB EPSTEIN / ASHMOLEAN MUSEUM, UNIVERSITY OF OXFORD, WA1979.32

Fig.76 Jacob Kramer (1892–1962) *The Day of Atonement*, 1919. Pencil, brush and ink on paper.
BEN URI GALLERY, THE LONDON JEWISH MUSEUM OF ART / BRIDGEMAN IMAGES. ESTATE OF JOHN DAVID ROBERTS. BY PERMISSION OF THE TREASURY SOLICITOR

Fig.77 Photograph of some of the Jewish counterfeiters from Sachsenhausen, including Max Groen, taken in May 1945 after their liberation from Ebensee concentration camp in Austria, where they had been taken to be executed.
IMAGE COURTESY OF LAWRENCE MALKIN

Fig.78 Paul Jacobsthal (1880–1957) after he had escaped Nazi Germany and settled in Oxford, one of over a thousand eminent scholars to take refuge in England in the 1930s.
© DEPT OF ARCHAEOLOGY, UNIVERSITY OF OXFORD

Fig.79 Samarkand Jews by Sergei Prokudin-Gorski, pioneer photographer of early twentieth-century Russian life.
PUBLIC DOMAIN

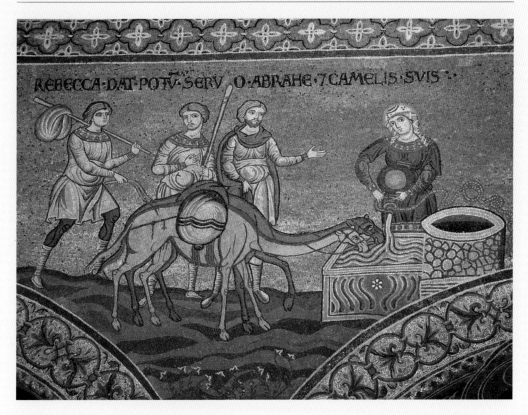

Fig.80 Twelfth-century mosaic wall panel from Monreale
Cathedral, Sicily, Italy. The meeting of Abraham's servant
and Rebecca at the well in Haran, when she identifies
herself as the future wife of Isaac and the matriarch of the
Jewish people by offering to draw water for his camels.

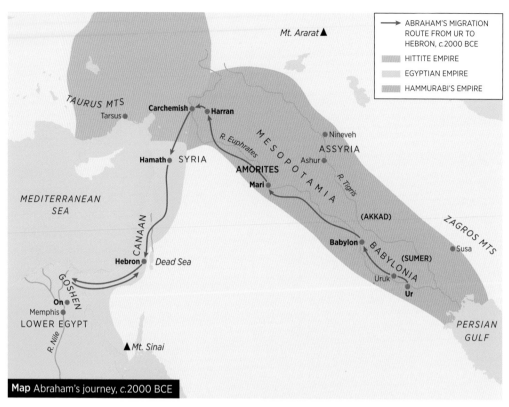

Map Abraham's journey, c.2000 BCE

ABRAHAM'S MIGRATION ROUTE FROM UR TO HEBRON, c.2000 BCE

HITTITE EMPIRE

EGYPTIAN EMPIRE

HAMMURABI'S EMPIRE

Mt. Ararat ▲

TAURUS MTS

Tarsus

Carchemish Harran

R. Euphrates

M E S O P O T A M I A

Nineveh

ASSYRIA

Ashur

R. Tigris

Hamath SYRIA

AMORITES

Mari

MEDITERRANEAN SEA

CANAAN

Hebron Dead Sea

(AKKAD)

Babylon B A B Y L O N I A

(SUMER)

Susa

ZAGROS MTS

GOSHEN

On

Memphis

LOWER EGYPT

R. Nile

▲ Mt. Sinai

Uruk Ur

PERSIAN GULF

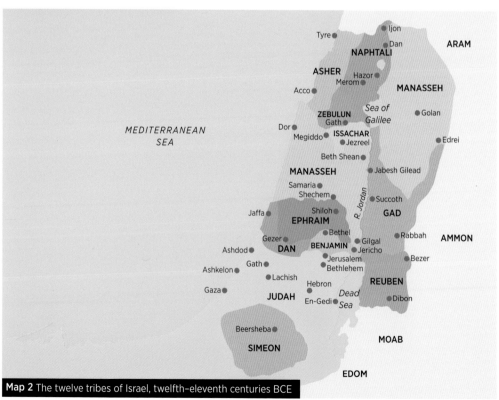

Map 2 The twelve tribes of Israel, twelfth–eleventh centuries BCE

Tyre Ijon

Dan ARAM

NAPHTALI

ASHER Hazor

Merom

Acco MANASSEH

ZEBULUN Sea of Galilee Golan

Dor Gath

Megiddo ISSACHAR Edrei

Jezreel

Beth Shean

MANASSEH Jabesh Gilead

Samaria R. Jordan

Shechem Succoth

Jaffa Shiloh GAD

EPHRAIM

Bethel Rabbah AMMON

Gezer Gilgal

Ashdod DAN BENJAMIN Jericho

Gath Jerusalem Bezer

Ashkelon Bethlehem

Lachish

Gaza Hebron REUBEN

JUDAH En-Gedi Dead Sea Dibon

MEDITERRANEAN SEA

Beersheba

SIMEON MOAB

EDOM

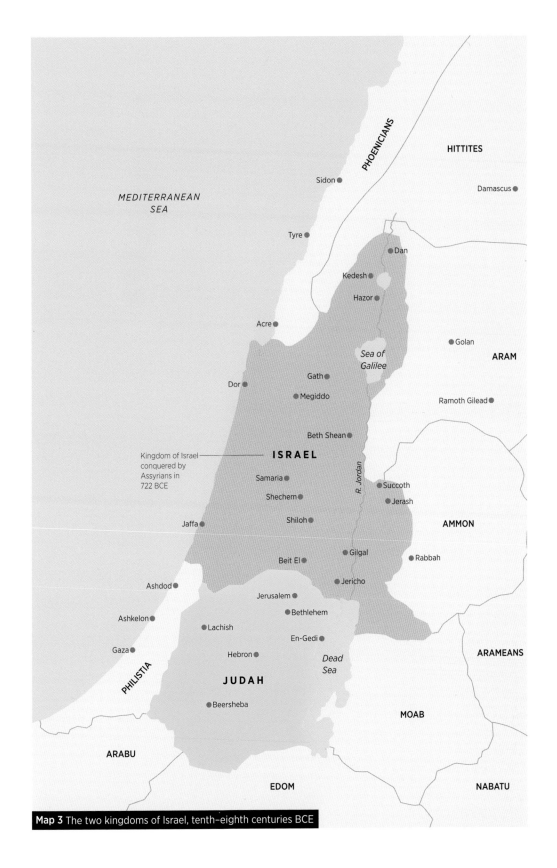

MEDITERRANEAN
SEA

PHOENICIANS

HITTITES

Sidon

Damascus

Tyre

Dan

Kedesh

Hazor

Acre

Golan

Sea of
Galilee

ARAM

Gath

Dor

Megiddo

Ramoth Gilead

Beth Shean

Kingdom of Israel
conquered by
Assyrians in
722 BCE

ISRAEL

Samaria

Succoth

Shechem

Jerash

R. Jordan

Jaffa

Shiloh

AMMON

Gilgal

Beit El

Rabbah

Jericho

Ashdod

Jerusalem

Bethlehem

Ashkelon

Lachish

En-Gedi

ARAMEANS

Gaza

Hebron

Dead
Sea

PHILISTIA

JUDAH

Beersheba

MOAB

ARABU

EDOM

NABATU

Map 3 The two kingdoms of Israel, tenth–eighth centuries BCE

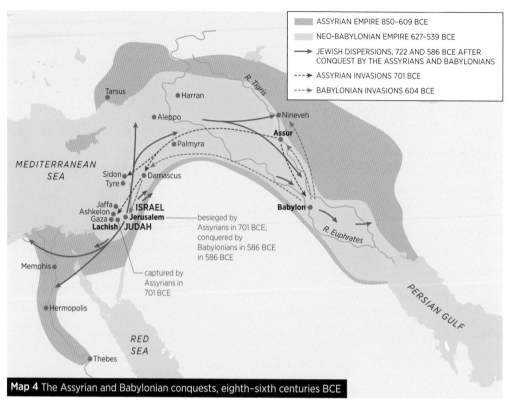

Map 4 The Assyrian and Babylonian conquests, eighth–sixth centuries BCE

Legend:
- ASSYRIAN EMPIRE 850–609 BCE
- NEO-BABYLONIAN EMPIRE 627–539 BCE
- JEWISH DISPERSIONS, 722 AND 586 BCE AFTER CONQUEST BY THE ASSYRIANS AND BABYLONIANS
- ASSYRIAN INVASIONS 701 BCE
- BABYLONIAN INVASIONS 604 BCE

MEDITERRANEAN SEA

Tarsus, Harran, R. Tigris, Aleppo, Nineveh, Palmyra, **Assur**, Sidon, Tyre, Damascus, Jaffa, **ISRAEL**, Ashkelon, **Jerusalem**, Gaza, **Lachish**, **JUDAH**, **Babylon**, R. Euphrates, Memphis, Hermopolis, RED SEA, Thebes, PERSIAN GULF

besieged by Assyrians in 701 BCE; conquered by Babylonians in 586 BCE in 586 BCE

captured by Assyrians in 701 BCE

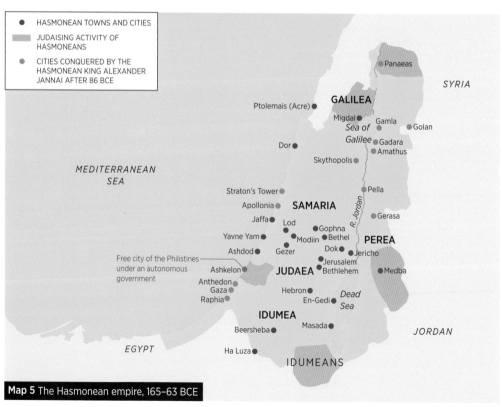

Map 5 The Hasmonean empire, 165–63 BCE

Legend:
- HASMONEAN TOWNS AND CITIES
- JUDAISING ACTIVITY OF HASMONEANS
- CITIES CONQUERED BY THE HASMONEAN KING ALEXANDER JANNAI AFTER 86 BCE

SYRIA

Panaeas, **GALILEA**, Ptolemais (Acre), Migdal, Gamla, Golan, *Sea of Galilee*, Dor, Gadara, Amathus, Skythopolis, Pella, Straton's Tower, Apollonia, **SAMARIA**, Gerasa, Jaffa, Lod, Gophna, R. Jordan, Yavne Yam, Modiin, Bethel, **PEREA**, Ashdod, Gezer, Dok, Jericho, Ashkelon, **JUDAEA**, Jerusalem, Bethlehem, Medba, Anthedon, Hebron, En-Gedi, *Dead Sea*, Gaza, Raphia, **IDUMEA**, Beersheba, Masada, JORDAN, Ha Luza, EGYPT, **IDUMEANS**

Free city of the Philistines under an autonomous government

MEDITERRANEAN SEA

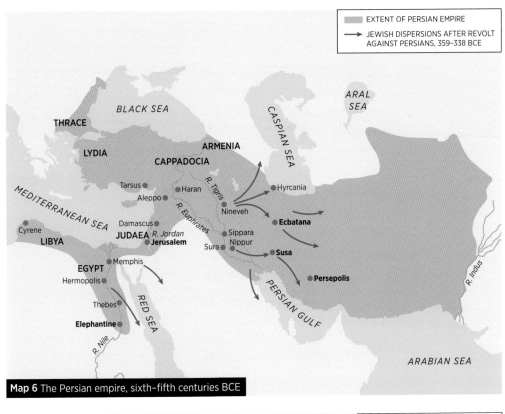

Map 6 The Persian empire, sixth–fifth centuries BCE

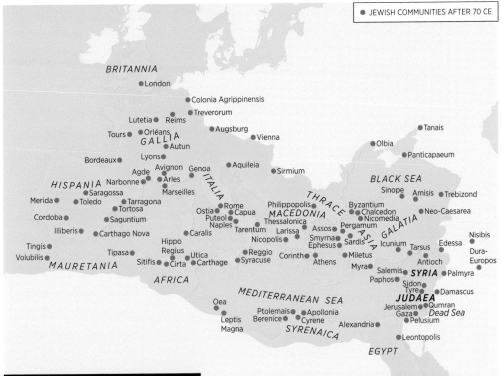

Map 7 The Roman empire, first century CE

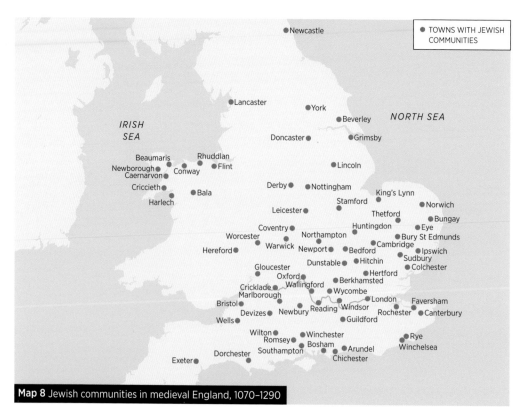

Map 8 Jewish communities in medieval England, 1070–1290

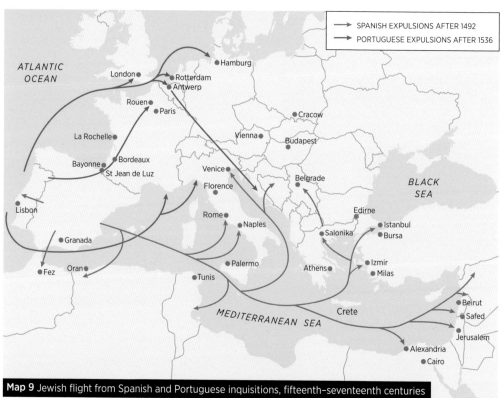

SPANISH EXPULSIONS AFTER 1492
PORTUGUESE EXPULSIONS AFTER 1536

Map 9 Jewish flight from Spanish and Portuguese inquisitions, fifteenth–seventeenth centuries

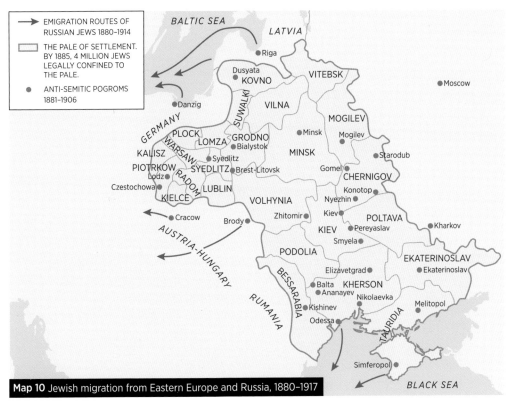

Map 10 Jewish migration from Eastern Europe and Russia, 1880–1917

Legend (Map 10):
- EMIGRATION ROUTES OF RUSSIAN JEWS 1880–1914
- THE PALE OF SETTLEMENT. BY 1885, 4 MILLION JEWS LEGALLY CONFINED TO THE PALE.
- ANTI-SEMITIC POGROMS 1881–1906

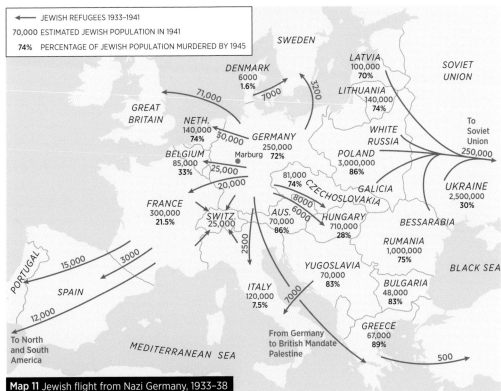

Map 11 Jewish flight from Nazi Germany, 1933–38

Legend (Map 11):
- JEWISH REFUGEES 1933–1941
- 70,000 ESTIMATED JEWISH POPULATION IN 1941
- 74% PERCENTAGE OF JEWISH POPULATION MURDERED BY 1945

ACKNOWLEDGEMENTS

The Jewish Journey is the result of an exciting collaboration between the Ashmolean Museum and the Oxford Jewish Congregation. It has been almost a decade in the making, and a great many people have helped with the book in one way or another during that time. I am extremely grateful to all of them for their advice, knowledge, and encouragement. The project started back in 2006 under the auspices of the Oxford Jewish Heritage Committee (OJHC), whose mission is to promote knowledge and understanding of Jewish history related to Oxford. The original idea was simply to compile a list of objects of Jewish interest in the Ashmolean Museum, a modest seedling that grew slowly but steadily into a fully-branched book. As Chair of the OJHC, Dr Evie Kemp has been the most tremendous support in overseeing that transformation from its very beginnings and nurturing the project to fruition. Jack Green, a former curator at the Ashmolean, now Deputy Director at the Corning Museum of Glass in New York, drew up the preliminary list of objects, and OJHC members carried out initial research and later provided helpful feedback on early drafts of the manuscript, for which I should like to thank Evie Kemp, Deborah Sandler, Victoria Bentata, Pam Manix, Glenda Abramson, Mike Ward, Lynne Ward, Katharine Shock, Richard Shock and Jesmond Blumenfeld. I am additionally grateful to Peter Bergamin, Jim Hilton, Glenda Abramson and Victoria Bentata for their help compiling the book's time-line, often working to very tight deadlines. Deborah Sandler's commitment to this project from start to finish has been invaluable. Deborah and I spent many enjoyable afternoons in the Ashmolean, tracking back and forth through the galleries, identifying objects that related to Jewish history, and discussing which ones to include in the book and which, with regret, to leave out. Deborah's personal conviction that *The Jewish Journey* would be of interest and value to a general non-academic audience played a vital part in shaping the focus and form of the finished book, and her enthusiasm and vision helped guide it through the inevitable rocks and hard places and bring it to safe harbor. I also wish to acknowledge the generous financial backing of the Henry Posner Educational Fund, the Ullman Trust, Rosie and Dan Kemp, the Oxford Jewish Congregation, and the Royal Literary Fund, without which the book would not have been possible.

The Ashmolean Museum's support has been indispensable. I am especially indebted to Paul Collins for his wholehearted endorsement of the original idea for *The Jewish Journey* and his unstinting guidance and enthusiasm thereafter. Xa Sturgis, the current Director of the Ashmolean, and his predecessor, Dr Christopher Brown, gave the book their blessing, without which it would never have become a reality, while a number of the Museum's curators were kind enough to provide advice and comments on the text, for which I wish to

thank Paul Collins, Susan Walker, Paul Roberts, Colin Harrison, Chris Howgego, Eleanor Standley and Shailendra Bhandare. I am also grateful to David Gowers for his wonderful photographs of the 22 objects and other artefacts from the Ashmolean Museum's collection; to Sue Aldridge at Oxford Designers and Illustrators for the fabulous maps, and to Ocky Murray for the book's beautiful and elegant design, and for introducing me to Berthold Wolpe and Albertus.

The text itself has benefited immeasurably from generous scholarly feedback from a wide range of experts and their knowledge of the historical contexts of specific objects. In particular, I should like to acknowledge Martin Goodman, Fergus Millar, Alan Bowman, Norman Solomon, Sally Crawford, Katherina Ulmschneider, Judith Rosenberry, Pam Manix, Glenda Abramson, Tessa Rajak, Emily Rose, Sarah McDougall, Aviva Burnstock, Emma Shackle, Claudia Roden, Joshua Goldman, Cesar Merchan-Hamman, Irving Finkel, Michael Fleming, Tal Ilan, Noah Hachum, Dr Susan Weingarten, Daniel Levene, Ros Abramsky, David Ariel, Ira Rezak, Abigail Green, David Rechter, Peter Bergamin, Lawrence Malkin, Filip Vukosavovic, Eli Brackman, and David Katz. I am also grateful to Margaret Vermes at the Oxford Centre for Jewish and Hebrew Studies, Rachel Fronda at Christ Church, and the librarians of Lincoln College, Oxford and the Bodleian Library. It goes without saying that any remaining historical errors and interpretative bias in the text are my sole responsibility.

For practical, emotional and moral support throughout the writing of this book, my heartfelt personal thanks to Jessie Slim, Solomon Slim, Sonia Jackson, Ellen Jackson, Diarmid Mogg, Andrew Fingret, Hester Abrams, Penny Boreham, Sarah Montague, Josh Getzler, Lucia Zedner, Esther Selsden, Alex Games, Miranda Creswell, Michael Holyoke, Sarah Caro, Sami Cohen, Natasha Podro, Jas Elsner, Susan Moxley, Tal Fineman, Francesca Shakespeare, Dot Little, Rosamund Bartlett, Andrew Kahn, Jessica Shukman, Tess and Bruce Blenkinsop, Sos Eltis, Mark Haddon, Joseph Rochlitz, Stef Conner, John Bowers, Suzanne Franks, Peter Straus and, above all, Jeremy Arden.

END NOTES

1 Patricia Berlyn, 2005, 'The Journey of Terah: To Ur-Kasdim or Urkesh?' In *Jewish Bible Quarterly*, 33:2.

2 Dr Paul Collins, personal communication.

3 Irving Finkel, 2014, *The Ark Before Noah: Decoding the Story of the Flood*. London: Hodder & Stoughton, pp.226, 234.

4 Exodus 32:29.

5 Joshua 6:1–27.

6 Dr Paul Collins, personal communication.

7 Acquisition references for objects referred to in this paragraph include: basket handle jars (2 AN1954.579); bronze dagger (22 AN1954.603); bronze toggle pins (14 AN1958.41); finger and ring (16 AN1954.601); gypsum stone jars (4 1954.594–7); large jars (8 AN1955.529; 9 AN1955.534); pestle and mortar (13 AN1954.598–9); scarab seals/amulets (20); stone beads (18 AN1958.48).

8 Josephus, *Jewish Wars*, Book 4:469, translated by Martin Hammond, 2017. Oxford: Oxford University Press.

9 Josephus, *Jewish Wars*, Book 1:112, *op. cit.*

10 Josephus, *Jewish Wars*, Book 1:118, *Ibid.*

11 Josephus, *Jewish Wars*, Book 1:656, *Ibid.*

12 Josephus, *Jewish Wars*, Book 1:671, *Ibid.*

13 J. R. Bartlett, 1976, 'The Seal of *Hnh* from the Neighbourhood of Tell Ed-Duweir.' In *Palestine Exploration Quarterly* 108:1, pp.59–61.

14 Bartlett, 1976, *Ibid.*

15 Bartlett, 1976, *Ibid.*

16 I. Eph'al, 1985, 'The Assyrian Siege Ramp at Lachish: Military and Lexical Aspects.' In *Journal of the Institute of Archaeology of Tel Aviv University* 11: 1.

17 *The Oriental Institute Prism*, translated by A. L. Oppenheim in ANET: 288, with correction in following CAD K: 67a. Cited in D. Ussishkin, 1977, 'The Destruction of Lachish by Sennacherib and the Dating of the Royal Judaean Storage Jars.' In *Journal of the Institute of Archaeology of Tel Aviv University* 4: 1–2, pp.28–60.

18 2 Kings, 23.

19 A. Kirk Grayson and Jamie Novotny, 2012, *The Royal Inscriptions of Sennacherib, King of Assyria (704–681 BC)*, Part 1. Warsaw, IN: Eisenbrauns.

20 Isaiah, Chronicles and Second Kings.

21 Translation cited in S. Schama, 2014, *The Story of the Jews*. London: Bodley Head, pp.54–5. The original inscription is in the Istanbul Archaeology Museum.

22 Herodutus ii, 141.

23 Henry T. Aubin, *The Rescue of Jerusalem: The Alliance Between Hebrews and Africans in 701 B.C.*

24 Stephen Langdon, 1903, 'Evidence for an Advance on Egypt by Sennacherib in the Campaign of 701–700 B.C.' In *Journal of the American Oriental Society* 24, pp.265–74.

25 Donald T. Ariel, Israel Antiquities Authority, 2017, 'The significance of the coin evidence from Judaea for Jewish history.' Seminar paper, Oxford Centre for Hebrew and Jewish Studies, 6 June 2017. See also Donald T. Ariel and Jean-Philippe Fontanille, 2012, *The coins of Herod: a modern analysis and die classification*. Leiden; Boston: Brill.

26 See also C. Howgego, V. Heuchert and A. Burnett, eds, 2005, *Coinage and Identity in the Roman Provinces*. Oxford: Oxford University Press.

27 James M. Lindenberger, 2003, *Ancient Aramaic and Hebrew Letters*, second edition, edited by Kent Harold Richards. Atlanta, GA: Society of Biblical Literature, pp.41–51.

28 Translated by Lindenberger, 2003, *Ibid.*, p.48.

29 Lindenberger, 2003, *Ibid.*

30 *Jewish Life in Ancient Egypt: A Family Archive from the Nile Valley*, 2002, Brooklyn Museum, NYC].

31 1 Chronicles 28:3.

32 Khnum statuette from Elephantine, AN1931.586.

33 Letter from Jedaniah to the Persian governor of Judaea. Cited in Simon Schama, 2013, *op. cit.*, p.25.

34 Paul Roberts, personal communication.

35 Object file (AN1951.477), Department of Antiquities, Ashmolean Museum.

36 AN1951.477a–c, *Ibid.*

37 AN1951.477, *Ibid.*

38 Damascus Document X: 17–21. Cited in Adolfo Roitman, ed., 1997, *A Day at Qumran: The Dead Sea Sect and Its Scrolls*. Jerusalem: The Israel Museum, p.57.

39 Josephus, *Jewish Wars*, Book 2:147, *op. cit.*

40 Adolfo Roitman, ed., 1997, *op. cit.*, pp.30–3.

41 Adolfo Roitman, ed., 1997, *op. cit.*, pp.51–5.

42 See also M. Goodman, ed., 1998, *The Jews in a Graceo-Roman World*; M. Goodman, 2000, *State and Society in Roman Galilee*, second edition.

43 Josephus, *Jewish Wars*, Book 5: 362–420, *op. cit.*

44 Josephus, *Jewish Wars*, Book 5: 429–30, *op. cit.*

45 Josephus, *Jewish Wars*, Book 5: 449–59, *op. cit.*

46 Josephus, *Jewish Wars*, Book 6: 271–6, *op. cit.*

47 Josephus, *Jewish Wars*, Book 5: 222–3, *op. cit.*

48 Fergus Millar, 2005, 'Last Year in Jerusalem: the Commemoration of the Jewish War in Rome.' In J. Edmondson, S. Mason and J. Rives, eds, *Josephus in Flavian Rome*, p.101.

49 C. Howgego, 2015, The Circulation of gold coinage of Vespasian struck in the East. London: Spink.

50 Josephus, *Jewish Wars*, Book 7: 148–62, *op. cit.*; see also M. Goodman, *Rome & Jerusalem*, *op. cit.*, pp.450–3.

51 C. Howgego, 2015, *op. cit.*, p.127.

52 C. Howgego, 2015, *op. cit.*, p.132.

53 C. Howgego, *op. cit.*, 1998, p.132–4. See also A. R. Hands, 1993–2004, *The Romano-British Roadside Settlement at Wilcote, Oxfordshire*, vol.2. Oxford: p.45.

54 Josephus, *Jewish Wars*.

55 Fergus Millar, Transformations of Judaism under Graeco-Roman Rule', *op. cit.*, pp.144–5. See also Seth Schwartz, 2001, 'Jews or Pagans? The Jews and the Greco-Roman Cities of Palestine.' In *Imperialism and Jewish Society, 200 BCE to 640 CE*, Princeton NJ/Oxford: Princeton University Press.

56 David Noy, 1993, *Jewish Inscriptions of Western Europe*, vol.1. Cambridge: Cambridge University Press.

57 Samuel Rocco, *A Jewish Gladiator in Pompeii*, www.academia.edu/4732530/A_Jewish_Gladiator_in_Pompeii.

58 Susan Walker, 2017, *Saints and Salvation: Charles Wilshere's collection of gold-glass, sarcophagi*

and inscriptions from Rome and southern Italy. Oxford: Ashmolean Museum.

59 Dr Susan Walker, personal communication.

60 Jessica Dello Rosso, 2011, 'The Discovery and Exploration of the Jewish Catacomb of Vigna Randanini in Rome.' In *Roma Subterranea Judaica 5*, Publications of the International Catacomb Society.

61 Elias J. Bickerman, 1944, 'The Colophon of the Greek Book of Esther.' *Journal of Biblical Literature* 63:4, pp.339–62. Cited in M. Ahuvia, www.thetorah.com/jewish-queens-from-the-story-of-esther-to-the-history-of-shelamzion.

62 T. Ilan, 1999, 'Esther, Judith and Susanna as Propaganda for Shelamzion's Queenship. In *Integrating Women into Second Temple History*. Tübingen: Mohr Siebeck, p.135. See also T. Ilan, 2006, *Silencing the Queen: The Literary Histories of Shelamzion and Other Jewish Women*. Tübingen: Mohr Siebeck.

63 T. Frymer-Kensky, 1992, *In the Wake of the Goddesses: Women, Culture, and the Biblical Transformation of Pagan Myth*. Free Press, p.130.

64 Dr Claudia Roden, personal communication.

65 Simon Schama, 2013, *op. cit.*, p.252.

66 Adina Hoffmann and Peter Cole, 2011, *Sacred Trash: The Lost and Found World of the Cairo Geniza*. London: Penguin Random House.

67 Norman Bentwich, 1938, *Solomon Schechter*. Philadelphia.

68 Adina Hoffmann and Peter Cole, 2011, *op. cit.*

69 Adina Hoffmann and Peter Cole, 2011, *op cit.*

70 Cited in Norman Bentwich, 1938, *op. cit.*

71 Dr Cesar Merchan-Hamann, personal communication.

72 Dr Israel Abrahams, 1902–5, 'A Note

on the Bodleian Bowl', *Transactions – Jewish Historical Society of England (TJHSE)*, vol.5, pp.184–92; Joe Hillaby and Caroline Hilaby, eds, *The Palgrave Dictionary Medieval Anglo-Jewish History*. Basingstoke: Palgrave Macmillan, p.58.

73 Isaiah 29:1: 'Woe, *Ariel, Ariel*, the city wherein David encamped'.

74 Rabbi Eli Brackman has further proposed that 'Jekuthiel' could refer to a famous London rabbi of this name, referenced in an Oxford Hebrew manuscript held at Christ Church College (MS 198; Neub. 2456:10). See E. Brackman, 'The Mystery of The Bodleian Bowl: New insights into a 320 year old mystery', 21.8.2015, www.oxfordchabad.org .

75 David S. Katz, 1990, 'The Conundrum of the Bodleian Bowl: An Anglo-Jewish mystery story'.

76 See Vivian D. Lipman, 1967, *The Jews of Medieval Norwich*, pp.113–15.

77 See discussion in E. Brackman, 2015, *op. cit.*

78 Simcha Emanuel, 2008, 'R. Yehiel of Paris: His biography and affinity to Eretz-Israel.' *Shalem*, 8, pp.86–99. Cited in E. Brackman, 2015, *op. cit.*

79 Frederic William Maitland, 1911, 'The Deacon and The Jewess; or Apostasy at Common Law.' In H. A. L. Fisher, ed., *The Collected Papers of Frederic William Maitland*, 3 vols, vol.1. Cambridge: Cambridge University Press, http://oll.libertyfund.org/titles/871#Maitland_0242-01_547.

80 I am greatly indebted to Pam Manix, historian of Jewish medieval Oxford, for the account of the university book riot and information about Jewish property ownership in the city. For a more detailed account of the Jews of medieval Oxford see Pam Manix, 2014, *Beneath Our Feet: Oxford's Medieval Jewish Cemetery*. Roke Elm Books.

81 Examples of these bilingual manuscripts include the Book of

Ezekiel, Bodleian Library, MS. Bodl. Or. 62, fol.59r.; Pentateuch, Corpus Christi College, Oxford, MS.CCC 5; Psalter, MS.CCC 10.

82 Michael Mahzor, Bodleian Library, MS.Mich.617/627; Laud Mahzor, Bodleian Library, MS.Laud Or. 321; Tripartite Mahzor, Bodleian Library, MS. Mich.619.

83 Eva Frojmovic, 2009, 'Early Ashkenazic Prayer Books and their Christian Illuminators. In Piet van Boxel and Sabine Arndt, eds, *Crossing Borders: Hebrew Manuscripts as a Meeting-place of Cultures*. Oxford: Bodleian Library, pp.45–56.

84 Eva Frojmovic, 2009, *Ibid.*, p.49–54.

85 Malachi Beit-Arie, 2009, 'The Script and Book Craft in the Hebrew Medieval Codex', pp.20–34. In Piet van Boxel and Sabine Arndt, eds, *Crossing Borders: Hebrew Manuscripts as a Meeting-place of Cultures*. Oxford: Bodleian Library, pp.12–13.

86 CCC MS 133.

87 Frederic William Maitland, 1911, op. cit., http://oll.libertyfund.org/titles/871#lf0242-01_footnote_nt541_ref .

88 Miri Rubin, trans. and ed., 2014, *The Life and Passion of William of Norwich*. London: Penguin Books. Cited in E. M. Rose, 2013, *The Murder of William of Norwich: the origins of the blood libel in medieval Europe*. Oxford: Oxford University Press, p.80.

89 E. M. Rose, 2013, *Ibid.*, pp.80–1.

90 For a detailed account of this extraordinary trial see E. M. Rose, 2013, *Ibid.*, pp.67–91.

91 E. M. Rose, 2013, *Ibid.*, pp.7–9.

92 Rabbi Meir of Norwich, *Who is Like You*. From Ellman Crasnow and Bente Elsworth, 2013, trans., Keiron Pim, ed., *The Medieval Hebrew Poetry of Meir of Norwich*. Norwich: East Publishing.

93 P. Manix, 2014, *op. cit.*, p.16.

94 *Encyclopedia of Jewish Magic, Myth and Mysticism*. Llewellyn Worldwide.

95 T. Schrire, 1966, *Hebrew Magic Amulets: Their Decipherment and Interpretation*. London: Routledge and Kegan Paul, p.65.

96 See for example the spell to heal eye disease in Pesahim 112b in the Talmud.

97 Rashi Commentary to Sotah 22a.

98 T. Schrire, 1996, *op. cit.*, pp.37–40.

99 T. Schrire, 1996, *op cit.*, p.71. See also J. Trachtenberg, 1943, *The Devil and the Jews*, New York: Meridian; J. Trachtenberg, 1939, *Jewish Magic and Superstition*. New York: Behrman.

100 T. Schrire, 1996, op. cit., pp.71–2.

101 E. Brackman, 21.8.2015, *op. cit.*, www.oxfordchabad.org .

102 William Shakespeare, 1605, *The Merchant of Venice*, Act III, Sc. 1, l.110–13.

103 William Shakespeare, Ibid, l.52–60.

104 I am indebted to Joseph Rochlitz for permission to quote here and elsewhere in this chapter from his marvellous documentary film *Hebreo: The Search for Salomone Rossi*, 2012, Lasso Film & TV Production and Joseph Rochlitz.

105 Francisco Bontempi, *Iron and Star: Jewish Brescia in the Renaissance Italy*. See also Samuel Kurinksy, 'The Jews of Brescia: Iron and Star of David', Fact Paper 34, Hebrew History Federation, www.hebrewhistory.info/factpapers/fp034_brescia.htm .

106 Francisco Bontempi, *Cremona and the Jews*, published by the Province of Cremona. See also Samuel Kurinsky and Francisco Bontempi, *Jewish History from the Archives of Florence and Cremona*, Part II: 'Cremona', Fact Paper 38, II, Hebrew History Federation, www.hebrewhistory.info_cremona.htm .

107 David Lasocki with Roger Prior, 1995, *The Bassanos: Venetian Musicians and Instrument Makers in England, 1531–1665*. Aldershot: Ashgate, p.94. See also Peter Holman, 1993, *Four and Twenty Fiddlers: The Violin at the English Court, 1540–1690*. Oxford: Clarendon Press, pp.81–3.

108 Roger Prior, 1983, 'Jewish Musicians in Tudor England. In *The Musical Quarterly* 69: 2, pp.253–65.

109 Cited in David Lasocki with Roger Prior, 1995, *op. cit.*, p.9.

110 Roger Prior with David Lasocki, 1995, *op. cit.*, Chapter 6: 'The Bassanos' Jewish Identity'.

111 A. L. Rowse, 'Revealed at Last, Shakespeare's Dark Lady', *The Times*, London, 29 January 1973, p.12. See also A. L. Rowse, 1973, *Shakespeare the Man*, second edition. London: Macmillan; A. L. Rowse, 1978, *The Poems of Shakespeare's Dark Lady: 'Salve Deux Rex Judaeorum' by Emilia Lanier*. London: Jonathan Cape.

112 For a more detailed account of the case for Emilia Bassano being the Dark Lady of Shakespeare's Sonnets see Roger Prior with D. Lasocki, 1995, *op. cit.*, pp.114–37.

113 Roger Prior with D. Lasocki, 1995, *op. cit.*, p.119.

114 Christopher Lloyd, 1992, *Pissarro*. London: Phaidon Press, p.23.

115 Christopher Lloyd, 1986, *Studies on Camille Pissarro*, p.17.

116 J. Bailly-Herzberg, 1890–1, *Correspondance de Camille Pissaro*, vol.1. Paris, p.64.

117 J. Bailly-Herzberg, 1890–1, *Ibid.*, vol.II, p.224.

118 J. Bailly-Herzberg, 1890–1, *Ibid.*, vol.II, p.74.

119 J. Bailly-Herzberg, 1890–1, *Ibid.*, vol.V, p.336.

120 Frances Malino, 1978. *The Sephardic Jews of Bordeaux: Assimilation and Emancipation*

in Revolutionary and Napoleonic France. No.7. University of Alabama Press.

121 J. Bailly-Herzberg, 1890–1, *op. cit.*, vol.I, p.123.

122 R. E. Shikes and P. Harper, 1980, *Pissarro His Life and Works*. New York, p.142.

123 Stephanie Rachum, *Camille Pissarro's Jewish Identity*. Jerusalem: The Israel Museum. Stephanie Rachum, 2000, *Assaph: Studies in Art History*, www.arts.tau.ac.il, pp.7–9.

124 R. E. Shikes and P. Harper, 1980, *op. cit.*, p.51.

125 Cited in R. E. Shikes and P. Harper, 1980, *op. cit.*, p.308.

126 Cited in Stephanie Rachum, 2000, *op. cit.*, p.13.

127 R. E. Shikes and P. Harper, 1980, *op. cit.*, p.305.

128 R. E. Shikes and P. Harper, 1980, *op cit.*, p.306.

129 Stephanie Rachum, *Camille Pissarro's Jewish Identity*, *op. cit.*, www.arts.tau.ac.il, p.19.

130 Stephanie Rachum, 2000, *op. cit.*, p.25.

131 I am grateful to Ashmolean conservator Jevon Thistlewood for his expert observations on *Procession*, which I've drawn on here, along with comments by Jon Whitely, Senior Curator of European Art at the Ashmolean.

132 Sarah MacDougall, chapter 5: '"Something is happening there": early British modernism, the Great War and the " Whitechapel Boys".' In Michael Walsh, ed., *London, Modernism and 1914*. Cambridge: Cambridge University Press.

133 I am indebted to Sarah McDougall for permission to draw on her fascinating chapter on the East End Jewish artists in Michael Walsh, ed., *Ibid.*

134 Juliet Steyn, 1994, 'Inside Out: Assumptions of " English"

Modernism in the Whitechapel Art Gallery, London, 1914.' In M. Pointon, ed., *Art Apart: Art Institutions and Ideology across England and North America*. Manchester: Manchester University Press, p.220.

135 Adina Hoffman, 2016, *Till We Have Built Jerusalem: Architects of a New City*. New York: Farrar Straus and Giroux, p.131.

136 Adina Hoffman, 2016, *Ibid.*, p.143.

137 Bomberg's painting, *View of Silwan*, was acquired by his friend, Austen St Barbe Harrison. After Harrison's death, it went to his sister, Helena, who gave it some years later to John Richmond, son of the architect Ernest Tatham Richmond and grandson of the eminent Victorian painter, William Blake Richmond. Ernest Richmond or ETR as he was commonly called, knew Harrison socially and professionally from his own years in Palestine from 1918-1924 as a member of the British Military Administration. In 1918/19, ETR was in charge of the restoration of the Dome of the Rock. From 1927-1937, he was Director of Antiquities in British Mandate Palestine. The painting is currently on loan to the Ashmolean.

138 Adina Hoffman, 2016, *op. cit.*, pp.150–1.

139 The Bomberg Papers, *X Magazine*, vol.1, no.3, June 1960, p.183.

140 Wyndham Lewis, 'Round the London Galleries', *The Listener*, 10 March 1949.

141 A more detailed account of Bomberg's treatment by the British art establishment can be found in Richard Cork's essay, 'Bomberg's Odyssey'. In R. Cork, 1998, *David Bomberg*. London: The Tate Gallery, pp 34–9.

142 R. Cork, 1998, *Ibid.*

143 Gil Polonsky, 1990, 'David Bomberg Landscapes: A Search for the Sublime.' In *David Bomberg,*

Modern British Masters, vol.II. London: Bernard Jacobson Gallery.

144 Sarah MacDougall, 2002, *Mark Gertler*. London: John Murray.

145 Sarah MacDougall, personal communication.

146 Sylvia Land, 1939, *Obituary for Mark Gertler*, reprinted in N. Carrington, ed., 1965, *Selected Letters*. London: Rupert Hart-Davies.

147 Sarah MacDougall, 2002, *op. cit.*

148 Sarah MacDougall, chapter 5: '"Something is happening there": early British modernism, the Great War and the "Whitechapel Boys"'. In Michael Walsh, *London, Modernism and 1914*. Cambridge: Cambridge University Press, p.128.

149 Mark Gertler, letter to William Rothenstein, 3 July 1918. In N. Carrington, ed., 1965, *op. cit.*

150 D. H. Lawrence, letter to Mark Gertler, 9 October 1916. In N. Carrington, ed., 1965, *op. cit.*

151 Ann Oliver Bell, ed., 1977, *The Diary of Virginia Woolf*, vol.1: 1915–19. London: The Hogarth Press, p.198.

152 Mark Gertler, letter to Dora Carrington, December 1912. In N. Carrington, ed., 1965, *op. cit.*

153 Mark Gertler, letter to Dora Carrington, 8 February 1917. In N. Carrington, ed., 1965, *op. cit.*

154 Mark Gertler, letter to S. S. Koteliansky, 9 February 1917. In N. Carrington, ed., 1965, *op. cit.*

155 David Motadel, *The Times Literary Supplement*, 4 December 2015. Review of Christopher Dillon, 2015, *Dachau and the SS: A Schooling in Violence*. Oxford: Oxford University Press.

156 L. Malkin, 26.3.2011. I am indebted to Lawrence Malkin for his kind permission to quote from his book, *Krueger's Men* (Lawrence Malkin, 2006. Little, Brown and Company), and website, www.lawrencemalkin.com.

This chapter draws on information from both of these invaluable sources.

157 Lawrence Malkin, 2006, *Ibid.*

158 David Motadel, *The Times Literary Supplement*, 4 December 2015. Review of Kim Wunschmann, 2015, *Before Auschwitz: Jewish prisoners in the prewar concentration camps.* Harvard University Press.

159 Report by Georg Kohn and Jack Plapler, 1946. The National Archives, Kew, PRO FO 1046/269; testimony of Salomon Smolianoff. The National Archives, PRO MEPO 3/2766, reproduced at www.lawrencemalkin.com. See also Lawrence Malkin, 2006, *op. cit.*

160 Winston Churchill, letter to Sir John Simon, 24 September 1939. The National Archives, PRO T 160/1332, reproduced at www.lawrencemalkin.com. See also Lawrence Malkin, 2006, *op. cit.*

161 John Maynard Keynes,

letter to S.W. Waley, 28 May 1942. Reproduced at www.lawrencemalkin.com. See also Lawrence Malkin, 2006, *op. cit.*

162 John Steinbeck, letter to Franklin D. Roosevelt, 13 August 1940. NARA/FDR Library, President's Official File 3858, reproduced at www.lawrencemalkin.com. See also Lawrence Malkin, 2006, *op. cit.*

163 Gaston to Morgenthau, minutes of meeting with Steinbeck et al., 9 December 1940. NARA/FDR Morgenthau Diaries, vol.305, pp.16–17. Reproduced at www. lawrencemalkin.com. See also Lawrence Malkin, 2006, *op. cit.*

164 For further information on the technical features of the forgeries see 'Operation Bernhard: The Ultimate Counterfeiting Scheme', 1985, in *The Numismatist*. The American Numismatic Association.

165 Louis Ginzberg, 1998, *The Legends of the Jews*, vol.1.

John Hopkins Paperbacks editions, pp.296–7.

166 Ulmschneider, K. and Crawford, S. 2016. 'The camel that escaped the Nazis: Paul Jacobsthal and a Tang camel at the Ashmolean.' *Oxoniensia* 81.

167 K. Ulmschneider and S. Crawford, forthcoming, 'Writing and Experiencing Internment: Rethinking Paul Jacobstshal's Internment Report in the Light of New Discoveries.' From chapter 13. I am most grateful to Katharina Ulmschneider and Sally Crawford for permission to quote from their forthcoming publication.

168 Paul Jacobsthal, Diary, 14–15, Bodleian Special Collection. Quoted in K. Ulmschneider and S. Crawford, forthcoming, *Ibid.*

169 K. Ulmschneider and S. Crawford, forthcoming, *Ibid.*

OBJECT LIST